# MAGNUM
# CYCLING

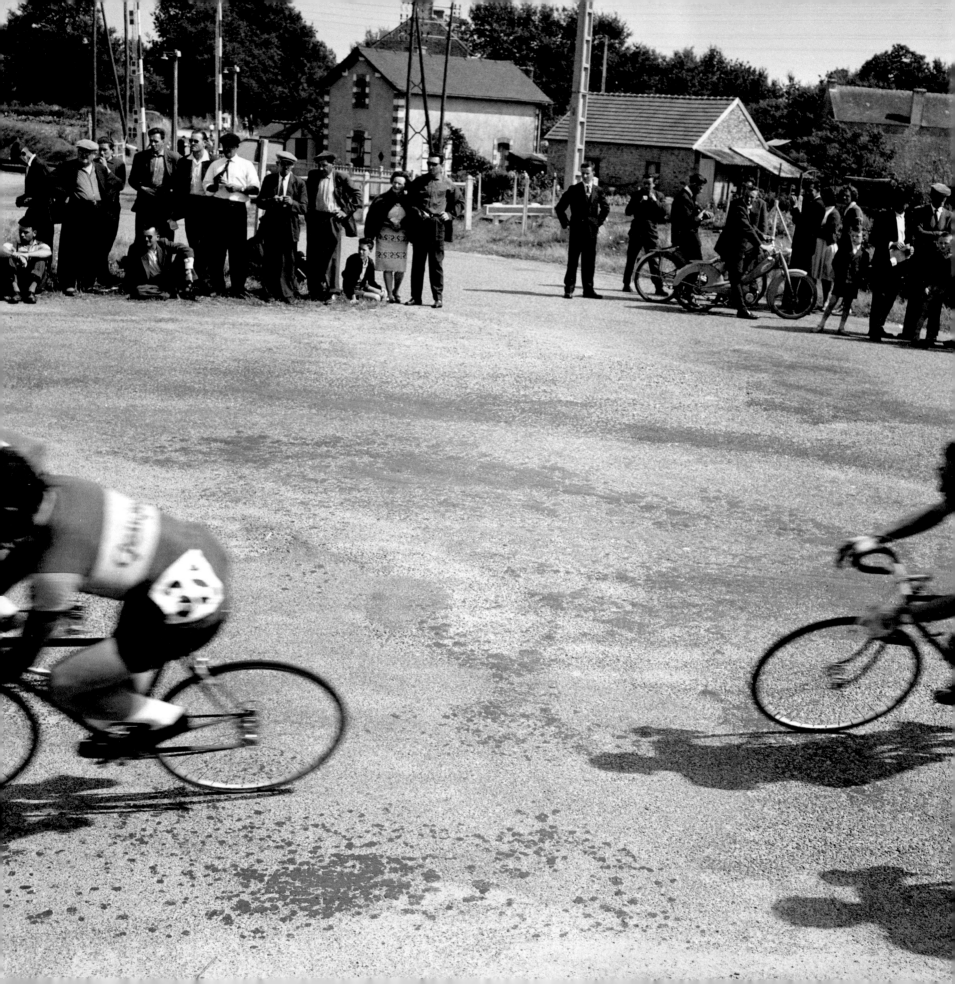

# GUY ANDREWS

# MAGNUM CYCLING

WITH MORE THAN 200 ILLUSTRATIONS

 Thames & Hudson

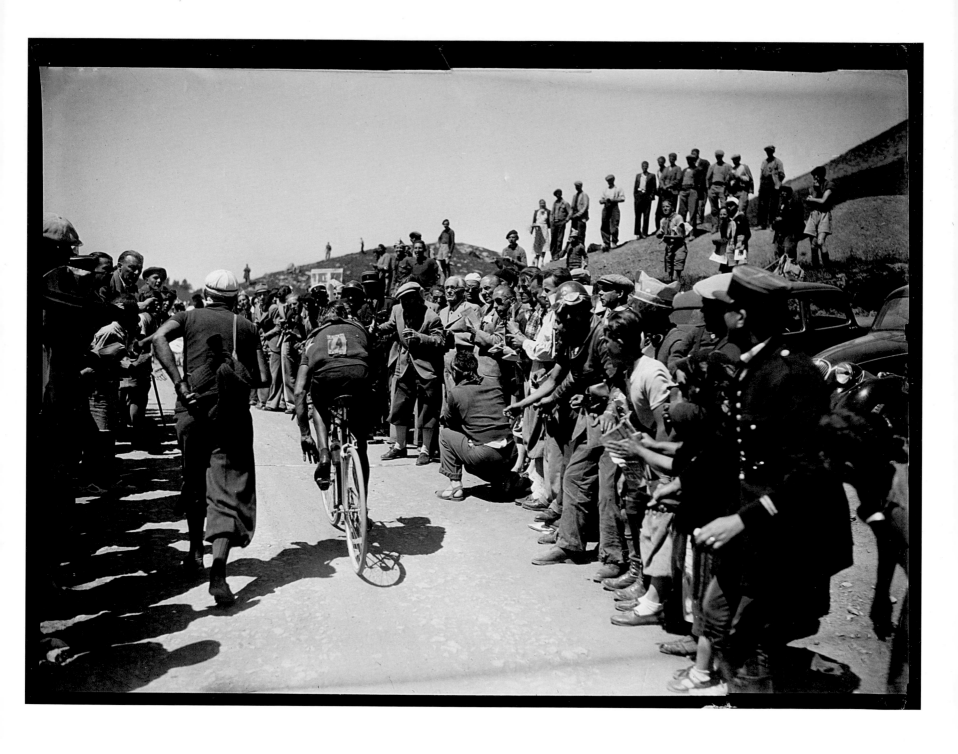

INTRODUCTION

As a spectacle, cycle racing transcends sport. For one thing, it can happen on the street outside your house, or in the centre of your home town, or in the mountains beside which you spend your holidays. In fact, anywhere a road goes, so too does the racing bicycle. And as the race itself is always a journey, either from one point to another or, in the Grand Tour format, around an entire country, many of these events combine the romance and adventure of a road trip with all the sporting drama of a cup final.

The idea that the racers were performing their trade on the open road has helped to romanticize the sport. At the start of the twentieth century, the riders (referred to in French as *les forçats de la route*, 'the convicts of the road') were perceived more as manual workers and less as the talented sportsmen they were – and are. Cycling has always attracted large crowds, and remains a sport for the people. What's more, it's free to watch, which, as live sporting experiences go, is a pretty rare thing.

Wherever there's a crowd, there's usually a photographer, and some of the world's finest – from Robert Capa to Henri Cartier-Bresson – have worked in and around a bicycle race. Of course, to follow as an official photographer, you need accreditation, transport and plenty of time, but as most races happen out in the open, in public, the photographer can get extremely close to the action. Cycling thus provides an ideal setting for the reportage, social-documentary or street photographer. Yet the picnics, the cafés and the roadside crowds are merely the beginning.

To produce this book, I was invited by Magnum, one of the world's best-known photo agencies, to look through its archives in London and Paris for photographs on the subject of cycling. The resulting collection of images – depicting such diverse events as the Tour de France, a Belgian cyclo-cross race and a six-day meeting in Paris – demonstrates an exciting balance between covering a race as an officially badged insider and covering it as an opportunist outsider. I also examined some of the media from the time the photographs were taken – the newspapers, magazines and books they appeared in – and interviewed

several of the featured image-makers, discovering that a photographer's motivation varies from simple curiosity to intensively commissioned reportage.

There is still nothing to prevent anyone from bowling up to the start of a bicycle race and taking photographs. But, as this book shows, Magnum's finest photographers provide a uniquely timeless view of cycle racing. Photography is so often about capturing the moment, and cycling is all about moments: the anticipation, the team cars, the police, the journalists, and the whole multicoloured circus before the race has even arrived. And when it does, it's through and gone in a heartbeat.

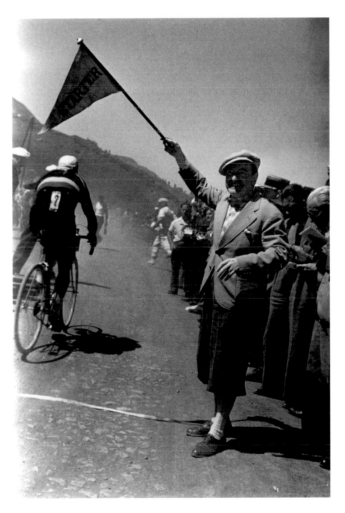

*Opposite*
A crouching Robert Capa can be seen taking a photograph of 1930s celebrity Georges Biscot at the top of the Col du Tourmalet during the 1939 Tour de France. Photograph: Offside/L'Équipe

*Left*
One of the photos that Capa took of Biscot on the Col du Tourmalet. The Tour's founder and long-time director, Henri Desgrange, can be seen standing behind Biscot in both pictures.

# 1939 TOUR DE FRANCE

## ROBERT CAPA

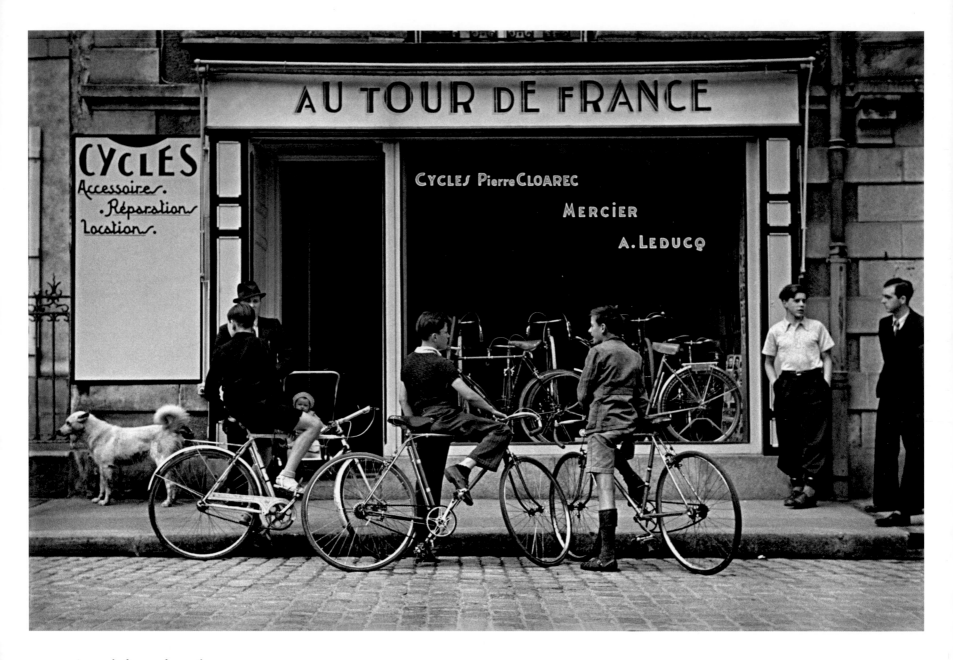

A crowd of young fans gathers outside Pierre-Marie Cloarec's bicycle shop in Quimper, Brittany, to watch Stage 4 of the 1939 Tour de France. Clo-Clo, as Cloarec was known to the Bretons, was not your average bike-shop owner: he was also a Tour rider, and was competing in that year's race.

**He could photograph motion and gaiety and heartbreak. He could photograph thought.**
—*John Steinbeck*

With war only a few months away, the 1939 Tour de France was a pretty meagre affair. The tension in France was mounting, and Europe as a whole was falling apart politically. As a result of the pending conflict, the Italians and Germans refused to send any teams to France to compete in the race. The Spanish, meanwhile, had just emerged from their bloody civil war, a bitter struggle from which most Spaniards of a Tour riding age were still recovering.

It was this war on the Iberian peninsula that had provided Robert Capa with his debut in the booming world of international photojournalism. In December 1938 the British weekly illustrated magazine *Picture Post* introduced 'The Greatest War Photographer in the World: Robert Capa' when it published twenty-six of the photographs he had taken during the conflict. The pictures had first been featured in the French magazine *Vu*, and in 1937 one image in particular – of a falling, dying loyalist soldier – had appeared in *Life* magazine in the United States, helping to make Robert Capa an international name. With *Picture Post* having a circulation of almost 2 million, Capa's worth increased considerably, and it was on the back of this success that *Match* magazine (the predecessor to *Paris Match* and a similar type of publication to *Life* and *Picture Post*) sent Capa to France to follow the depleted and lacklustre Tour of 1939. It was to be the last edition of *Match* for eight years.

Many of the race's recent winners and favourites were injured, sidelined or excluded for political reasons, so 1939 was far from the Tour's finest year in terms of competition. André Leducq, winner in 1930 and 1932, and Antonin Magne, victor in 1931 and 1934, had retired the previous year. The winner of the 1933 Tour, Georges Speicher, did not ride, and the 1937 champion, Roger Lapébie, was injured. Italian prodigy Gino Bartali, the 1938 victor, also sat it out and – thanks to the impending war – missed the opportunity to become the greatest Tour rider in

history. Bartali was to spend the war years on long training rides, ferrying counterfeit identity papers across the Italian border for persecuted Italian Jews.

With the Tour at that time still contested by national and regional teams, 'La Grande Boucle' (literally, 'The Big Loop') of 1939 was down to a few Swiss, a Luxembourger or two, some Dutch, several Belgian squads and the French. Although some concessions had been made to rider welfare by 1939 – following the brutally tough Tours of the 1920s and early 1930s – the race was still a monumentally difficult event: twenty-eight stages (some split into three parts, on the same day) and an overall distance of 4,224 km (2,625 miles). In all, just seventy-nine riders lined up in Paris for the start of the 1939 Tour de France. Three weeks later, only forty-nine would be classified as finishers.

The Tour de France was founded in 1903 by the French bicycle racer and sports journalist Henri Desgrange. Desgrange was the editor of *L'Auto*, the first sports newspaper in continental Europe, and it was to boost the paper's flagging circulation that he established the Tour. The French public adored the competition, with many claiming that it was through Desgrange and the Tour that they learnt the shape of their country. The race was in fact the idea of another French sports journalist, Géo Lefèvre, but it was Desgrange's enthusiasm and considerable personality that carried the idea forward. The leader's yellow jersey still bears the initials 'HD' on the chest.

The Tour has changed considerably since 1939, as of course has photography. But in the case of Robert Capa, how he worked is more important than what he worked with. Capa was originally from Hungary, a country that produced many exceptional photographers (he once joked that 'It's not enough to have talent, you also have to be Hungarian'), and the reportage style he and many of his compatriots had helped develop perfectly suited cycle racing.

The success of Capa's pictures from the 1939 Tour can be attributed to at least one technical element. Rather than using a large-format plate camera, the tool of the trade for press photographers of the time,

he opted to use his small 35mm Contax camera. This gave him an immediate advantage over the newspaper photographers around him: not only was he able to shoot several rolls of film a day, rather than a few, very carefully composed frames, he was able to work quickly and in a variety of conditions.

The Tour-hardened French photojournalist Raymond Vanker remembers Capa as a 'brave and daring photographer'. He was willing to take risks: his are some of the first Tour photos taken from the back of a motorbike (ridden by a friend of Capa), allowing him to capture a more intense side to the action than had ever been shown before. Taking photos from a motorcycle may not sound like a big deal today, but in 1939 it was a very dangerous activity indeed. The roads were full of potholes, and the motorbikes had poor brakes and worse suspension.

The action taking place around the race seemed to have occupied Capa much more than the race itself – a unique approach in the late 1930s, and one that has ensured that his pictures remain fresh and alive. Capa never described his work as anything more than journalism, and it was his spontaneous approach to photography that would be much in demand by the press a few years later, when the French countryside became one of the bloody battlefields of the Second World War.

There are thirty extant contact sheets from Capa's time on the Tour, and it's fairly safe to say that he didn't shoot every stage. Interestingly, there is no evidence of the early starts, but the long transfers and drives between stage starts and finishes seem to have been done mostly on a motorbike. Many of the photos seen here were not used at the time, which in retrospect is rather a shame: much of what Capa shot of the 1939 Tour was some of the finest photography the race has ever seen.

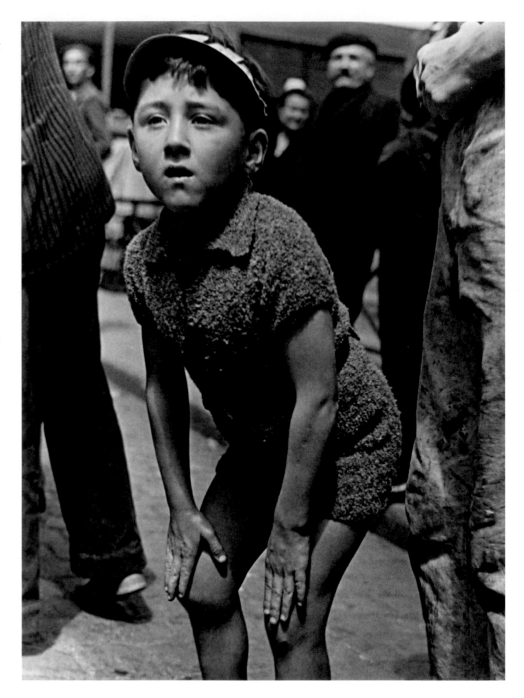

Cloarec's son, Pierrot, waits with anticipation to greet his father and wave him and the rest of the Tour past the family shop in Quimper.

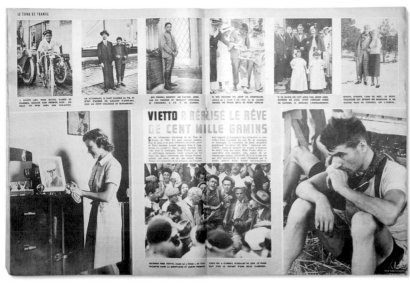

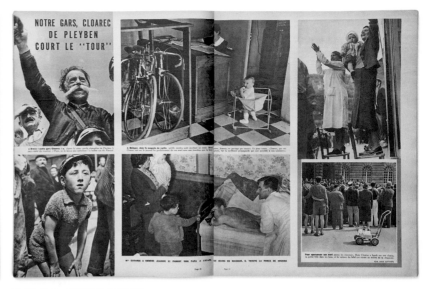

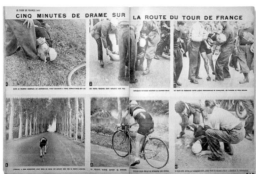

## MATCH MAGAZINE

The period between 1930 and 1950 was arguably a golden age for the photojournalist. This was due in large part to the popularity of a handful of high-quality magazines willing and able to print full-page photographs and double-page spreads. At the start of the 1930s, photographers had begun to use lighter and better equipment, and could send pictures down a wire to the press rooms and news desks. And since the quality of printed photographs had increased considerably, publishers were able to offer the public a unique view on the world – and the public

loved it. *Life* magazine in the United States, *Picture Post* in Britain, and *Vu* and *Match* in France were the main publications for which Robert Capa and his contemporaries worked, and circulations reached many millions. In the 1960s and 1970s demand for this type of journal decreased as newspapers caught up photographically. Luckily, the photojournalist survived.

*Match* featured two sets of Capa's photographs of the 1939 Tour, in issues 55 and 56 of July that year. In issue 56, the main Tour story is about the French rider René Vietto (above, top row, left). In the same issue,

the spread of the Belgian champion Romain Maes giving up on Stage 8 (above, bottom row, centre) certainly reaches the level of drama expected of *Match*, although it is possible that the magazine was gloating slightly at the misfortune of the 1935 Tour winner. This was the type of journalism that would help sell copies.

Issue 55 features a story about Pierre-Marie Cloarec's family and their day out when the Tour visited Quimper (above, top row, right) – the day after Clo-Clo had won the stage into Brest.

Cloarec's family, friends and supporters await the Tour's arrival in Quimper. By this time they already had something to celebrate: the day before, Cloarec – whose family was originally from nearby Pleyben – had won Stage 3, from Rennes to Brest. At 244 km (152 miles) and around seven hours in the saddle, it was the longest stage of that year's race.

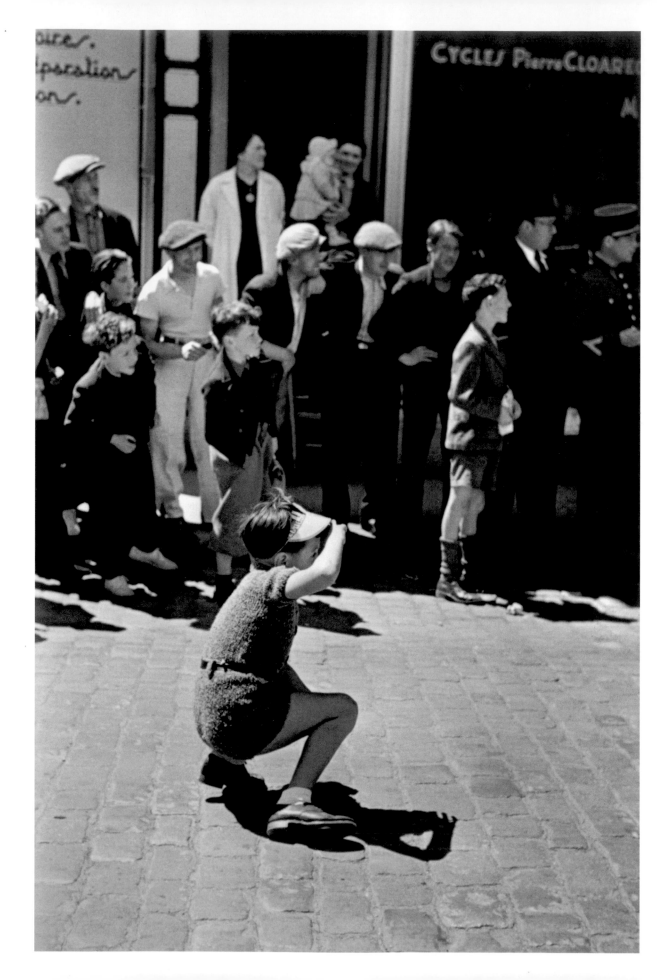

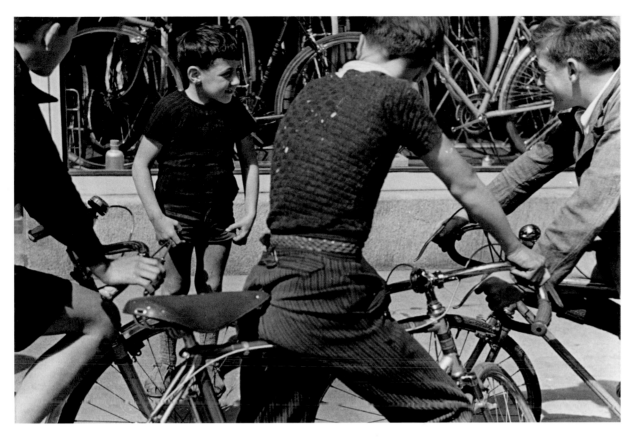

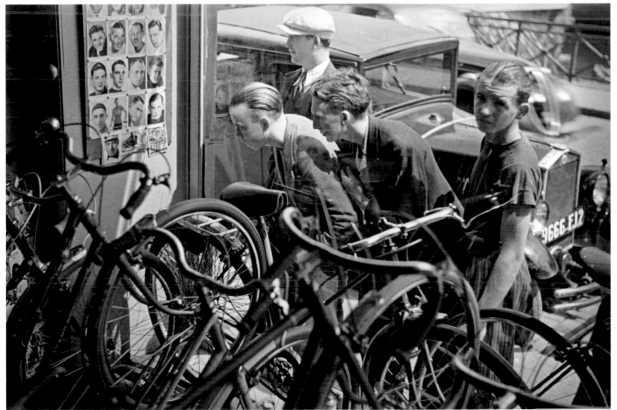

15

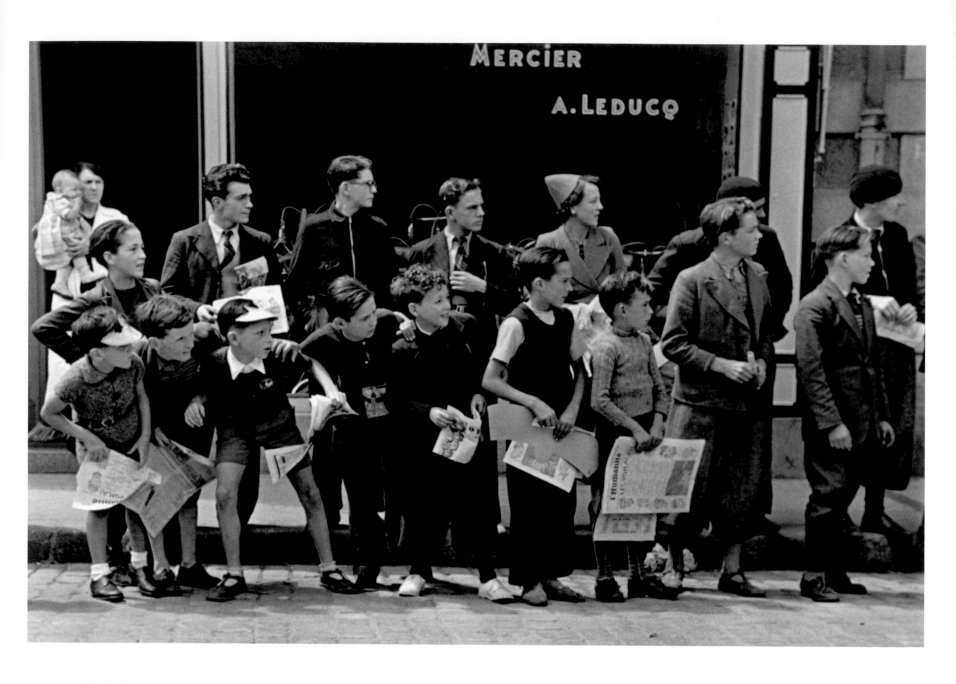

This pair of images was intended as a diptych, the switching of heads from right to left perfectly suggesting the movement of the passing peloton. Capa has succeeded in capturing what the race is like from the spectator's point of view: over in an instant.

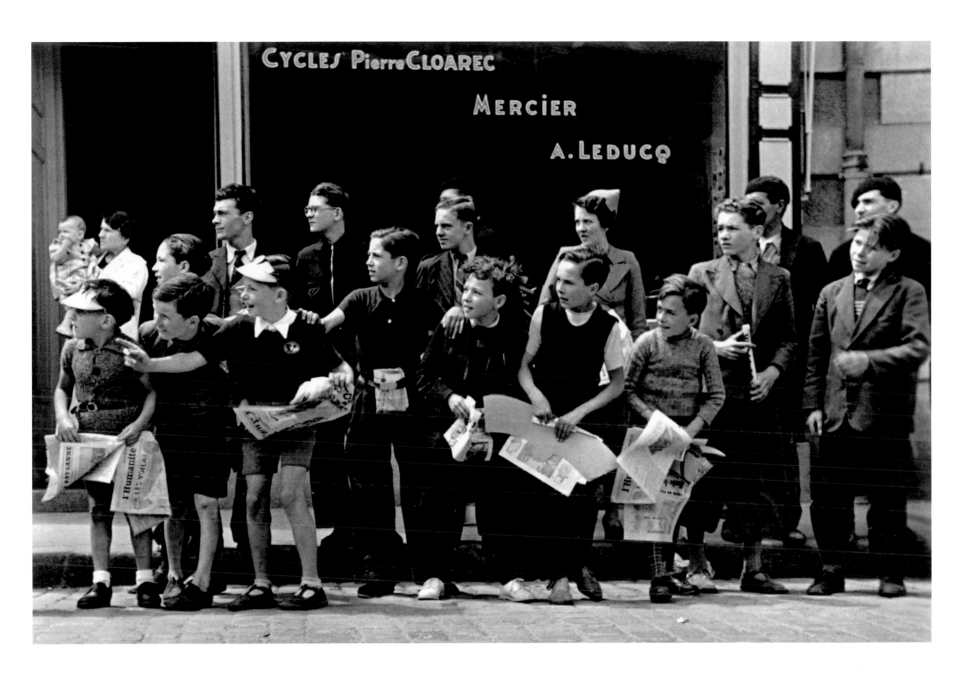

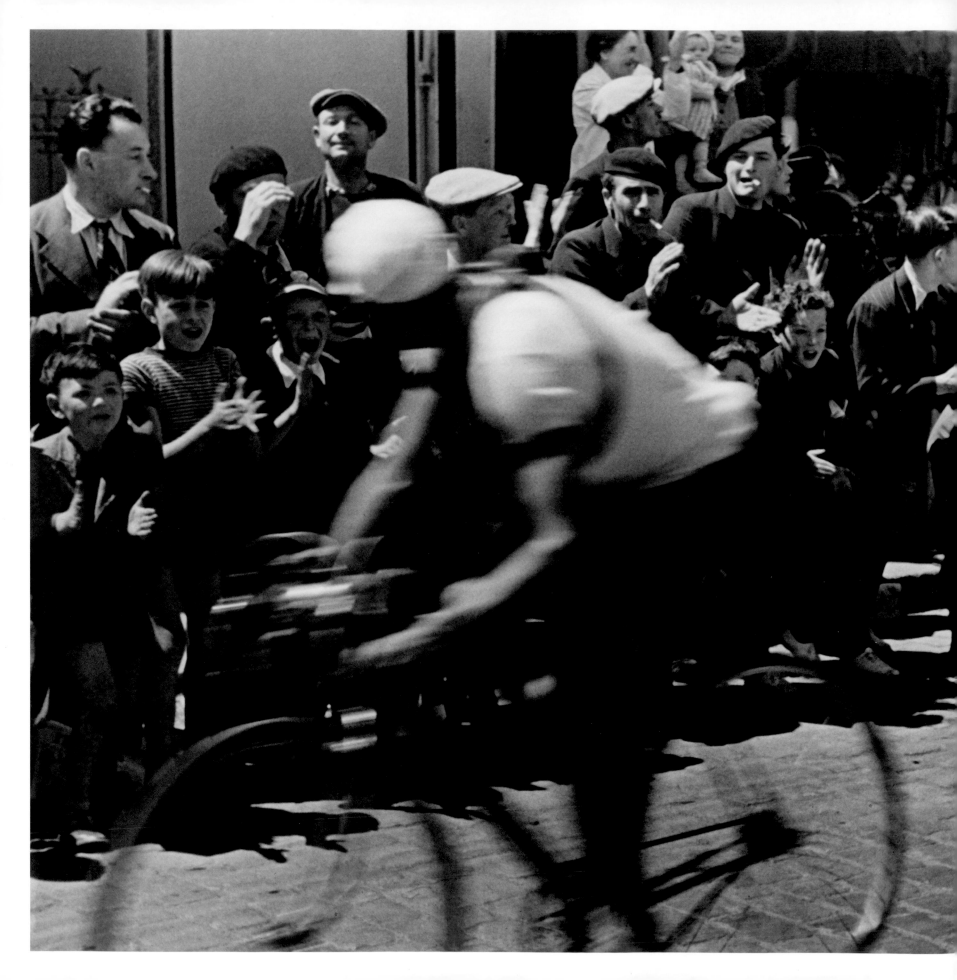

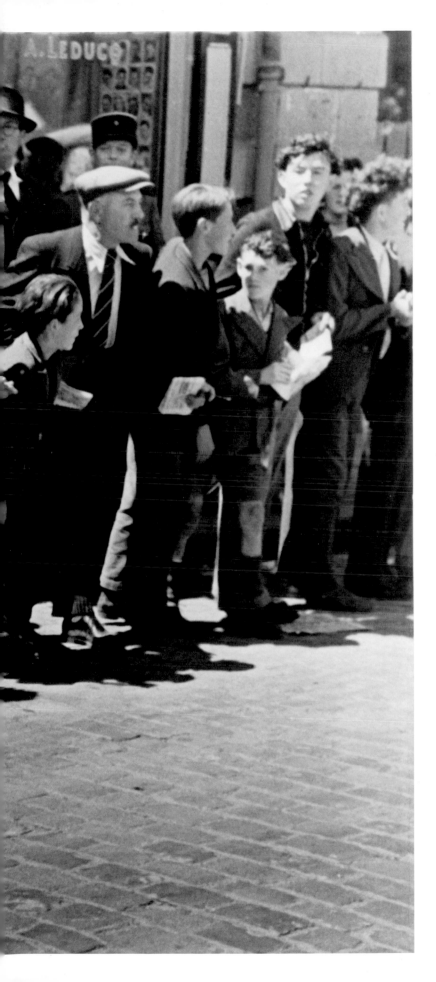

By the time the Tour reached Paris, Cloarec – pictured here passing his bicycle shop – was more than two hours behind the eventual winner, Belgian rider Sylvère Maes. But thirty-first overall was still very respectable for a bike-shop owner, and he had won not only Stage 3 but also the 175-km (109-mile) Stage 14, between Monaco and Digne. Clo-Clo died aged eighty-five in 1994, still a legend in the sleepy town of Pleyben. He also has a road named after him in Quimper.

The newspapers that were sold to the waiting crowds – including Henri Desgrange's *L'Auto*, which acted as the Tour's sponsor – carried all the results and information from the previous day's racing. They also featured rider profiles, interviews and stories from the road. It was compelling stuff, dramatically presented, and the papers sold in their hundreds of thousands.

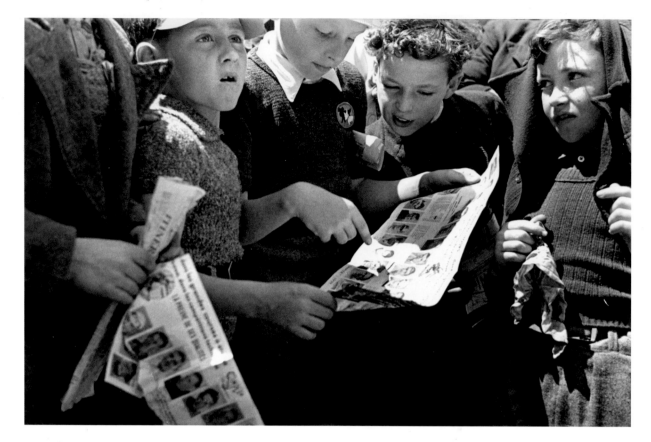

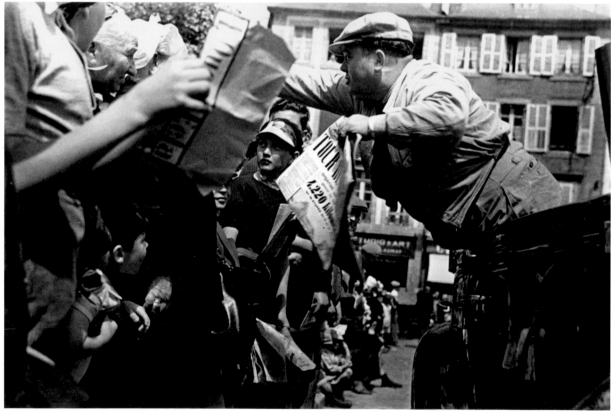

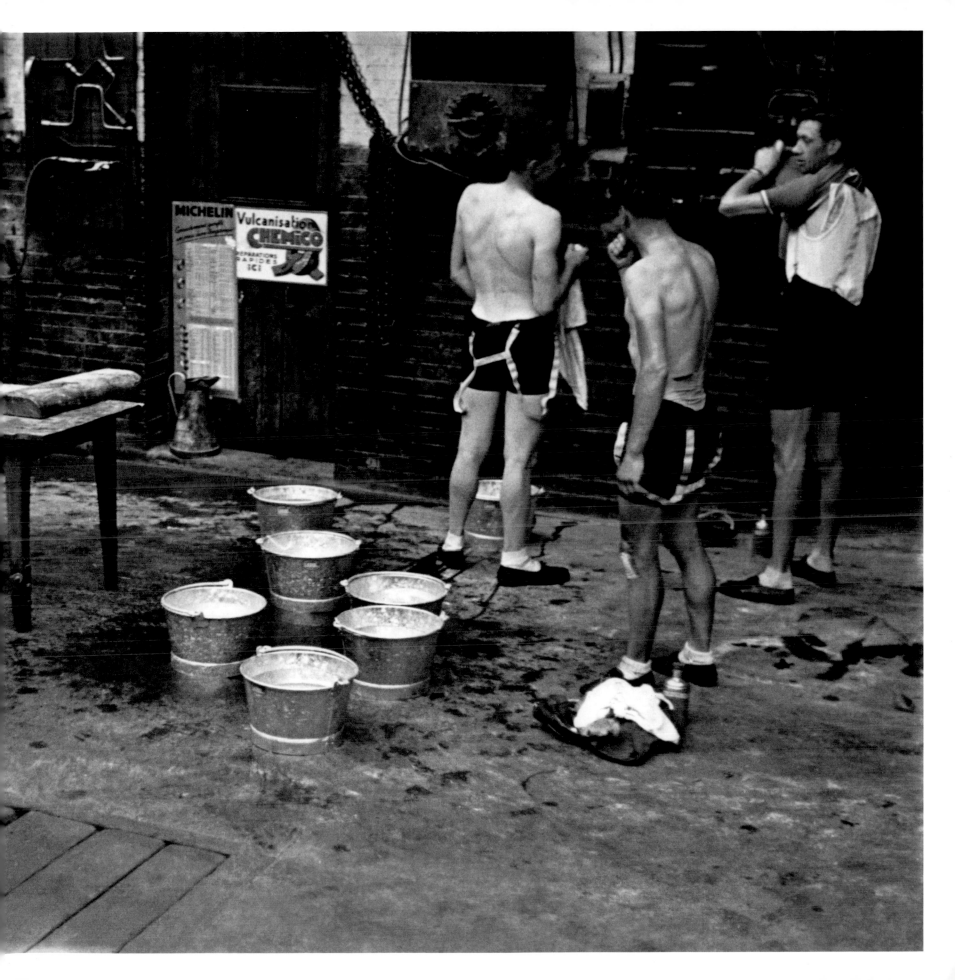

As Tour director, Henri Desgrange had some fairly draconian ideas about how hard the riders should race, and, at times, the conditions they endured were quite brutal. Needless to say that when everyone stopped for lunch, Desgrange didn't eat with the riders. In 1939 he was struggling with his health, having missed most of the previous year's Tour because of a prostate operation; he had more or less recovered by 1939, but was still weak. His plans for the 1940 Tour never materialized owing to the Second World War, and he died in August of that year.

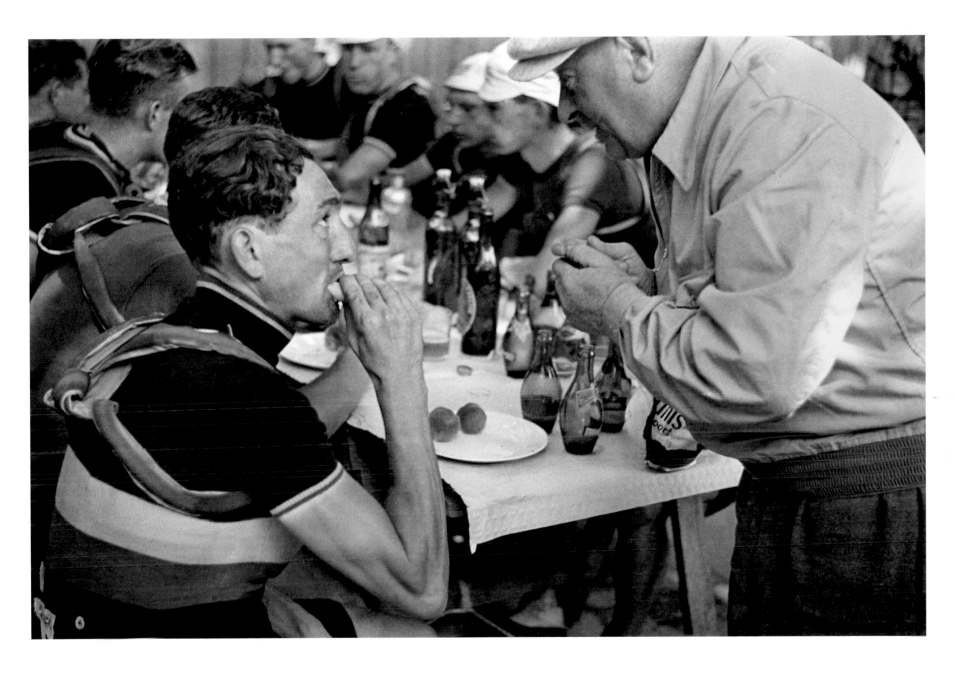

Edward Vissers, a member of the Belgian team and at one point a contender for the yellow jersey, eats lunch with his teammates. This was to be his last Tour, during which he won Stage 9 and the mountains classification. He finished the race fifth overall.

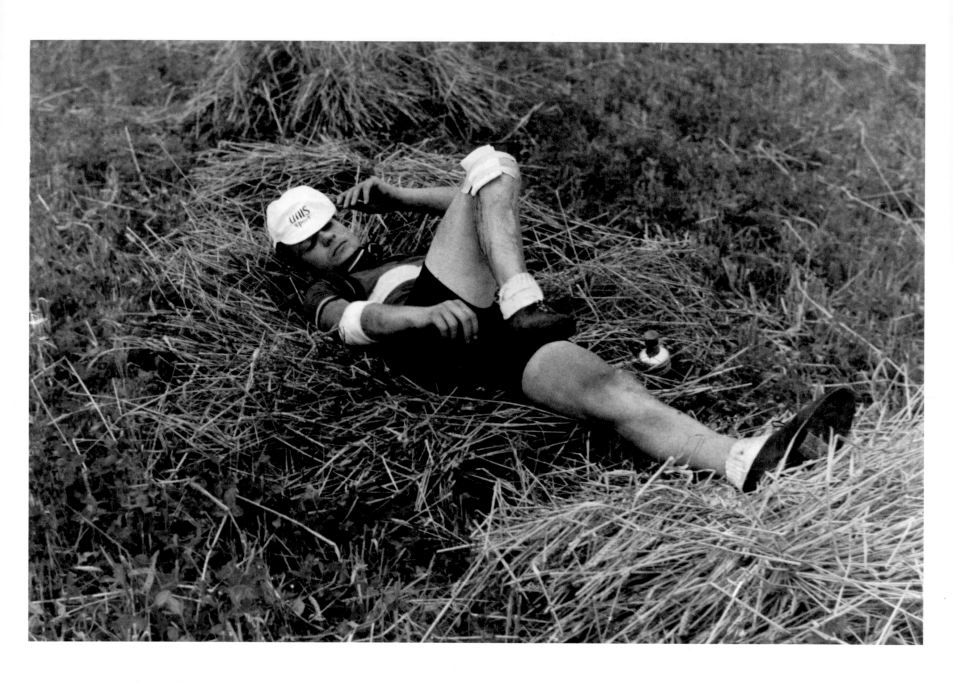

Resting up whenever the race stopped was the name of the game, with endurance rather than speed becoming the key to a successful Tour de France. In 1939 Stage 16 was divided into three sections. In the first, René Vietto managed to stay on Sylvère Maes's wheel, but in the second – a gruelling 64-km (40-mile) individual time trial (TT) up the Col de l'Iseran, the first mountain TT in Tour history – Maes gained another ten minutes over the wasted Frenchman. Maes would lead for the rest of the Tour and win by half an hour.

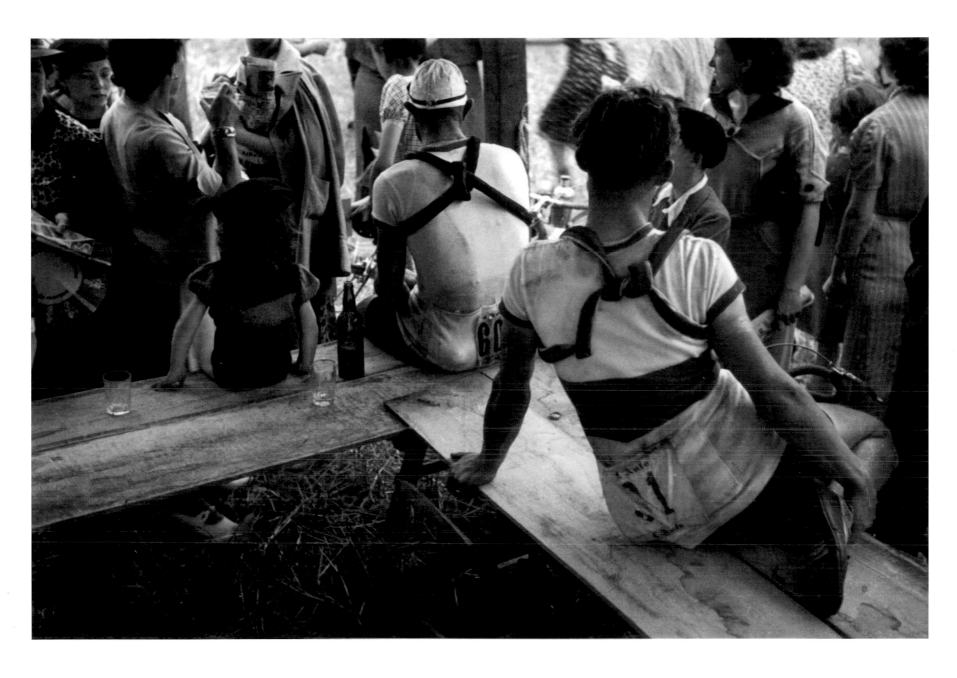

During the first three decades of the Tour, technological advances were few and far between. Spare tubular tyres were tied around the shoulders because spare wheels were forbidden – as was pretty much any outside assistance for the riders along the way.

Although the Tour de France was established as a means of promoting *L'Auto* – the yellow pages of which are said to have inspired the colour of the race-leader's jersey – in the pre-war period the daily newspaper *Paris-soir* also had a vested interest in the race. Both newspapers took the action directly to the public.

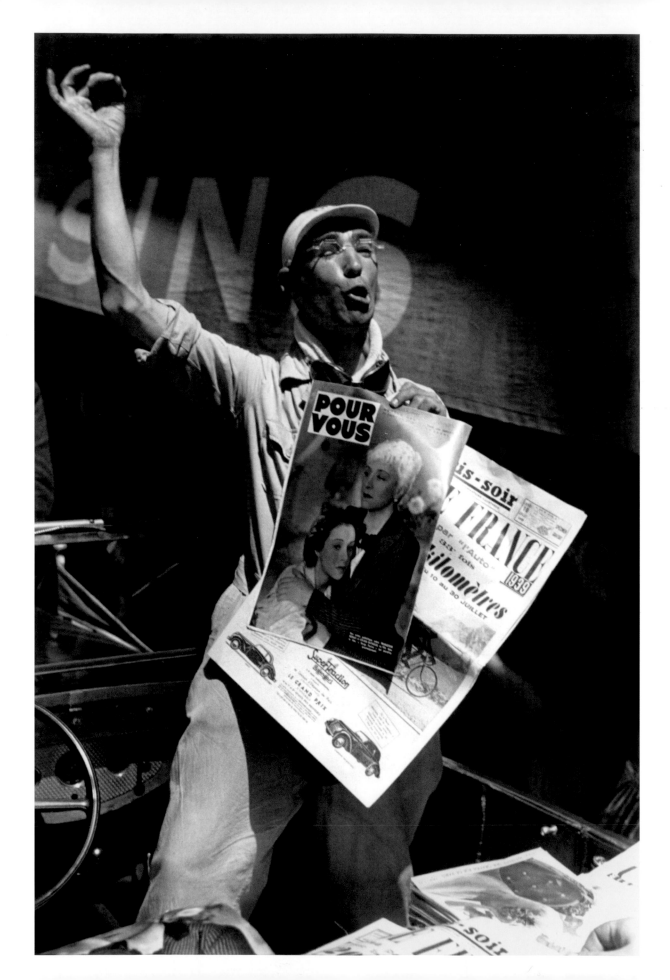

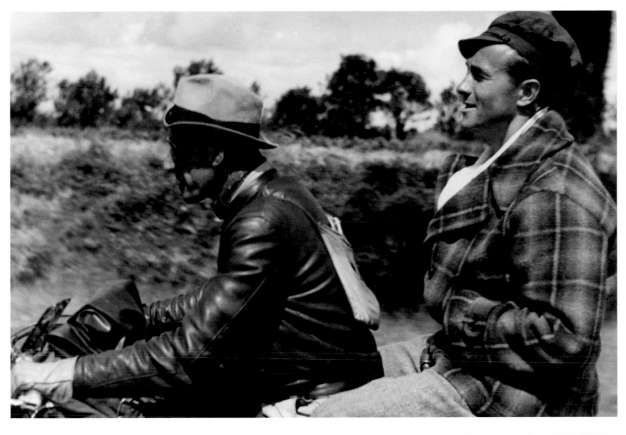

Motorbikes and cars – especially fast ones – were a rarity in rural France, so much of the public's attention was directed at the motorcycles and support cars that followed the race. Both journalists and photographers seem to have had a very enjoyable time.

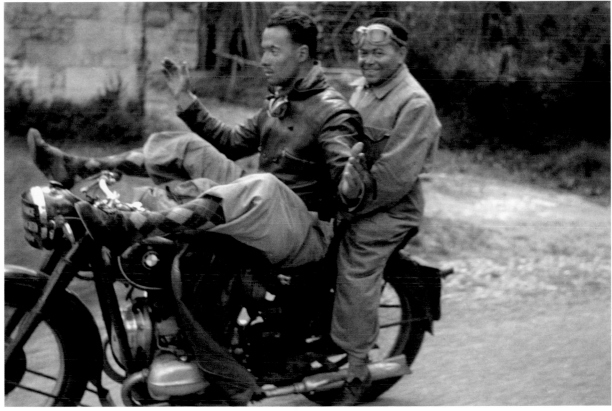

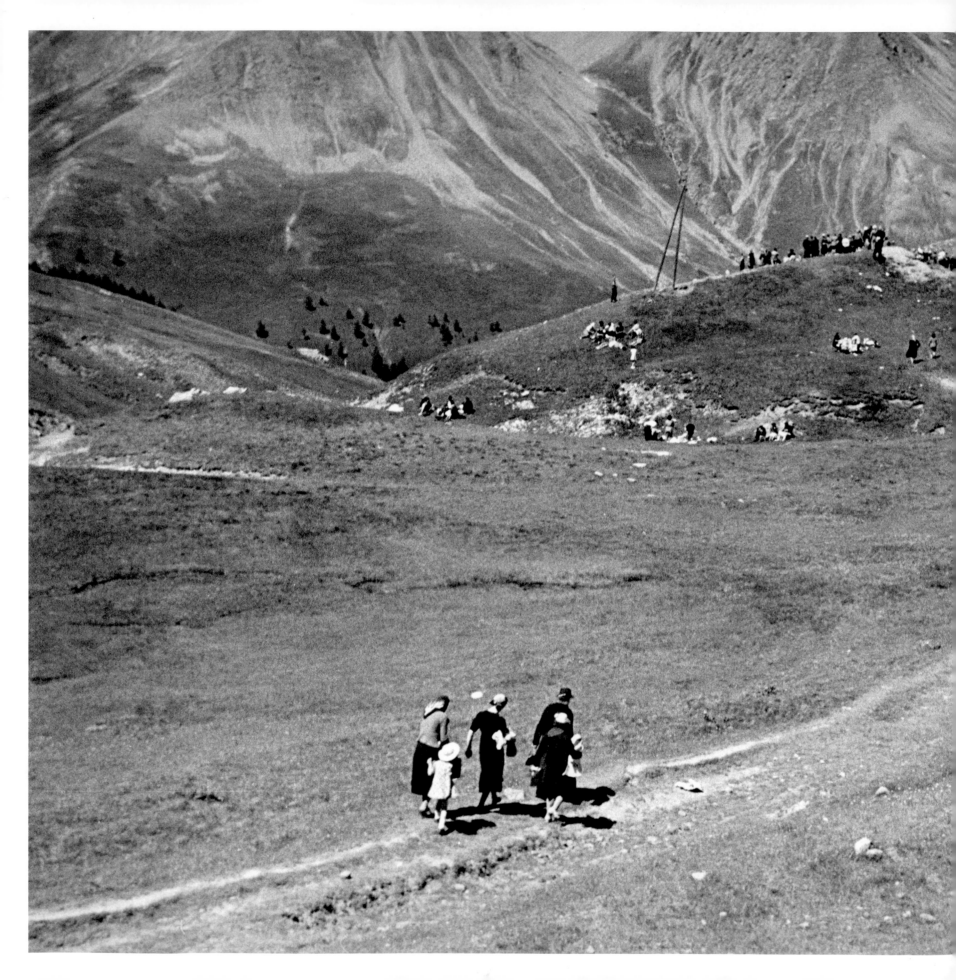

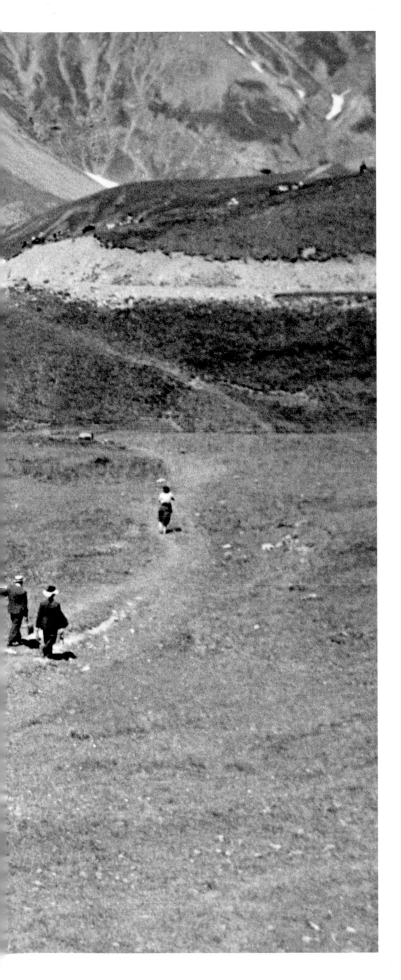

Rising to more than 2,000 m (6,500 ft) above sea level, the Col du Tourmalet was for many years the highest point in the Tour de France. It was a beast of a climb, whatever the conditions; in the wet, however, the roads were barely walkable, let alone bikeable. Here, spectators, journalists and photographers await the riders.

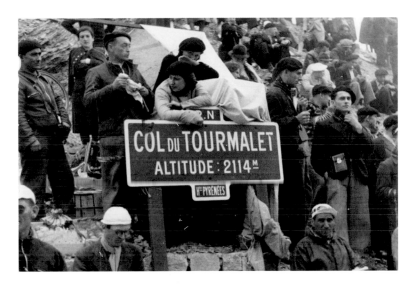

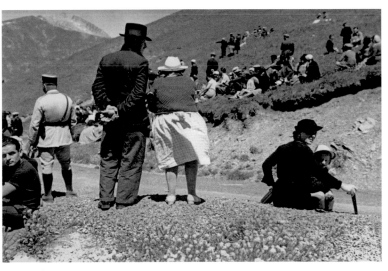

A gendarme (right) directs the race. The rope to hold back the spectators (below and opposite) didn't always work, and the race often had to be stopped because of the number of people in the road trying to catch a glimpse of the action.

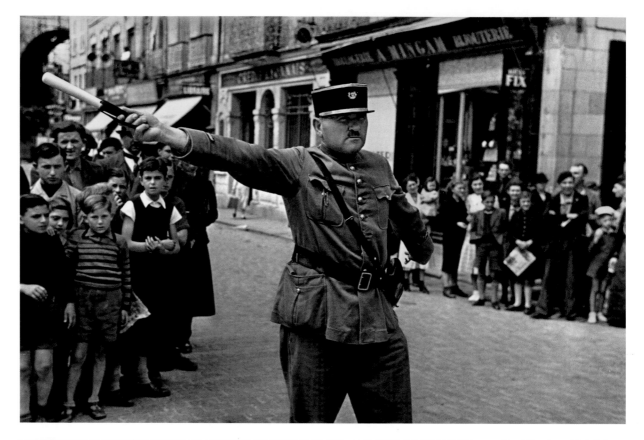

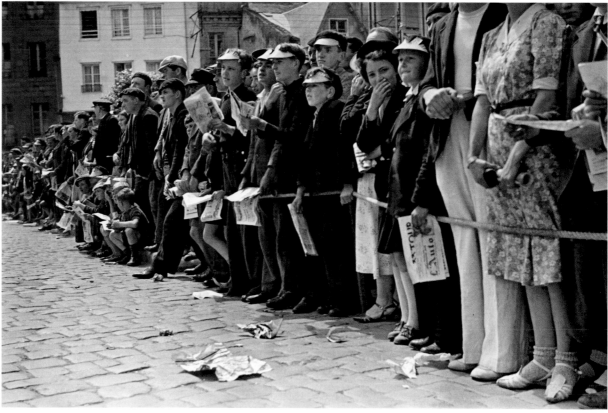

A crowd gathers outside the Hôtel de Ville in the town of Morlaix in Brittany on Stage 3 of the Tour, from Rennes to Brest.

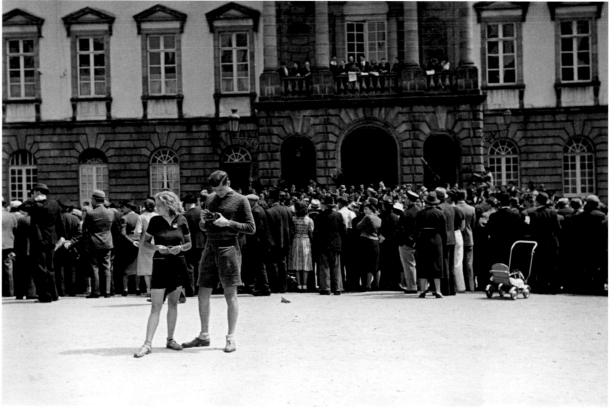

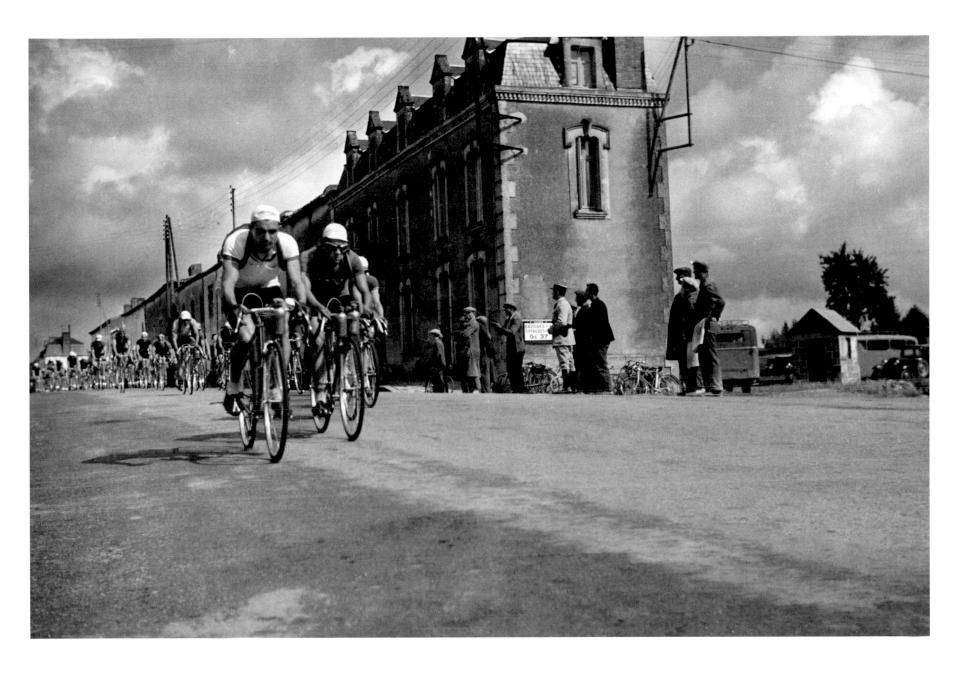

In 1939 riders still had to use bicycles supplied by the Tour's sponsor, *L'Auto*. They were not popular with the competitors, looking like a collection of holiday-hire bikes compared to the refined, custom-made machines the riders would normally have ridden.

The riders arrive in Paris in the pouring rain. Those who completed the Tour of 1939 were not so much competitors as survivors, having ridden 4,224 km (2,625 miles) at an average speed of 32 km/h (19.9 mph) on essentially dirt roads. Compare this to the 2015 edition, which was held over a distance of 3,360 km (2,088 miles) and ridden at an average speed of 39.6 km/h (24.6 mph).

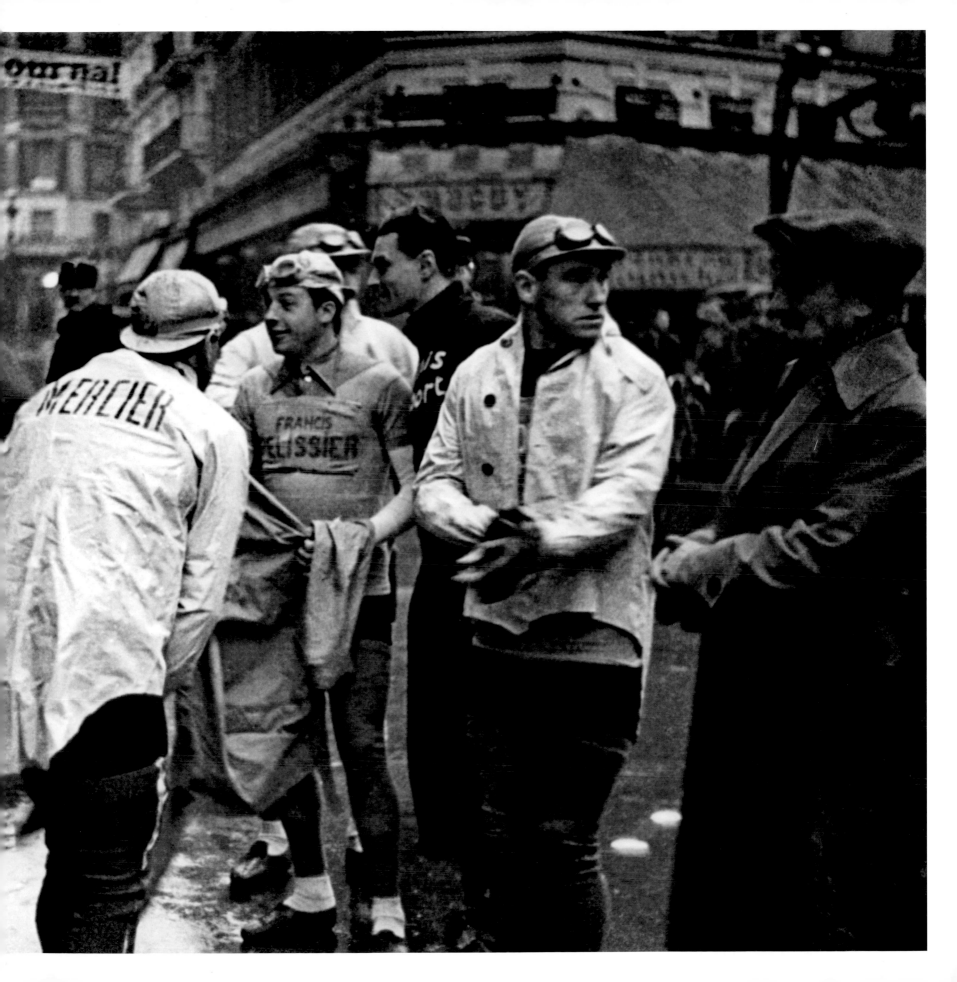

# WINTER AND SPRING

A racing cyclist remembers a puncture like a photographer recalls a photograph. They remember at which point, and where it happened, for the rest of their life.
—*Philippe Bordas*

The first photograph Guy Le Querrec took at a bicycle race was, to use his own words, the third 'decent' photograph he had ever taken. It was 15 July 1954 on the eighth stage of the Tour de France, and Guy was thirteen years old. He is very specific about it being his third decent photo, but he took several that day and they're all good (see opposite), evidence of his emerging talent. So how did a young Le Querrec find himself at the Tour de France? Much like any French schoolchild, he was on his summer holidays, staying in a part of Brittany through which the Tour was due to pass, camera at the ready. As the race rushed through the nearby town, he barely had a chance to take a picture before it was gone. First and foremost, however, Guy was a fan of cycling, imagining a career for himself that was very different from photography.

'My dream was cycling, even then', he explains. We're sitting in Magnum's Paris office, looking through one of Guy's old photo albums; among his pictures of the Tour are some of him on a bike. 'It was at the Tour de France 1954 – I still have the copy of *L'Équipe*. It was Stage 8, from Vannes to Angers, and it passed La Roche-Bernard. The village of my grandparents was very close. I went out with my parents on a scooter; at the time, that was really something. We didn't put helmets on or anything. It was 35 kilometres [22 miles] or so to see the passage of the Tour at this village, with three of us on it. And my dad drove very badly!'

Even now you can hear the excitement in Guy's voice – recognition of the fact that, at a young age and with simple equipment, he was able to capture such a great image of a champion in a state of duress. It is certainly a dramatic photograph. The Italian-French rider Attilio Redolfi had picked up a puncture. After the race had sped through the town and the dust had settled, he was left at the side of the road to fend for himself (in those days riders had to fix their own tyres). Redolfi mended his puncture and completed that day's stage but never made it to Paris, retiring on Stage 14.

'It was a bit of reportage', Guy recalls. 'And I liked it a lot. This guy [Redolfi] wasn't known; he rode for Leducq. He only won one race, the Boucle de la Seine in '53. The riders passed at 50 kilometres an hour [31 mph], and this guy … You can imagine, me saying, "I'll take a photo from the roadside with all the chaos of the race" and all that … Anyway, this guy, he punctures. So, I crossed the road – it was a bit dangerous with the motorbikes – and I photographed him. I thought I was going to become a bike racer.

'It's just a photo I took … I was thirteen, and I wanted to be a rider on the Tour de France. After, I said to myself, "There's nothing else to compare this to." Louison Bobet won the Tour that year, so my first bike was a Stella [the bike Bobet rode], and later I had a Mercier too.'

Almost thirty years later, in 1985, Guy was invited to follow the Renault-Elf team during its racing season. His first rendezvous with the team was in January that year, for a winter training ride on the outskirts of Paris. His second was in February, for the team's annual spring camp further south, in Provence.

# GUY LE QUERREC
## RENAULT-ELF WINTER TRAINING

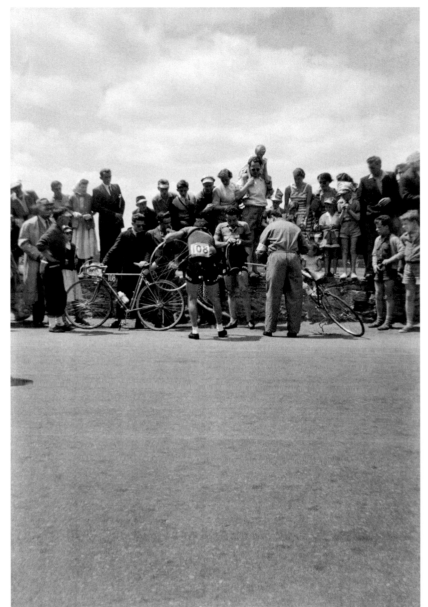

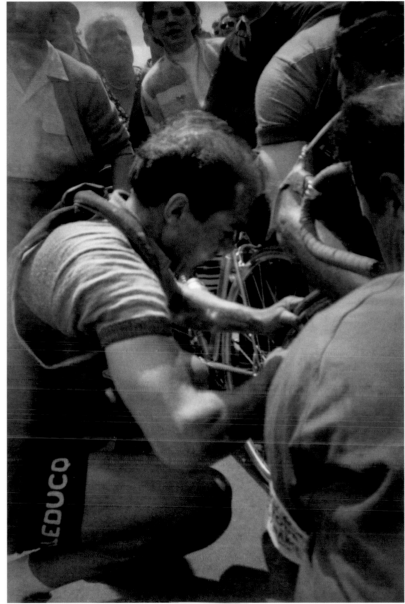

*Above, left*
15 July 1954, Tour de France, Stage 8: With the peloton long gone, the puncture-stricken Attilio Redolfi of the Leducq team is left stranded by the side of the road.

*Above, right*
There is plenty of advice for Redolfi, who has to fix the puncture himself. In 1954 mending flats was always the responsibility of the riders. The leading contenders would swap wheels with a teammate, but lesser riders would have to change the tyre themselves. It could cost them their place in the race – it often took many minutes to get back riding again – so they had to be quick.

The Renault-Elf team train in the freezing suburbs of Paris in 1985. The average professional rider will need to chalk up around 10,000 km (6,214 miles) of winter training, so snow and ice are an occupational hazard.

LE QUERREC: WINTER TRAINING

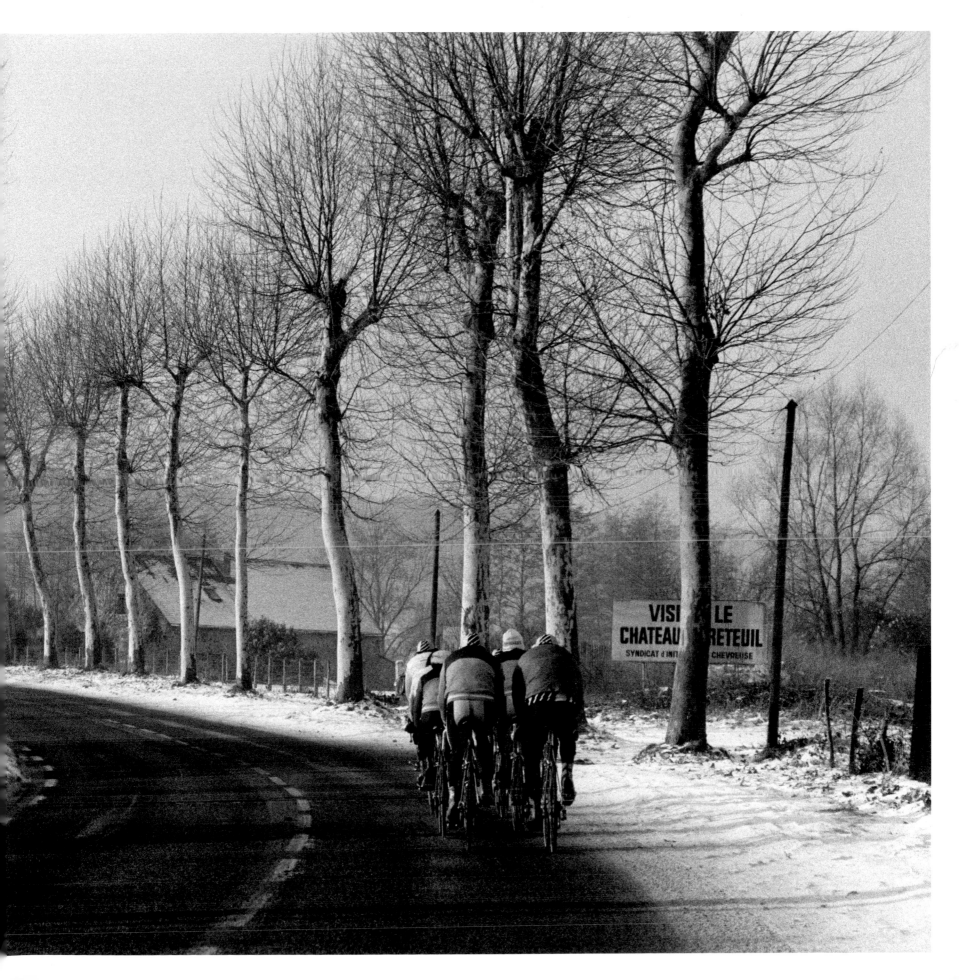

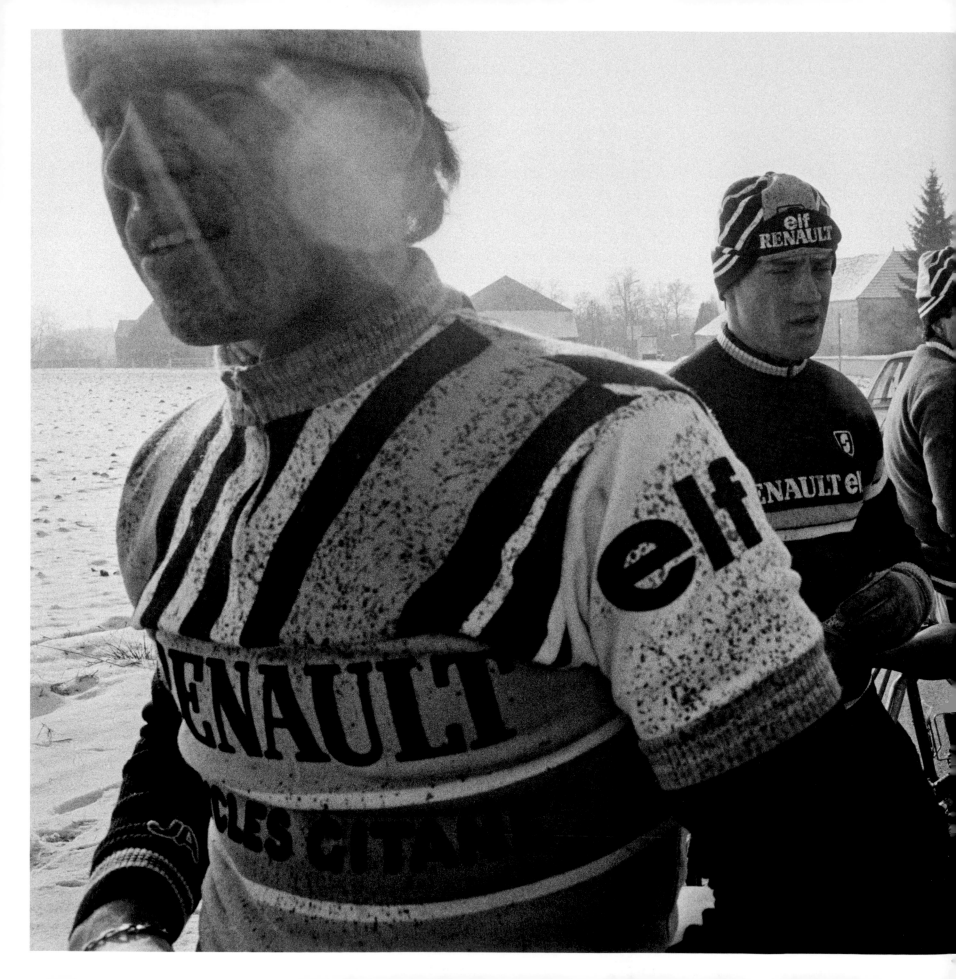

Team members Philippe Chevallier, Pascal Jules, Bruno Wojtinek and Christian Corre take a drinks break during training. Hot tea and soup are often drunk when it's this cold.

## WHATEVER THE WEATHER

Guy Le Querrec's photos of the Renault-Elf team were taken in part during a training ride in January 1985 near Rambouillet in the suburbs of Paris. The riders are dressed to face the wintry conditions, including snow and ice. According to an old cycle-racing adage, winter miles bring summer smiles, meaning that whatever riding you do in the winter will help your chances of success in the grand tours, national titles and world championships of the summer months. This approach has changed very little in the past century, and riders still put in many hours of on-the-bike training. More recently, research into the science of cycling has helped prove the point that the only way to get better is to do more. The riders of the sport's early days clearly had the right idea.

In 1985 the professional cycle-racing season was long and hard, running from February to October. The teams were smaller too, meaning that every rider had to be fit and ready to compete in most of the season's races, and couldn't be rested or allowed to focus on specific events as they are today. As a consequence, all riders would follow more or less the same training patterns, from November to January, whatever the weather. One drawback to putting in six or seven hours of road training in the depths of winter is that such training is very hard on the body and can put the rider at risk of injury or illness. Nowadays, therefore, the riders head to sunnier climes for their winter rides.

Advancements in fabric technology took time to reach the sport of cycling, and in 1985 warm clothing meant plenty of layers. Indeed, much of the clothing was custom-made. As for the bicycles, the mechanics would fit heavier tyres for winter training, although some of the riders used cyclo-cross bikes, which are more suitable for poor road conditions.

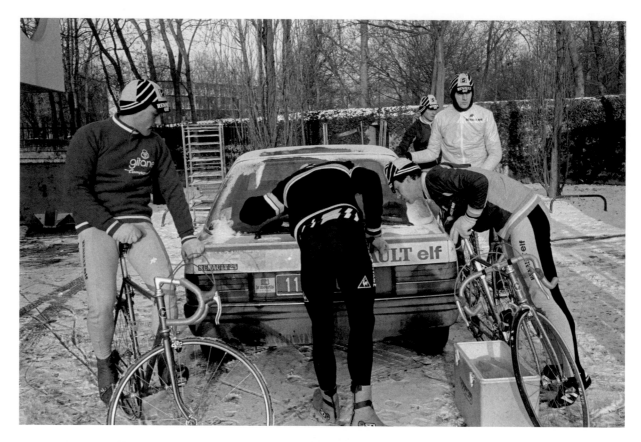

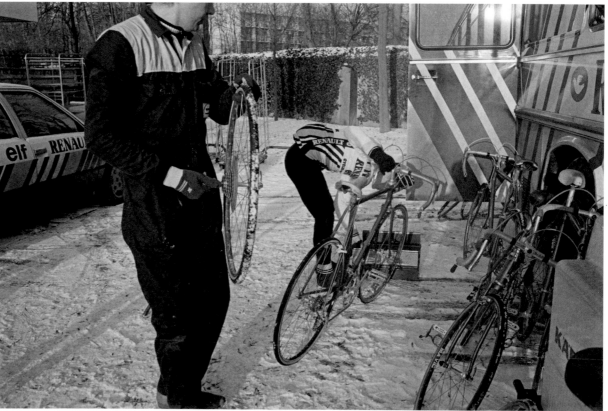

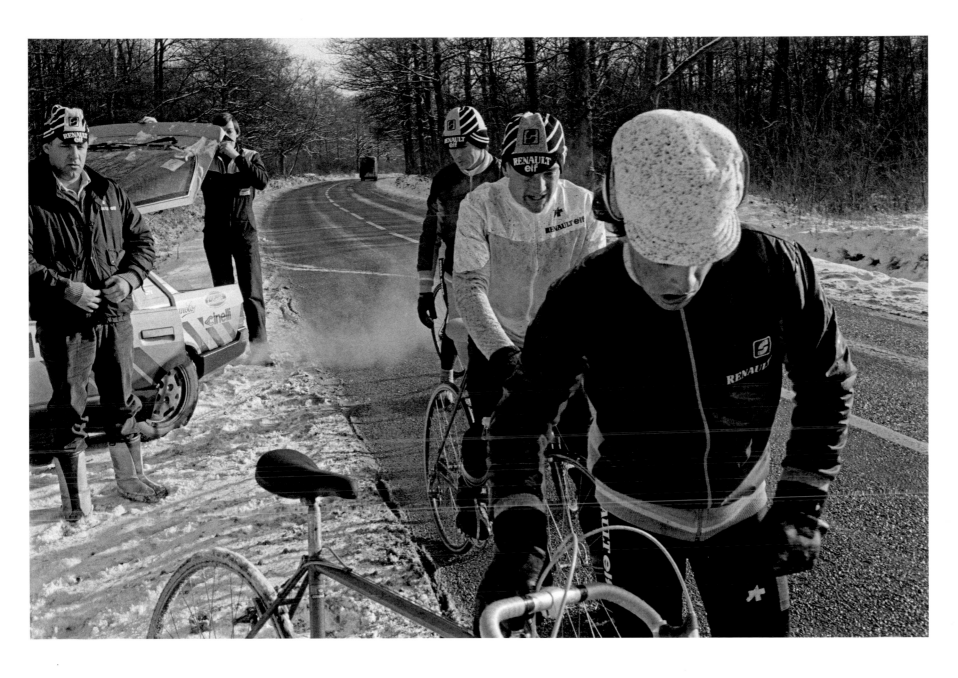

The faces here say it all. From left: Bernard Quilfen, sports director of the Renault-Elf team; a team mechanic; and, showing signs of the cold, riders Bruno Wojtinek, Thierry Marie and Christian Corre.

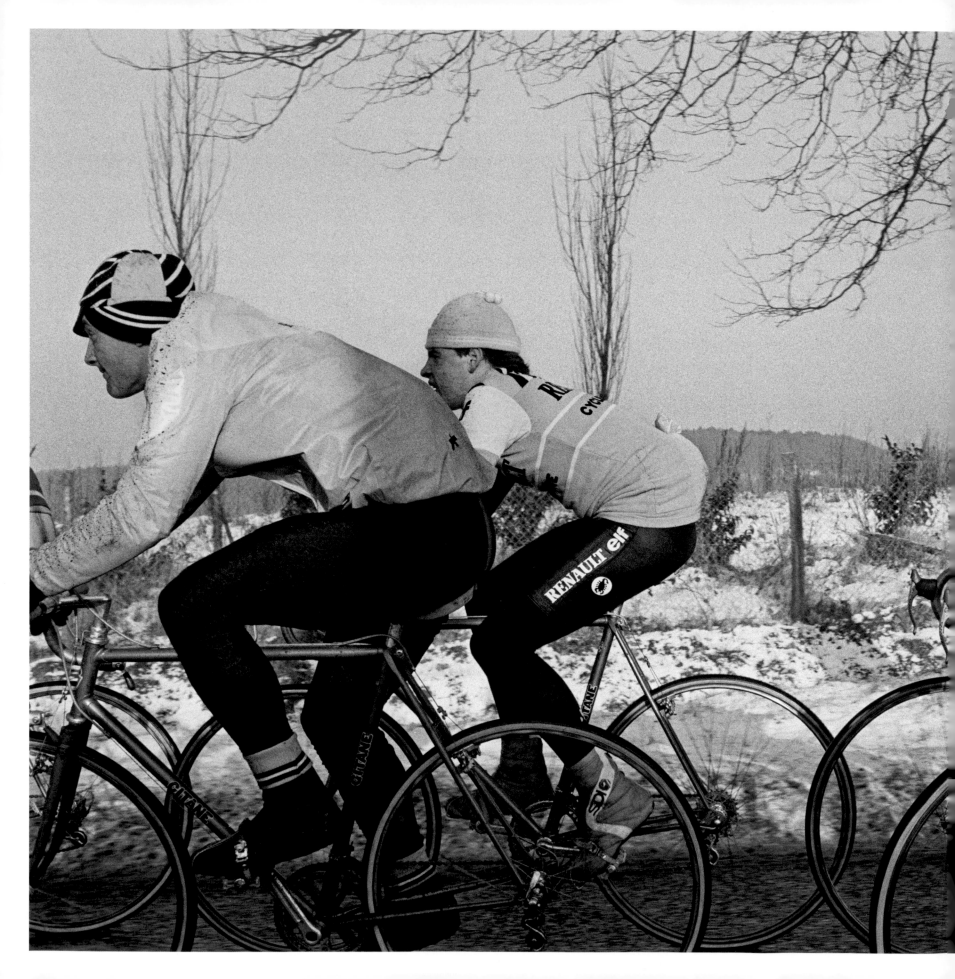

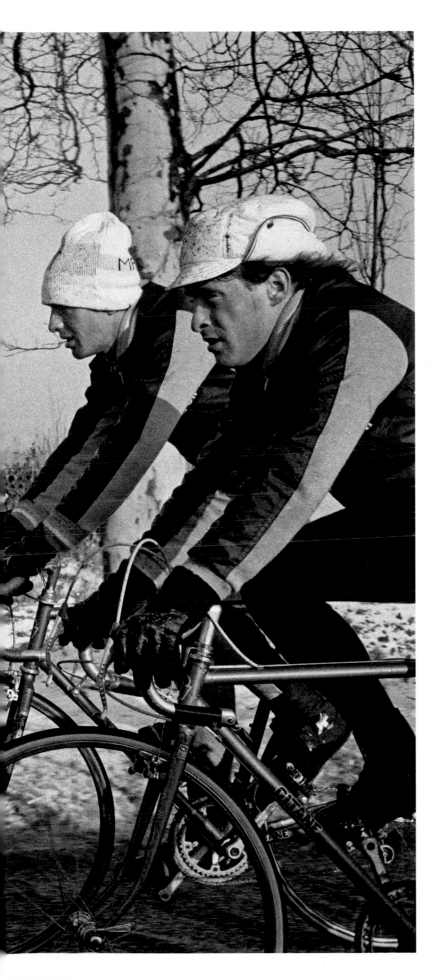

Winter riding in conditions such as these is now a rarity for the professional bike rider. Today, most teams carry out their winter training in warmer parts of the world, including southern Europe, South Africa and even Australia.

*Right, top*
Pascal Jules is in need of a hat.
The team car that accompanies
the riders will carry everything
they might need, from food,
warm clothes and tools to
spare wheels and woolly hats.

*Right, bottom*
The whole team takes shelter
from the wind behind the
team car during a training ride
as Marc Madiot, right, decides
to stretch his legs.

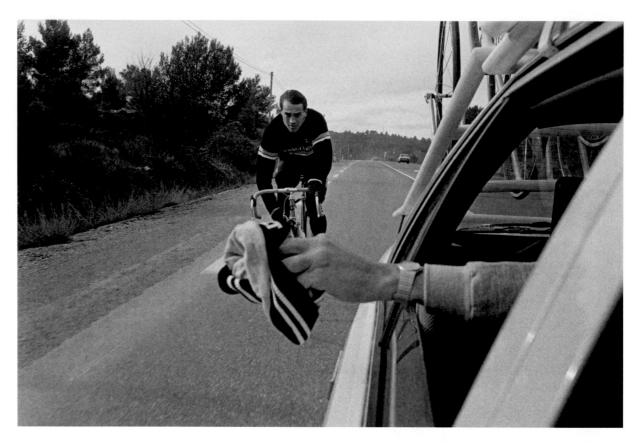

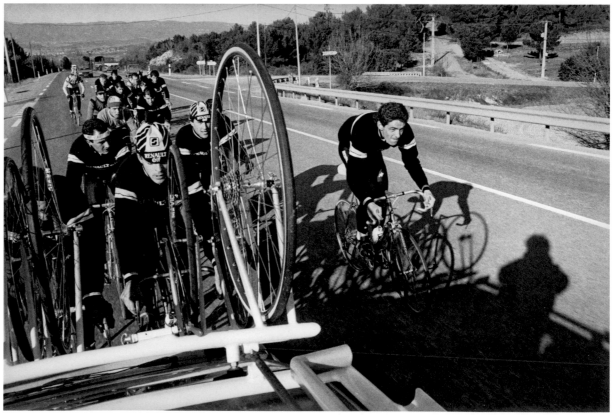

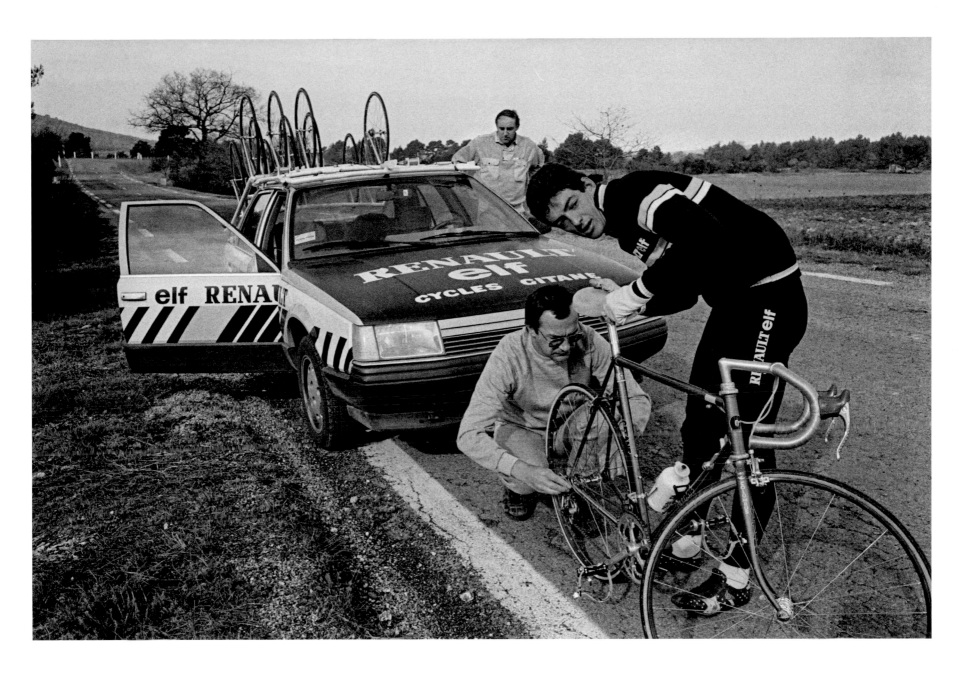

Punctures are a regular
occurrence for the bicycle
racer. With a team car behind
you, however, there's always
a mechanic on duty to change
the wheel and get you back
into the action.

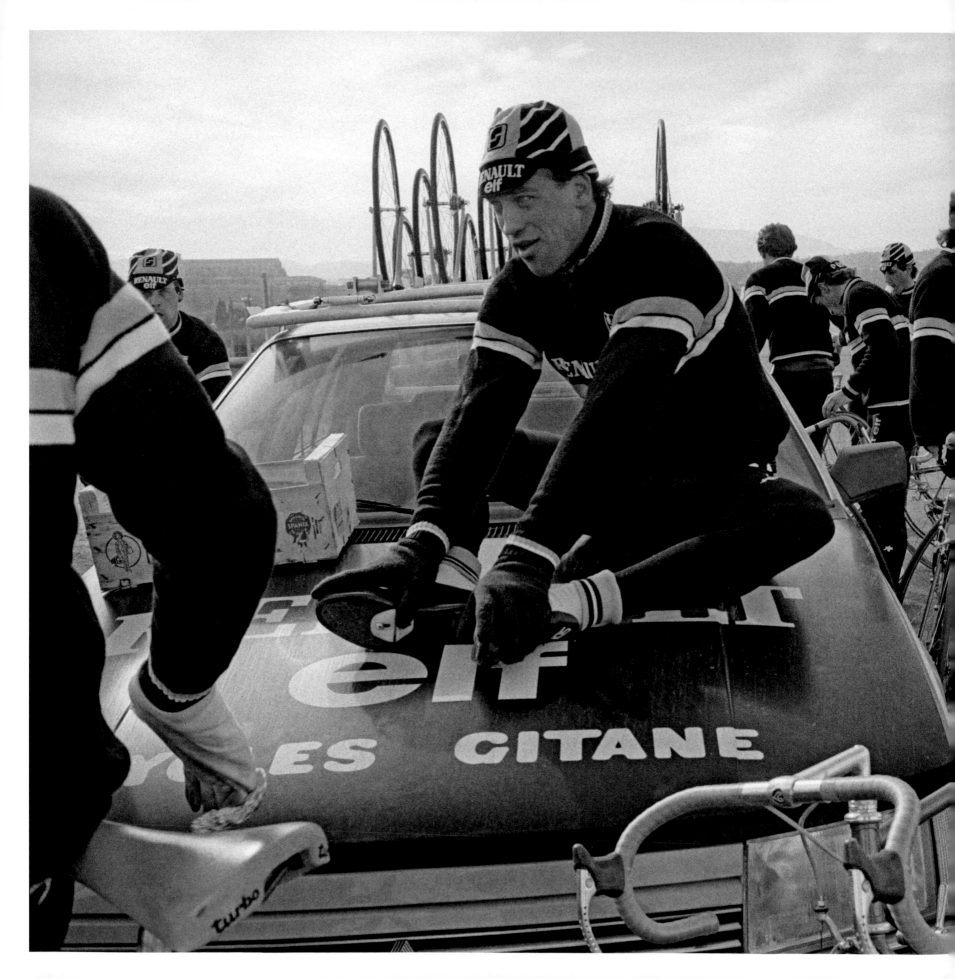

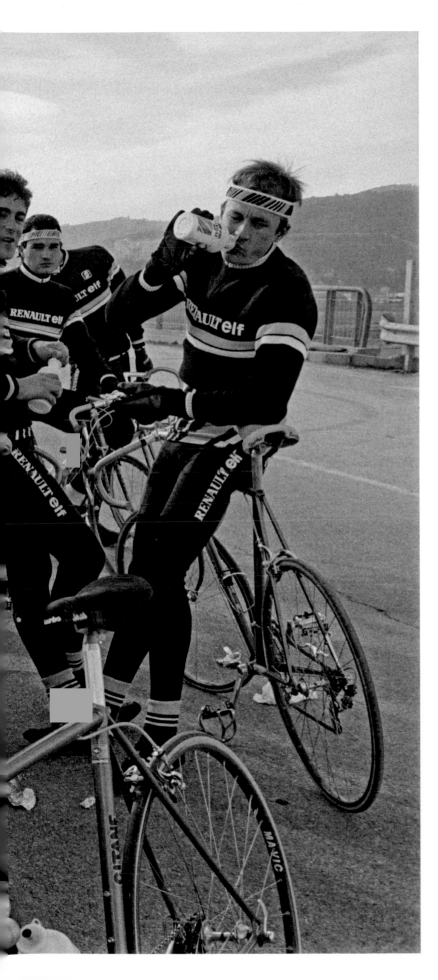

Members of the Renault-Elf team take a break during training. Among them, from left, are Pascal Jules (sitting on the bonnet of the car), Yvon Madiot (drinks bottle in hand), Christophe Lavainne and Denis Roux (taking a drink).

## IMPROVISATION

When I met up with Le Querrec in Paris, he was accompanied by fellow photographer John Vink and Magnum's Enrico Mochi. We started talking about photography, cycling and music. Le Querrec spent many years photographing musicians, specifically jazz musicians, and his portraits of Charles Mingus, Dexter Gordon, Miles Davis, John Coltrane and the like are synonymous with the modern era of jazz. But throughout his career, he has maintained his boyhood passion for cycling – as, it seems, have others.

'A young guy [he laughs] like me could say we are the improvisers of the eye because there's going to be very few things in place. It's true, no?' he asks John Vink. 'Never!' Vink replies.

'Photographers are improvisers', Le Querrec continues. 'It's a job I've done for years and years; it's like an improvisation of musicians, but improvisation all the same, on photography. Michel Portal, a famous French musician in contemporary music, classical, jazz, is a big reference to music in France. But we always speak about cycling, not music. He says, "It's incredible. I've done a lot – I've played La Scala, lots of places – but I don't dream about the big musicians anymore. It's the names of riders." That's to say, we talk of Raymond Impanis and Émile Idée, of Apo Lazaridès and Nello Lauredi; we talk like that.

'There is a poetry in the names – these are the names that make us dream still.'

*Below*
Massage and relaxation
are both part of a training
camp – as are boredom and
restlessness. However, the
rest and recovery time is as
important as the many hours
spent in the saddle, and
cyclists have the ability
to sleep anywhere.

*Right*
Charly Mottet leads Vincent
Barteau and Pascal Robert
through the forests of Provence.

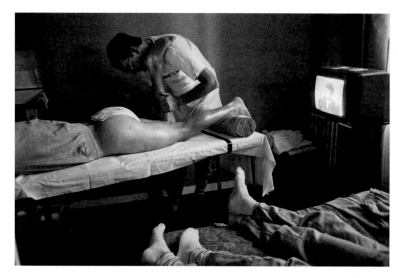

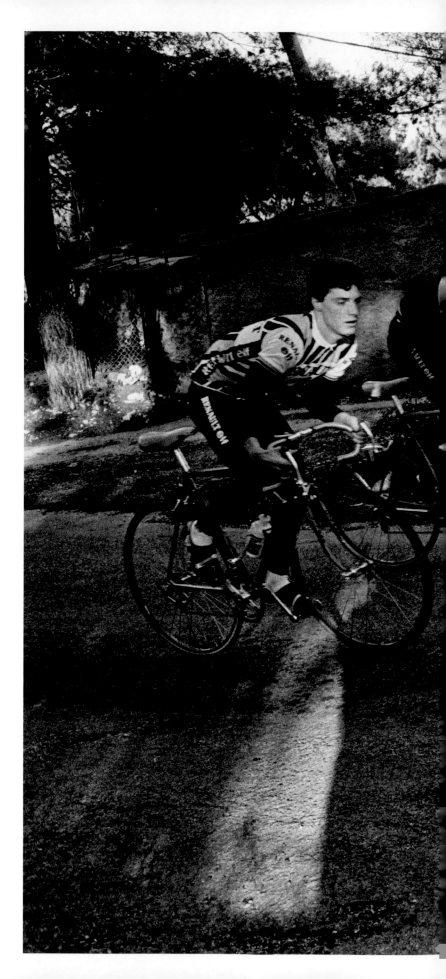

LE QUERREC: WINTER TRAINING

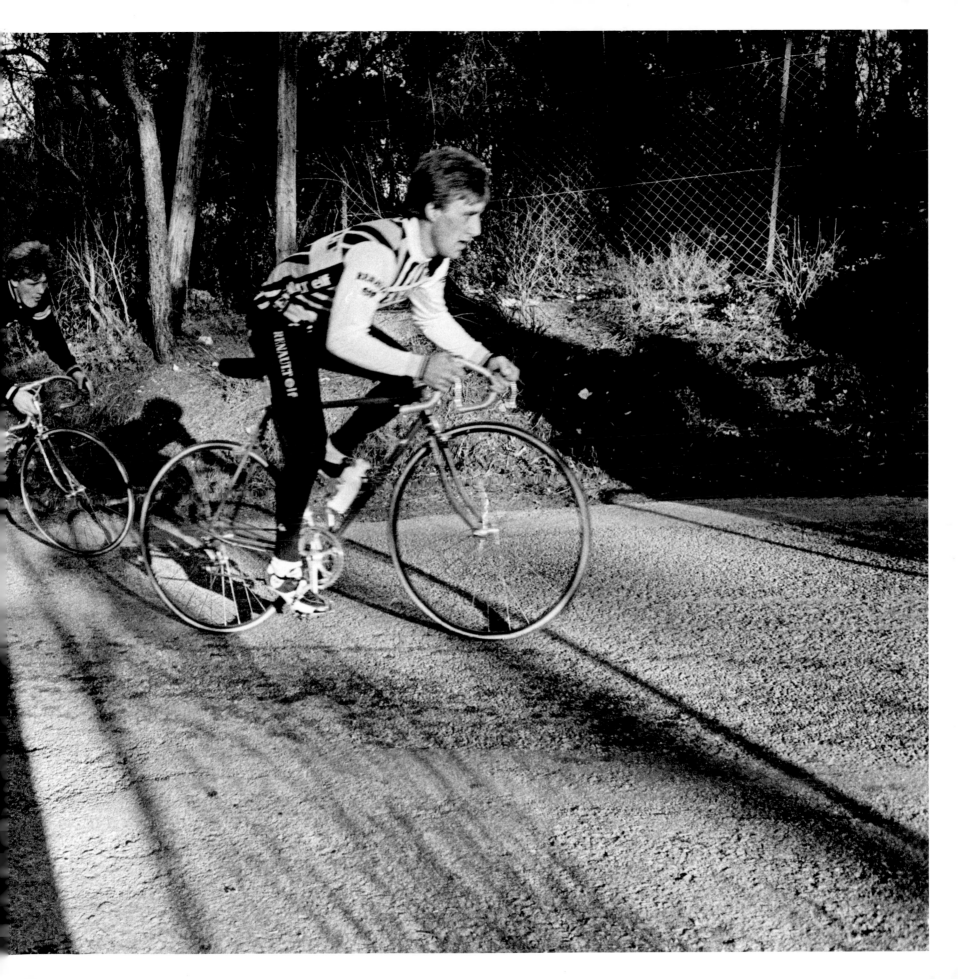

**He always fought to win.**
*—Jean-François Bernard*

During the Renault-Elf winter training camp of 1985, Guy Le Querrec took a series of relaxed and intimate photographs of Laurent Fignon. It showed a side to the French champion and team leader that was very different from his public persona. Fignon's bespectacled, slightly bookish appearance, combined with an aggressive approach to racing, certainly attracted a lot of media attention, but he was regarded as one of the strongest riders of his generation. Indeed, he was a fierce competitor who did not suffer fools gladly, and he made plenty of racing enemies too.

The French journalist and author Philippe Brunel said of Fignon that 'His career seemed to be defined by grace but dogged by misfortune.' A cultured, well-educated Parisian, Fignon was quite unlike the previous generations of riders, and was well liked, funny and intelligent. During the first half of the twentieth century, cycle racing in France, Spain, Italy and Belgium was very much a working-class sport. Although Fignon wasn't exactly bourgeois, he did pass his baccalaureate, making him unique among his peers and earning him the nickname 'Le Professeur'. Fignon's real passion was bike racing, however, and he was quite phlegmatic about missing out on a university education. 'I've got a lot from cycling,' he was once quoted as saying, 'except on an intellectual level.'

One of Fignon's finest years was 1984, during which he successfully defended his Tour de France title from the year before, emphatically winning five stages along the way. He also finished second at the Giro d'Italia, to the Italian rider Francesco Moser, and won the French national championships (which, at the time, was regarded as one of the toughest national jerseys to win). Although his form going into the 1985 season was reported to be good, he succumbed to a knee injury during the spring races that would keep him out of that year's Tour. He struggled at the Tour from then on, his frustration at his poor performance making him increasingly irritable, especially towards the media. He was under intense scrutiny from the French press in particular, notably throwing his bidons at photographers at the 1988 Tour when his knee began to give him trouble again and he was dropped from the race. It may not have been the behaviour of a true champion, but it proved Fignon was human and his fans loved him for it all the more.

Fignon was one of the last Tour de France and Giro d'Italia winners who enjoyed success throughout the racing season, from Milano–Sanremo in March through to the now defunct Grand Prix des Nations in the autumn. But he never regained his Tour title of 1984. Losing the Tour de France in 1989 to the American Greg LeMond by eight seconds, on the final stage of the race, was possibly the greatest disappointment of his career, not only because he was leading the race going into the last stage, but also because the finish was a time trial into his native city of Paris on the final day of the Tour. As sporting tragedies go, it is possibly one of the worst in cycling history. Despite their rivalry, LeMond and Fignon became great friends, LeMond saying of the Frenchman that 'He really knew himself.'

After retiring from racing in 1993, Fignon worked as a race organizer and television commentator. He died of cancer in 2010 at the age of fifty.

# GUY LE QUERREC
# LAURENT FIGNON IN PROVENCE

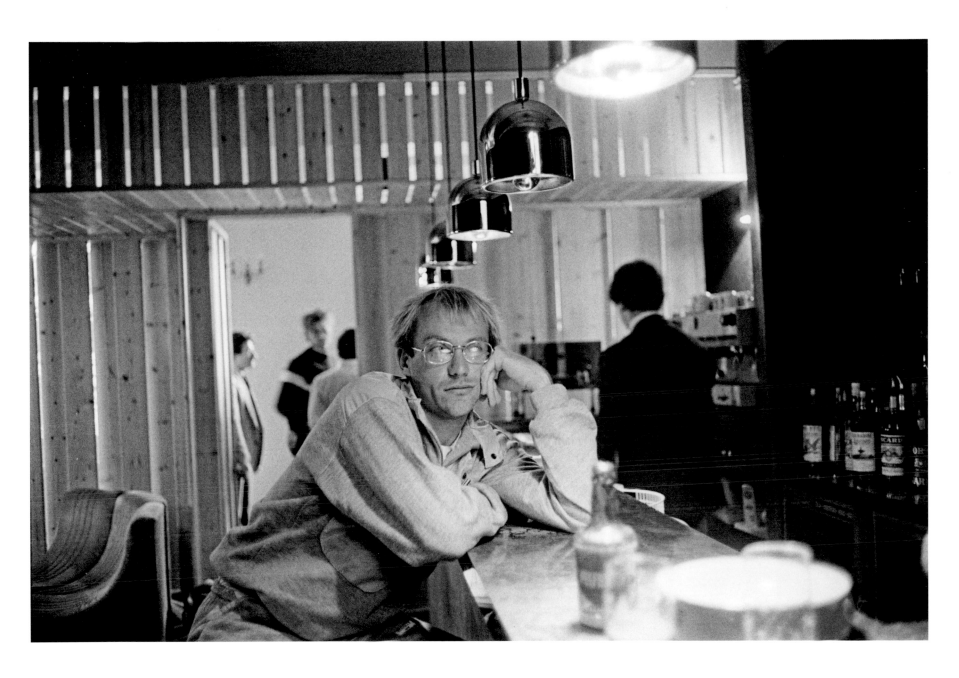

Laurent Fignon won two
Tour de France titles, the Giro
d'Italia and several one-day
races, including La Flèche
Wallone, Milano–Sanremo
and the French national
championships.

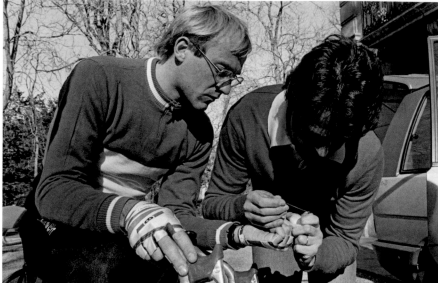

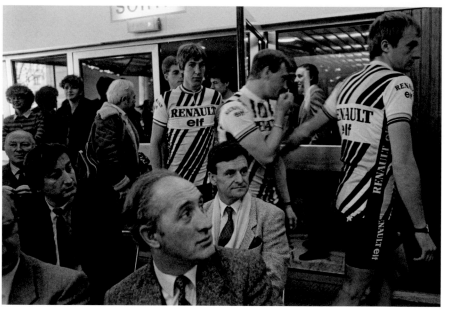

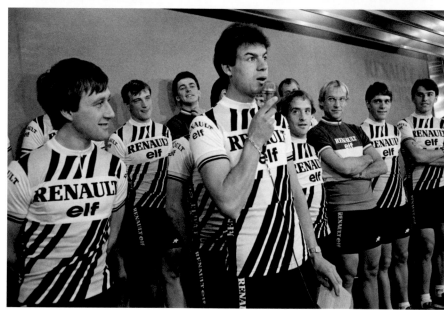

Laurent Fignon shares
a joke with Denis Roux
during a team outing to
a football match.

The 1985 Renault-Elf team
is presented to the media and
sponsors at the company's
headquarters in Paris.

Fignon is given a blood-
lactate test during a training
ride. Such tests are designed
to help optimize a rider's
performance.

Pascal Poisson addresses
the media and sponsors at
the 1985 team presentation.

LE QUERREC: LAURENT FIGNON

The Renault-Elf team was one of the best resourced and supported teams on the racing circuit. It was also one of the first to use specialist sports scientists, physiologists and psychologists.

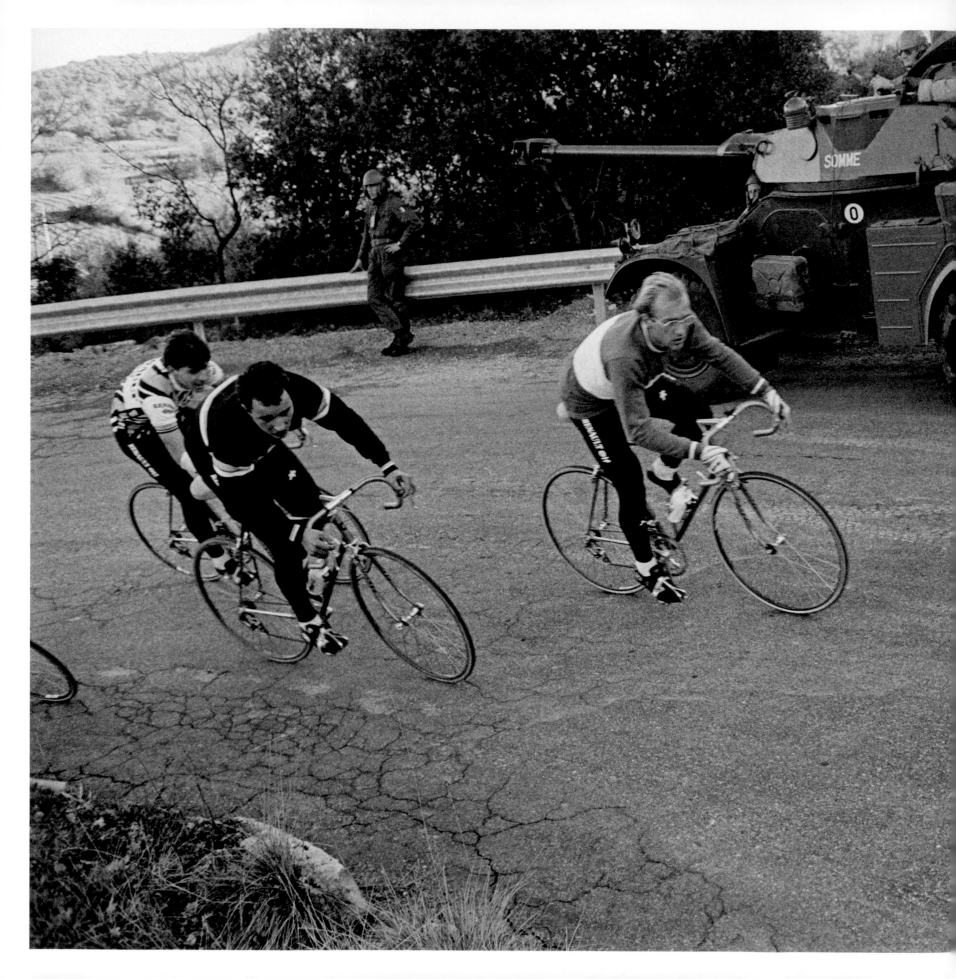

The 1985 Renault-Elf winter training camp was based largely in the hills around the Côte d'Azur. It was no holiday, however. The training would have been tough, with such stronger riders as Fignon pushing the pace.

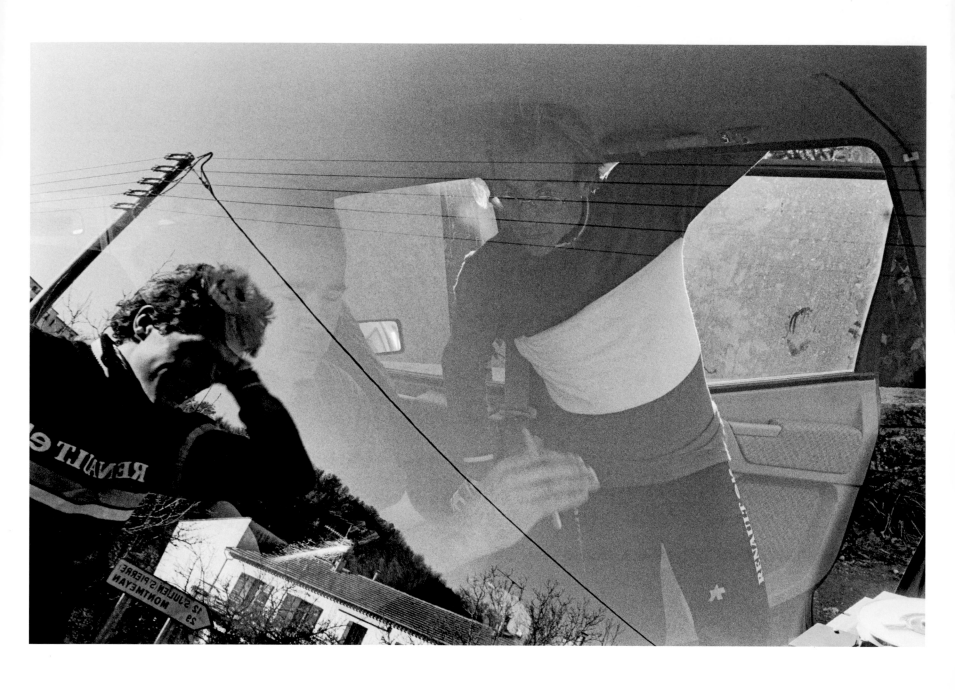

Laurent Fignon speaks to
the team doctor about his
blood-lactate test.

LE QUERREC: LAURENT FIGNON

**For me, cycling's not just a job, it's a way of life.**
**—Marc Madiot**

There are several forms of competitive cycling that exist on the edge of reason, and cyclo-cross is no exception. It is a simple form of racing, and simply bonkers – a combination of physical hardship and the thrills and spills of riding fast off-road. It's all about the rider's skill and, when done well, resembles a kind of bicycle gymnastics, with the top riders dancing through the mud and over obstacles with apparent ease. Essentially, cyclo-cross involves racing a road bike, off-road, in winter. The courses are usually a mixture of surfaces: wide, unmade tracks, tarmac roads, sometimes a path through a park, running tracks or football pitches, and mud, lots of mud. Then there are the man-made obstacles and diversions, such as sand traps, single-track wooded sections with exposed tree roots (which are extremely slippery when wet), and hurdles, steps and logs.

Cyclo-cross was a pretty radical idea from the moment it emerged in Europe at the turn of the last century. One of its earliest adopters was the French army, which used it as a way of keeping its soldiers fit. In the 1900s it was sometimes staged as a through-the-woods-type race between French villages; however, given the simplicity and weight of the bicycles of the time, it was for the bravest and fittest riders only (fixed wheels probably added to the entertainment). It was something for the whole community to get involved with – an activity akin, perhaps, to bull-running in Pamplona or cheese-rolling in Gloucestershire. But these early participants were the forefathers of the modern-day sport, much like the mountain-biking pioneers who rode 'clunkers' down Mount Tamalpais, California, in the late 1970s.

Cyclo-cross requires a unique combination of skills, from sure-footed bike handling and a good sense of balance to running and sometimes jumping over obstacles – be they man-made or natural hazards that the course builders have managed to find – while carrying your bike. Races are often 'gridded' on the start line, allowing the faster competitors a clearer path to the first obstacle and preventing any hold-ups behind slower riders. The starts themselves are conducted at sprinting speed, with the leaders continuing at a seemingly unsustainable pace until they have stretched out the field, leaving the course littered with plodding, sorry-looking solo riders and small groups that never seem to come together.

It is in Belgium where 'cross is king: the riders are bigger and stronger, and so too are the crowds. The spectators resemble (and often behave like) a bunch of unruly football supporters, with tens of thousands of overcoated Flemish fans swarming across wintry fields to watch local heroes take on the best the world has to offer. The following is substantial, with a lively network of fan clubs supporting individual riders and enabling a significant number of competitors to make a decent living from the sport. Indeed, the size of the crowd in Belgium is staggering, especially when compared to the numbers who go to watch races in the rest of the world, where the majority of spectators are the long-suffering family of a rider or confused Sunday dog-walkers who really have no idea what's going on. On the 'cross-rich Continent, an intense rivalry exists between Dutch and Belgian racers, and this can often spill over into the crowd; tempers fray,

At the French national cyclo-cross championships in 1985, the strong Renault-Elf team made up all the top spots on the podium. Yvon Madiot was first, his brother Marc second and Martial Gayant third.

and the atmosphere can get surprisingly hostile at times. By contrast, cyclo-cross races in other parts of the world are marked by some of the friendliest atmospheres you can get in cycling.

The animosity that can sometimes mar the sport of cyclo-cross made an appearance in 2005, when Bart Wellens, the usually genial and gentlemanly former world champion from Belgium, kicked a drunken heckler in the crowd, catching his detractor in the throat as he sped past. Wellens went on to win the race, and the race jury (who had, it seems, also spent too much time in the beer tent) allowed his victory. Wellens was later disqualified by the UCI (Union Cycliste Internationale, sports cycling's governing body), which described the Belgian's actions as unsporting behaviour. For their part, the Belgian fans had been at it before, in the 1994 World Championships at Koksijde, throwing sand in the face of second-placed Dutch rider Richard Groenendaal as the Belgian favourite Paul Herijgers rode away to victory. The Dutch fans spotted the shenanigans of their international neighbours, and the violence that ensued certainly was not the sport's finest hour.

As alluded to earlier, cyclo-cross – just like the springtime classics – is Belgian territory, since few Spanish and Italian riders can cope with the harsh winter conditions in which the races are held. The courses themselves come in a variety of styles. Belgium, for example, loves sand (a great idea, that, for skinny-tyred bikes), the idea being to make people fall off, which happens a lot. Top riders attack it at speed – arms bent, head up and body relaxed. Lesser, more tired riders find this approach almost impossible, so crashes are regular and spectators head straight to the sand pits for a view of the carnage. Situated on the coast of the North Sea, Koksijde, along with several other purpose-built courses in Belgium, incorporates sand dunes and traps, with the muddy sections properly drained to keep the racing fast and furious.

The weather can cause as much havoc as the crowd and the terrain – snow, ice and fog just seem to add to the excitement. When the mud is plentiful, a race quickly turns into a war of attrition, fought among those who can master the slips and slides and keep their machine running smoothly. It's a tall order, so bike changes can be critical when the weather is harsh, and often shape the outcome of a race. Top riders will have several bikes available to them, as well as a multitude of wheels and tyres for different conditions. Some even have special lightweight machines – stripped-down versions of their usual bike – for the final lap.

Team tactics in cyclo-cross are much harder to define. As the race progresses, the battles are essentially between individual riders, but there are times when teammates will hold up the chasers in the single-track areas of the course to let another member of the team escape. Belgian dominance in world cups is based largely on such tactics, although rivalry between teams within the 'home country' make for exciting duels. And while the sharp end of cyclo-cross is massively competitive, the reality of local races is far from unfriendly. Indeed, it is the camaraderie of 'cross that makes it is so compelling; there must be something in all that mud and hard graft that bonds people together.

Knobbly tyres help when the conditions are muddy, but with their width limited to 35 mm (1⅜ in.), they still require great skill to master at speed. The current preferred specification for a cyclo-cross course is 90 per cent rideable, with each lap between 2.5 and 4 km (1½ and 2½ miles) long. Races are measured in time rather than laps, to account for bad weather, and riders are allowed to change bikes at a designated pit area, with helpers handing out drinks bottles and shouting encouragement – or abuse. As sports cycling goes, cyclo-cross is very sociable. It's also the perfect entry into competitive cycling, as, unlike road racing, it's safe from cars and mass pile-ups. But that's not to say that it can't be intimidating. Few sports permit the best professionals to line up alongside the worst amateurs, and, to quote just two of its many aphorisms, it's as level as the muddy playing field you start on and as grass roots as it gets.

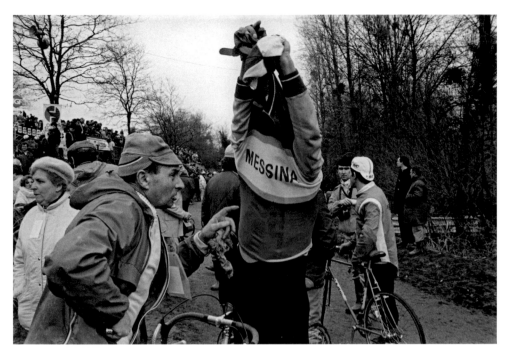

Marc Madiot won many road races in 1985, including the prestigious cobbled springtime classic Paris–Roubaix. Cyclo-cross was an important part of his training for the classics season, since it helps to improve both strength and technique.

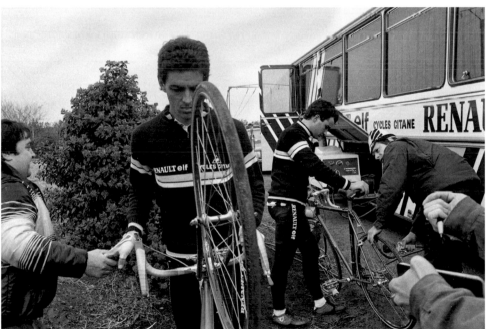

## THE RIDERS

The first cyclo-cross world championships were held in Paris in 1950 and were won by Jean Robic, the diminutive French winner of the 1947 Tour de France. Robic was known as 'Tête de Cuir', or 'Leatherhead', as he always wore a leather helmet. He was also dogged by accidents on the road, a fact that made him unpopular among the professional road peloton, so perhaps his 'cross exertions were designed to hone his bike-handling skills.

Although many road riders use cyclo-cross as a winter workout, only a few top pros have found success in both road racing and cyclo-cross. One such pro was the 1975 world champion, Roger De Vlaeminck. Nicknamed 'Mr Paris–Roubaix' and 'The Gypsy', De Vlaeminck was at home on any kind of bike in any kind of race. Other road riders who could manage a bike off-road include Bernard Hinault, Claudio Chiappucci (who competed in the 1992 world championships for Italy) and Tour de France stage winner Dominique Arnould. British professional road racer Roger

Hammond won the junior world cyclo-cross title, and managed to win the national title most years with very little specialist training.

In the 1980s the French scene was dominated by the Madiot brothers, Marc and Yvon, who between them won several national championships and other national races. For them, cyclo-cross was not the specialism that it is today. Like most road riders of the time, they saw it as a form of winter training, but they also happened to be very good at it. They went on to have long and successful road-racing careers, both winning several major events. Marc, for instance, won the Paris–Roubaix twice, his off-road skills helping him to negotiate the farm tracks and rough, muddy and cobbled roads that make up the race. The Madiots continue to manage and coach professional cycling teams, and every winter hold a cyclo-cross session for their riders. On the world scene, however, 'cross is now a fine art with specialists all of its own.

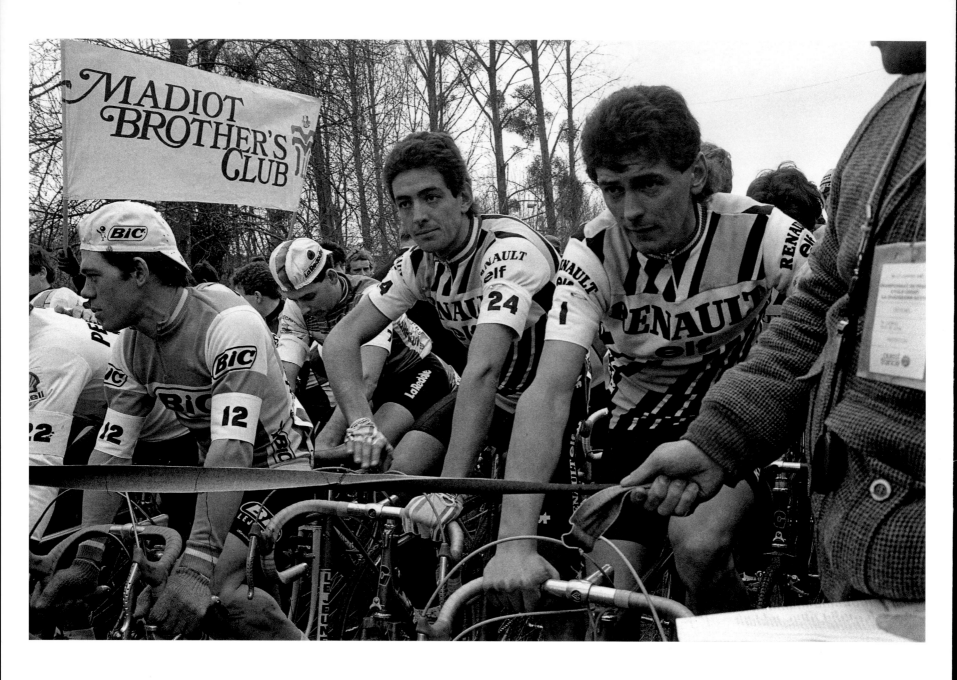

The Madiot brothers
line up at the start of the
professional race at the 1985
French national cyclo-cross
championships, Yvon (right)
looking a little more nervous
than his brother. Behind them,
members of the Madiots' fan
club offer their support.

LE QUERREC: FRENCH CYCLO-CROSS

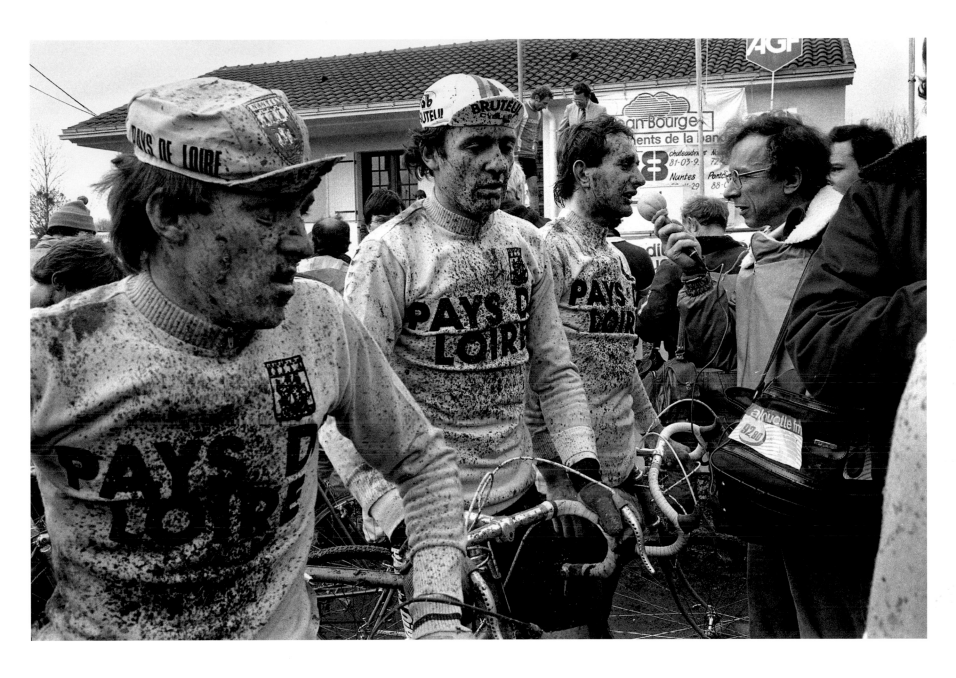

Riders from the strong
cycling region of Pays de
la Loire are left muddy and
tired after the amateur race
at the 1985 French national
championships.

**Below, top**
Professional cyclo-cross rider
Bernard Bourreau tackles
a steep, muddy incline, or
run-up. It's also off-camber,
making it considerably harder
to negotiate than it looks.

**Below, bottom**
Cyclo-cross is often a war
of attrition. As the race
progresses, riders tire on the
run-ups and the mud takes
its toll on their leg speed.

**Right**
Yvon Madiot wins the 1985
French national cyclo-cross
championships, one of
the three national titles he
acquired during his eleven-
year career as a professional.

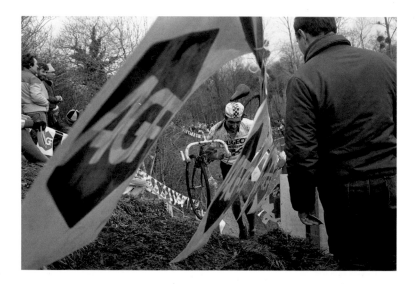

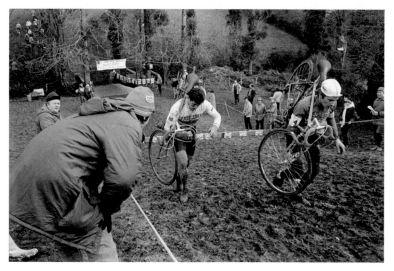

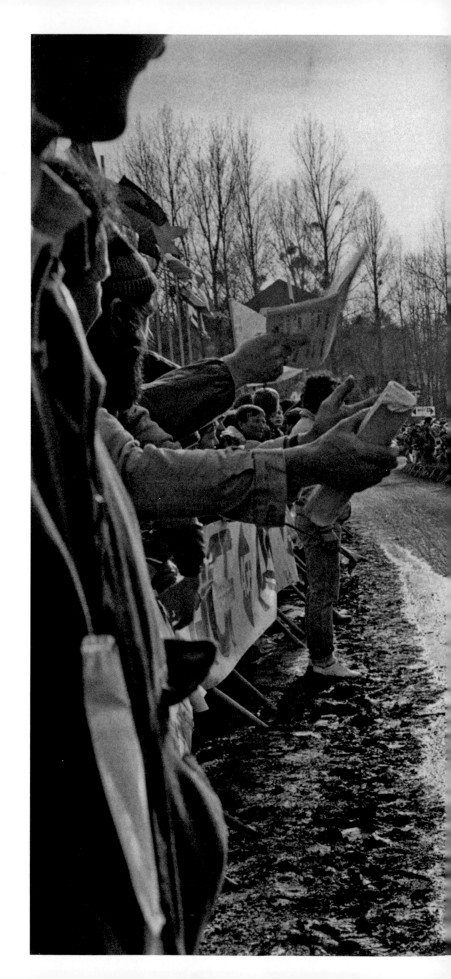

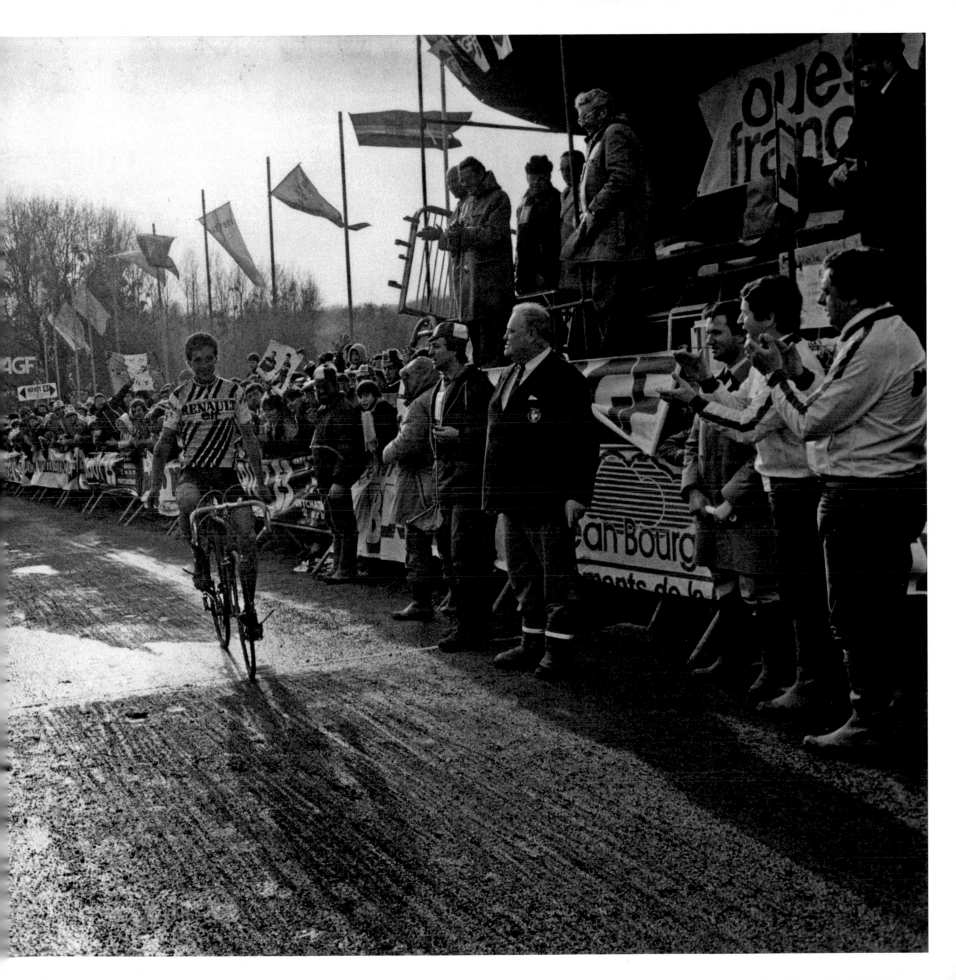

**The photographer, just another participant in the daily round, plays the important role of making introductions.**
—*John Vink*

John Vink is a Belgian. And Belgians are passionate about cycling, in the way that Americans love baseball and the English love cricket. It's no exaggeration to say that it's a cultural cornerstone of their society, and anyone growing up in Belgium will learn about the sport – the rules, the tactics, the personalities – through a sort of osmosis.

Compared to its performance and enjoyment in other countries, cycling in Belgium is different. It's the homeland of cycle racing, and it's where the best cyclists come from too. It's also the home of the keenest, most knowledgeable fans. Everybody in Belgium understands cycling, not least because it's been part of daily life for more than a century.

Cycling is built into the very fabric of the country, and races are held all year round. There is no grand tour as such because every race is seen as significant. Springtime is when the major events take place: the Tour of Flanders followed by the Ardennes classics, all of which are as important to the Belgians as the Grand Tours and world championships are to the rest of the cycling world. And then there's cyclo-cross. As international sports go, it's fairly specialist, and there's one area of Belgium that does it best: Flanders. Indeed, nowhere else in the country is cycling of any kind regarded with such reverence.

All the big races on the calendar of the Cyclo-cross World Cup are in Belgium. Most of the smaller races are held there too, enabling the best riders to race two or three times a week, even in the middle of winter. The courses at the most popular races often incorporate a beer tent, with the riders passing through it each lap, meaning that patrons don't have to venture outside to watch the race unfold until the very last minute.

Cyclo-cross's popularity in Belgium is perhaps the reason why John Vink ended up travelling to various races between 1979 and 1984. He was working on a story about his home country, which was inspired in part by the question, what do Belgians do at the weekend?

'I was working on Belgium as a whole', he explains, 'and bicycle racing is one very specific part of what's happening on weekends in Belgium … so I integrated the cycling races into the project. I thought that would be revealing as to who these people are. I didn't travel far – but nothing is very far in Belgium.'

While cyclo-cross extends the cycling season into the winter months, the Belgians, as John explains, see cycle racing as special at any time of the year. 'It's something that I wanted to have. The crowds at the Tour of Flanders … I knew about that. But the fact that cycling's so completely intertwined with the local habits; it's part of the village and community. So much in people's minds and in their blood. It's really deeply rooted for many years now, and still today. The people are crazy about it.'

Such devotion to the sport might go some way towards explaining why, in recent years, photographers have found cycling such a lure. It shares something with the culture in which it takes place, with the environment, with the people who follow it so closely.

# JOHN VINK
# BELGIAN CYCLO-CROSS RACING

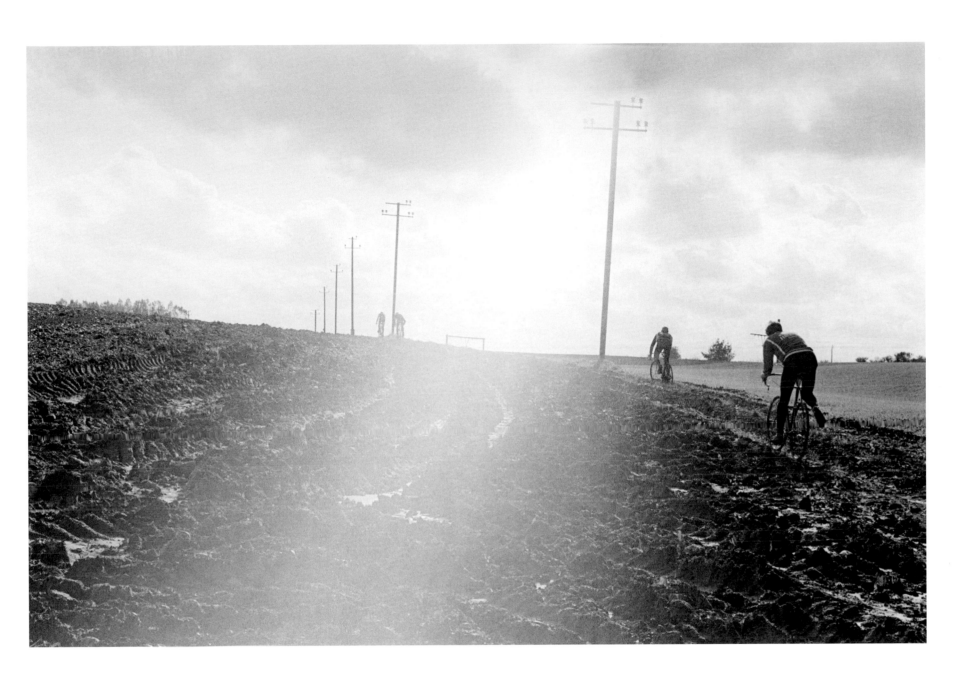

Brussels, 18 October 1982:
Cyclo-cross races cover all
sorts of terrain. A ploughed
field after heavy rainfall is not
at all easy to negotiate: the mud
is heavy going, energy-sapping
and unpredictably slippery.

Access to the sport is changing, however, and the photographer has had to adapt, both ideologically and physically. By way of a comparison, John recalls his early days taking pictures of motor racing.

'I didn't even have accreditation when I started', he explains. 'You could take pictures anywhere and go to the pits and take pictures of people just centimetres from their face. You can forget that now; that's all gone. And I think it's very similar in bicycle racing. There's too much money involved now. There's more protection and security and a lot less access. The press officers have become much more efficient at presenting their racers in the way they want, and it's much more about branding.'

But it's not all doom and gloom. 'It's still one of the most accessible sports there is,' John says, 'apart from maybe track and field and cross-country running. At the start and finish, it's still impossible to really separate the racers from the fans. There are still moments when you can mingle with the racers.'

Kapelle-op-den-Bos, 7 October 1985: Ideally, a cyclo-cross rider's bikes should be identical. That way, the parts are interchangeable, and each bike will fit the rider exactly. When it's really muddy some riders will bring even more bikes than usual, as they may need to change machine twice per lap. It's an expensive sport when you don't have a sponsor.

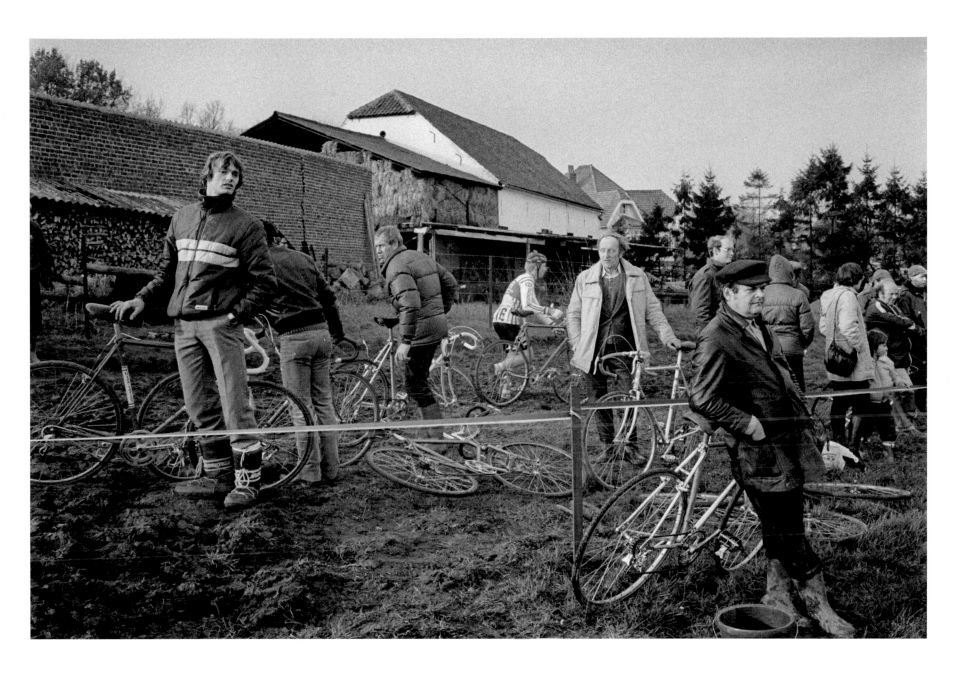

Overijse, 21 January 1982:
The pit area at a cyclo-cross
race is used primarily for
changing bikes. Helpers are
usually members of the rider's
family, their friends or, in the
case of professional riders,
team soigneurs (helpers) or

mechanics. It's especially
important to change bikes
when they become caked
in mud, which not only
adds considerable weight
to the bike but also prevents
the gears and brakes from
working properly.

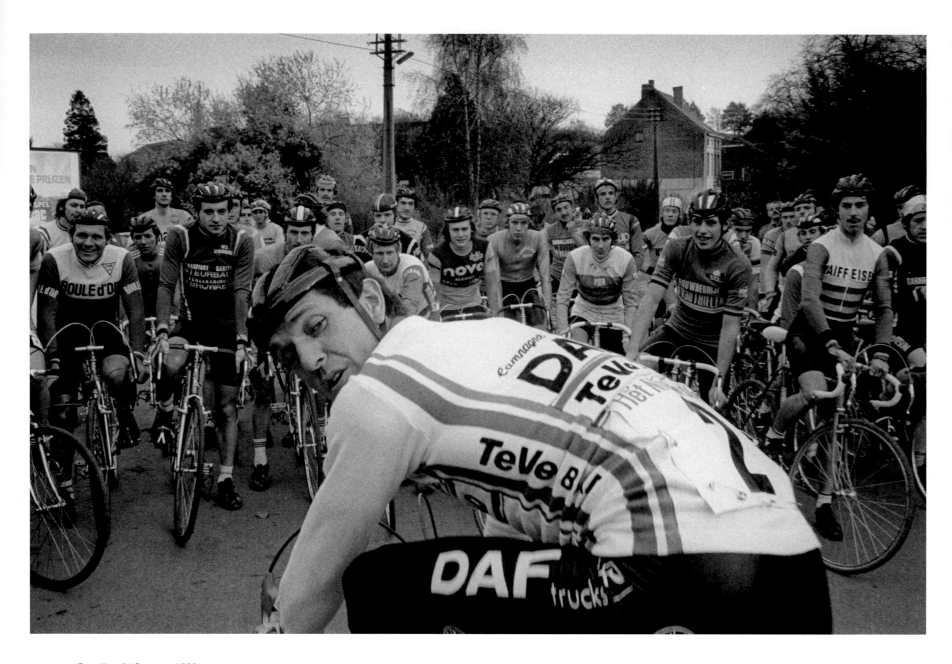

Overijse, 21 January 1982:
Getting a good start at a cyclo-
cross race is critical: riders
need sharp elbows and strong
nerves. They are lined up in
order of ability, but there is
always one who will try to
jump the queue. Here, it's the
Belgian 'cross legend Roger
De Vlaeminck.

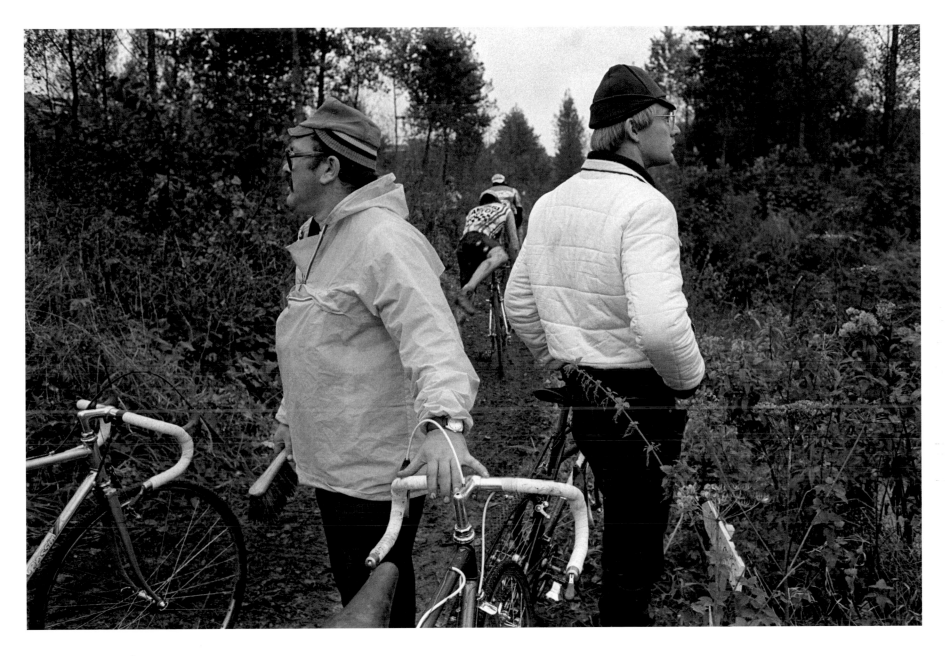

Vossem, 9 October 1982:
Helpers usually work in teams
of two or three. Cleaning the
bikes and handing them
quickly and safely to the riders
is a complicated and stressful
affair. Riders can also get in
one another's way, making
these exchanges quite fractious
at times.

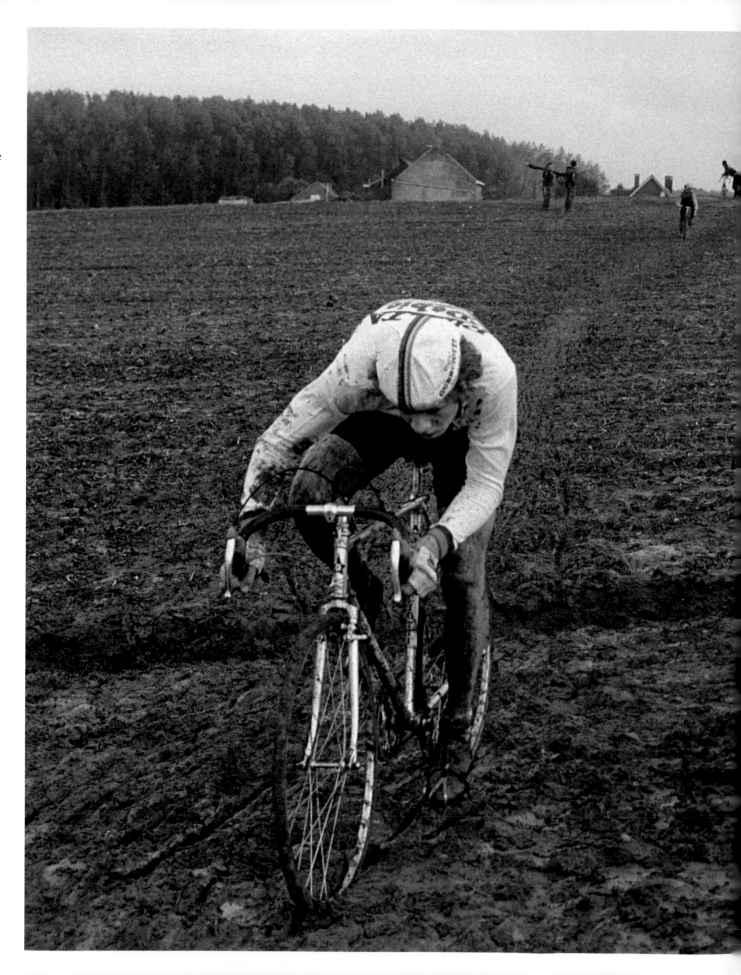

Vossem, 9 October 1982: When riding through mud, technique is everything. The bike tends to slide away in every direction, making progress extremely difficult. The best cyclo-cross riders are those that manage to stay relaxed and focused on the bike. If you tense up, a crash is inevitable.

*Below, top*
Vossem, 2 October 1982: The bunny-hop is a lot harder than it looks; get it wrong, and you can have a nasty crash. Clearing the obstacle is the goal, so riders often choose to dismount and jump over them.

*Below, bottom*
Roosdaal, 17 November 1979: The *frituur* (fast-food van), crêpe stall and beer tent are regular fixtures at cyclo-cross races in Belgium.

*Opposite*
Jezus-Eik, 24 December 1983: There are run-ups on all cyclo-cross courses, and spectators have a habit of congregating around them. The riders often receive a fair amount of abuse from the increasingly drunken crowd, but most of it is good-humoured.

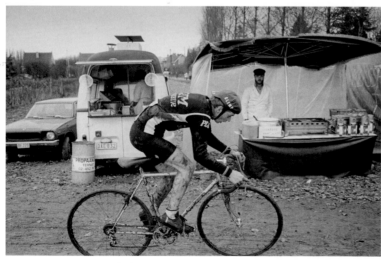

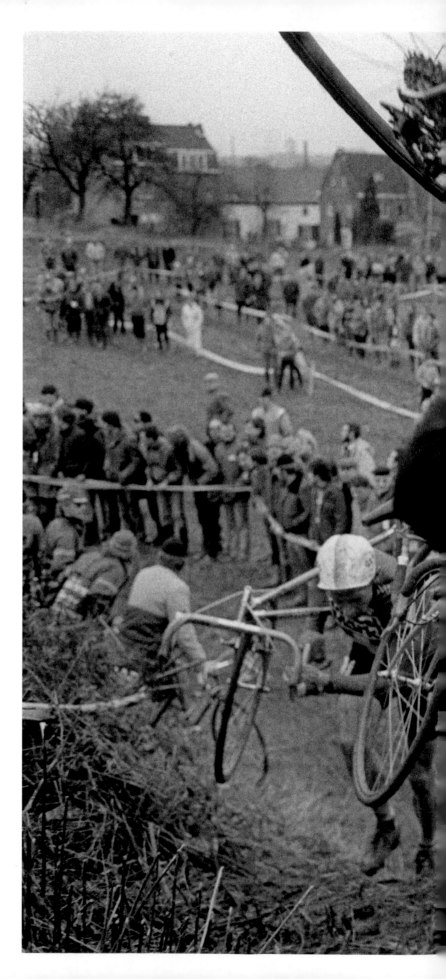

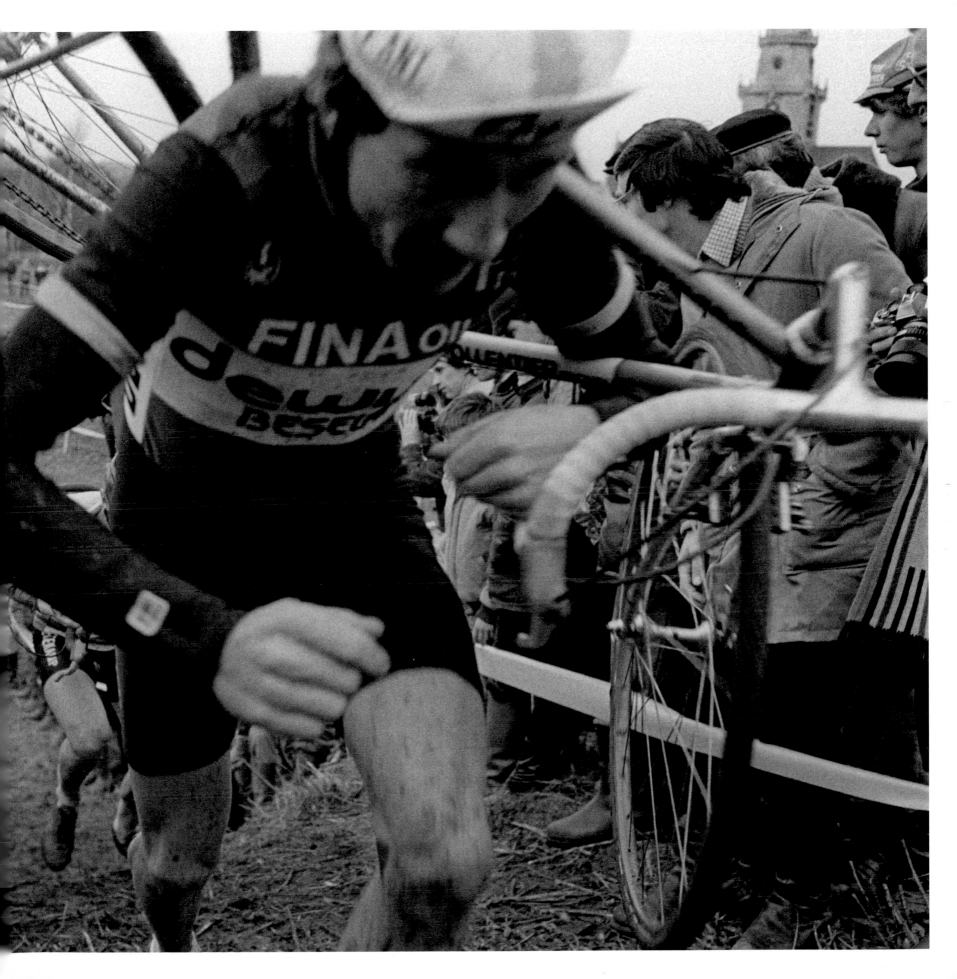

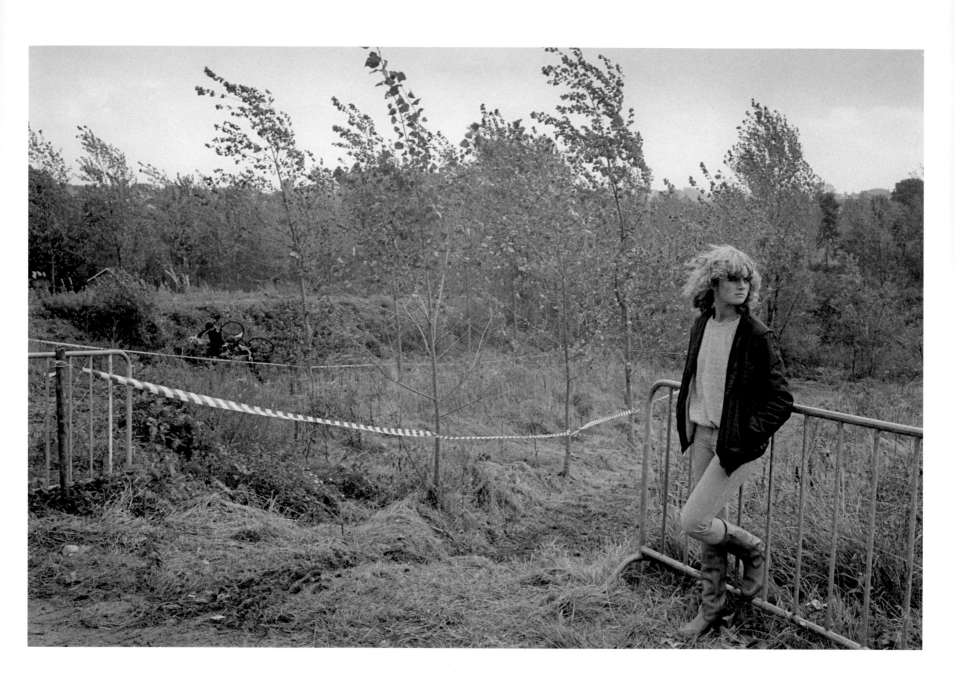

Vossem, 9 October 1982:
Crowds at the major cyclo-
cross events can be huge.
At the majority of the smaller,
local races, however, the
supporters and fans tend
to be either family members
or teammates.

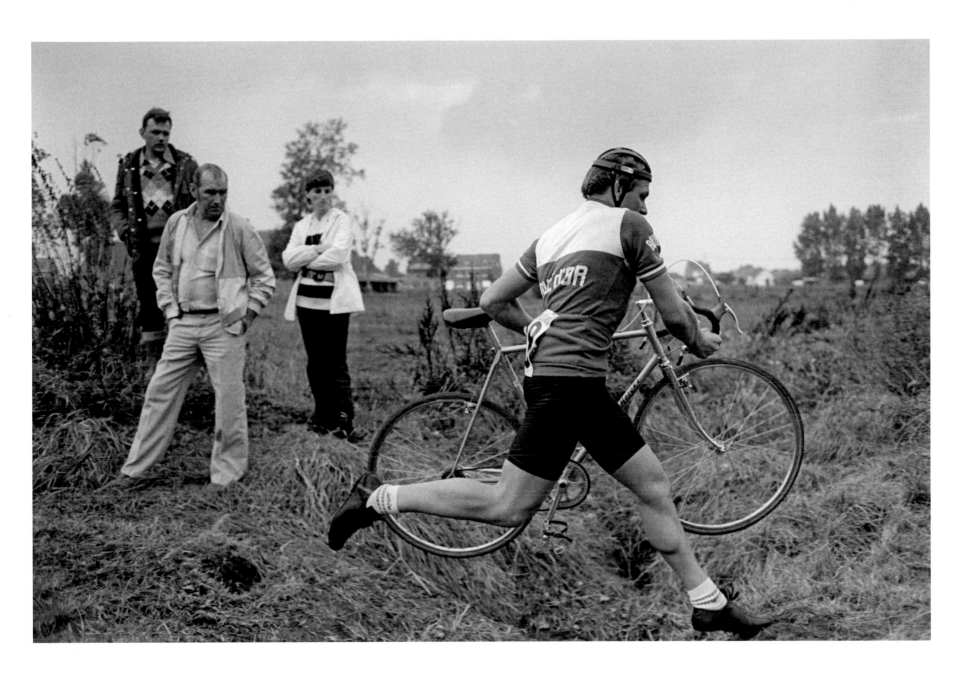

Vossem, 2 October 1982: Course obstacles can be naturally occurring, such as ditches and steep hills, or man-made, as in the case of hurdles, planks and run-ups in the form of steps. The idea is to test the riders' technical skills by forcing them to dismount and remount.

Berchem, Antwerp, 15 October 1983: Slipstreaming is not as important in cyclo-cross as it is in road racing, and riding in groups can sometimes slow you down, with crashes and slips leading to delays. Once you're ahead of the competition, it's good to stay there.

Jezus-Eik, 24 December 1983: The Christmas cyclo-cross race is traditional fare in Belgium, as is the ever-present *frituur*. The main interest beyond the racing – and the gambling on the racing – is eating frites with generous helpings of mayonnaise, all washed down with large amounts of beer.

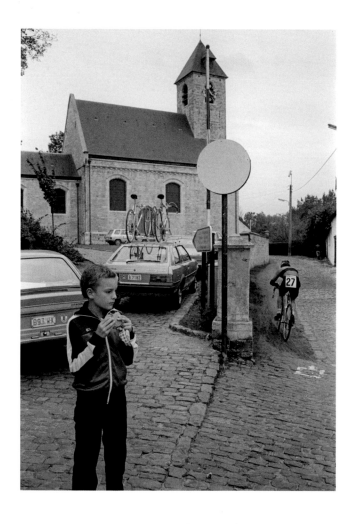

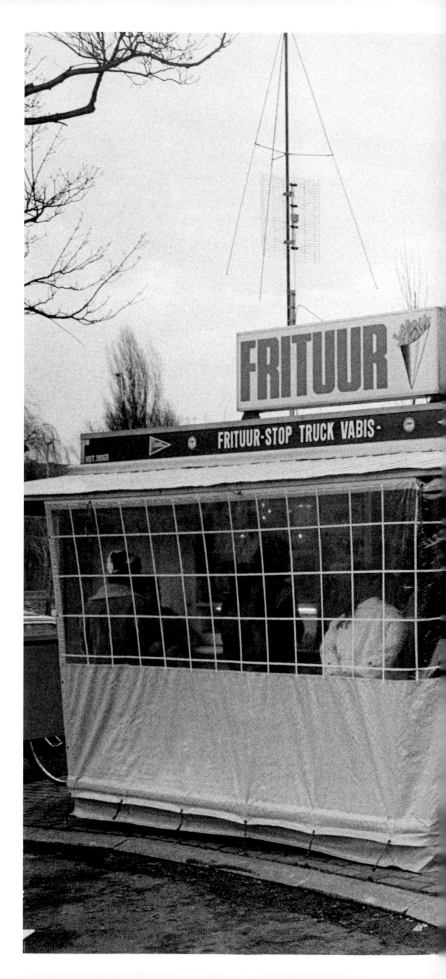

VINK: BELGIAN CYCLO-CROSS

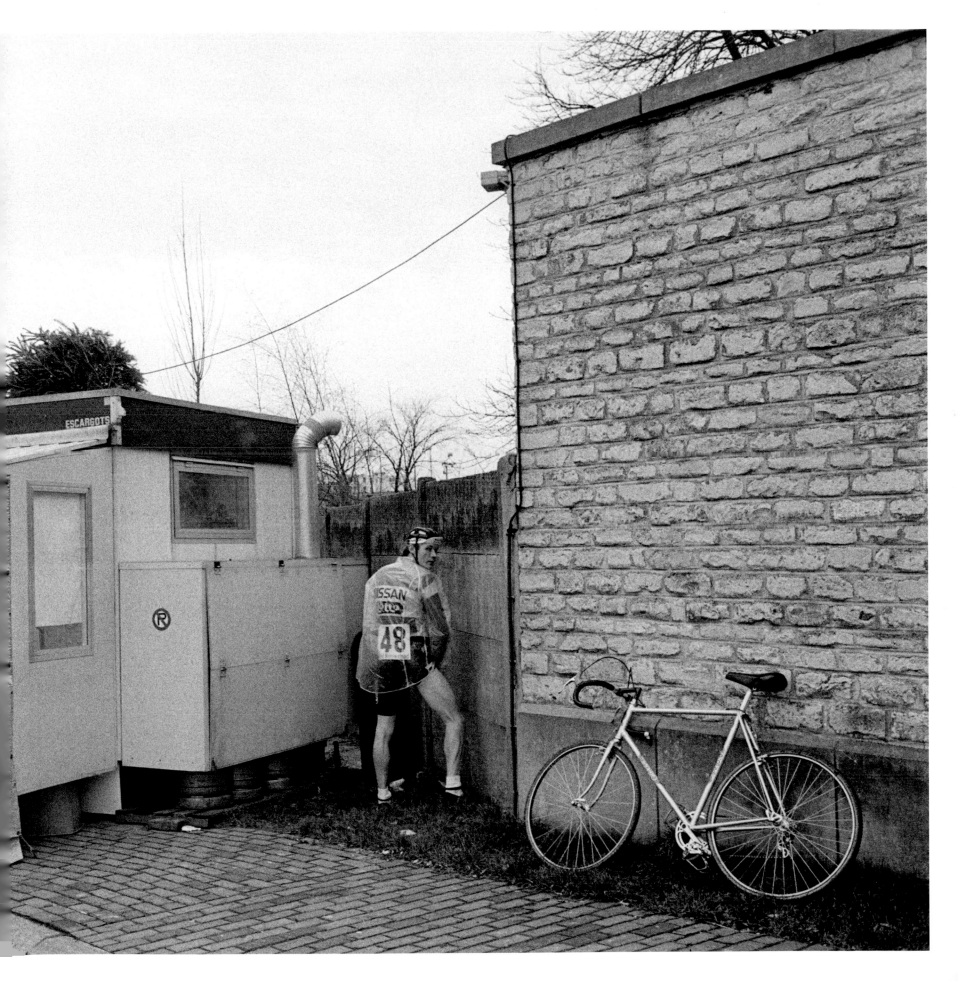

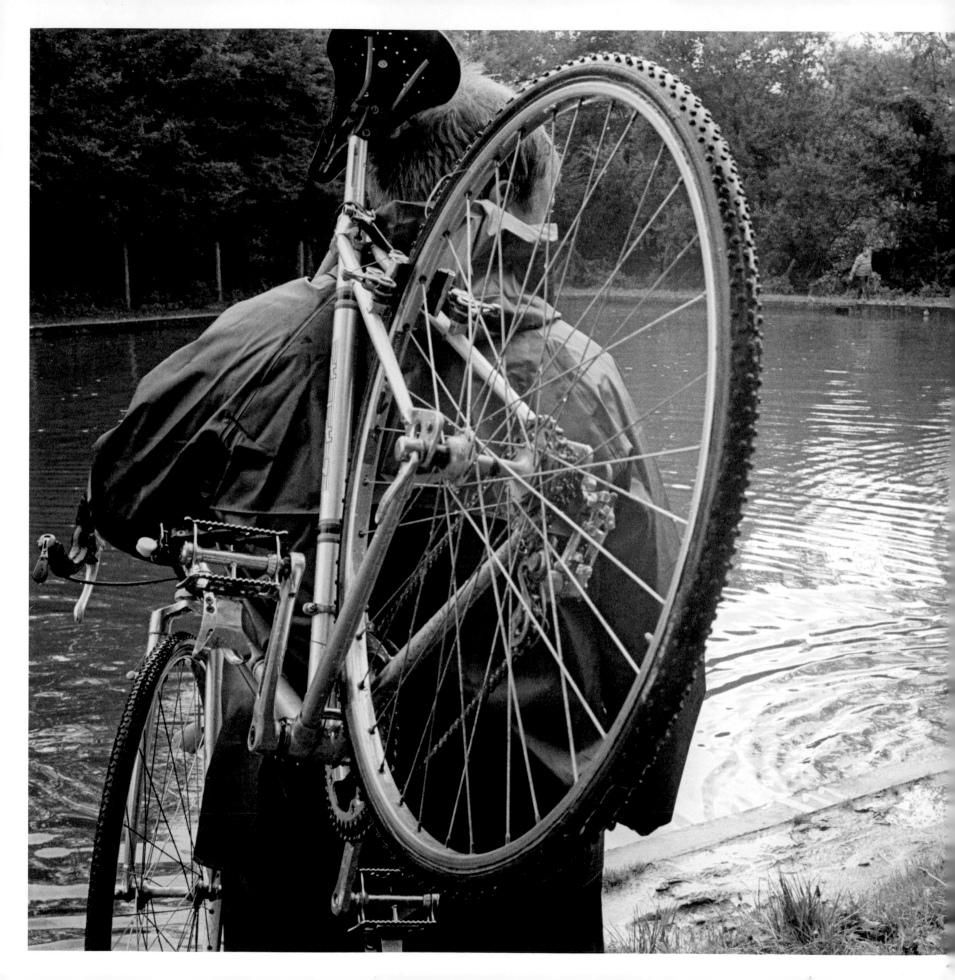

Vossem, 9 October 1982:
Today, bike-washing is mostly
done with pressure washers.
At one time, however, mud had
to be removed with a bucket
and sponge, or any other
nearby source of clean water.

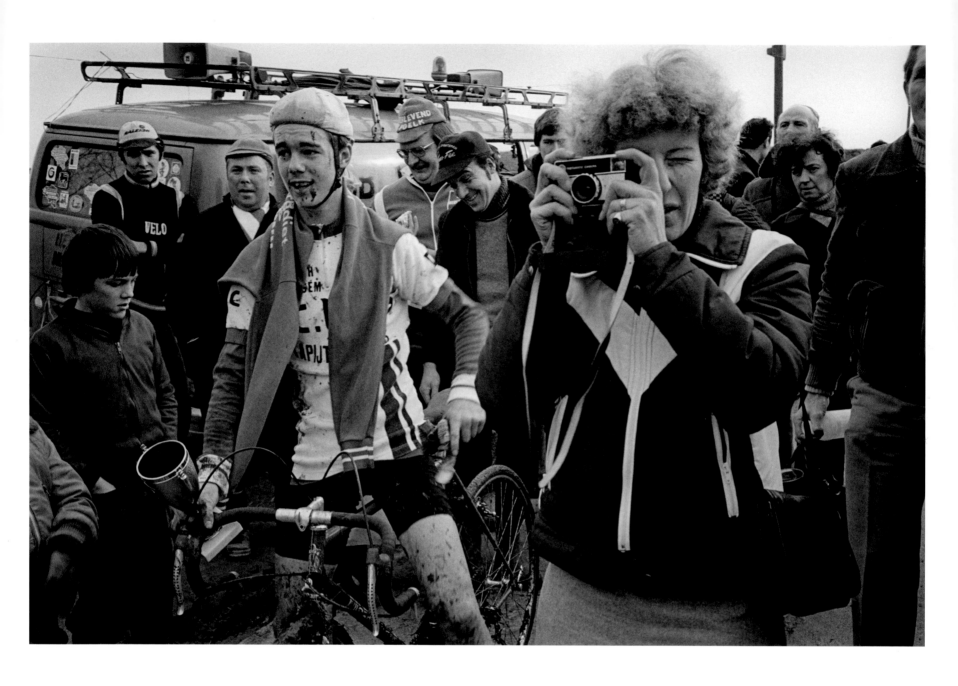

Roosdaal, 17 November 1979:
The Belgians have been the
dominant force in cyclo-cross
for more than fifty years.
The standard of racing is
exceptional at all levels, and
juniors often progress into
the professional ranks.

VINK: BELGIAN CYCL0-CROSS

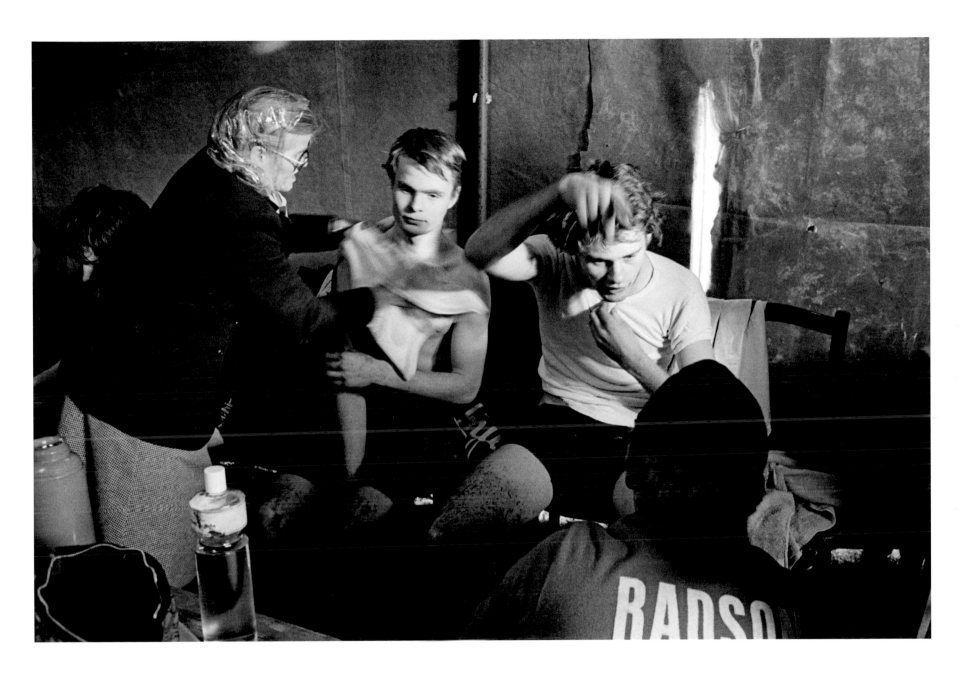

Roosdaal, 17 November 1979:
There is always much to
discuss during the post-race
clean-up, even if the riders
are exhausted, both physically
and mentally.

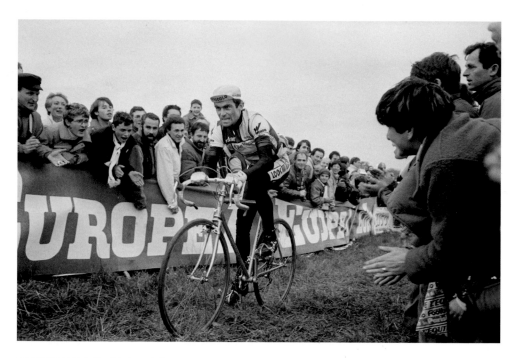

## BERNARD HINAULT'S LAST RACE

Nicknamed 'Le Blaireau', or 'The Badger', Bernard Hinault retired from professional racing at the age of thirty-two. For a leading cyclist, that's quite young. Many riders continue to race into their late thirties, not only because they can earn more in their final years, but also because a cycling career, even a successful one, is relatively short.

In Hinault's day, the average professional rider viewed success as making enough money to buy a café or open a bike shop for their retirement, and many of the great riders milked their final years in order to secure such a future. Some attempted the world hour record, while others embarked on one last Tour de France. But not Hinault. He quit while he was ahead, on a pre-determined date in 1986: 14 November, his birthday. There were no surprises, no comebacks, no pursuit of the spotlight. Instead, he went back to his roots in Brittany and worked on a farm.

The only thing strange about Hinault's retirement was his decision to make his last competitive outing a cyclo-cross event rather than a road

race, a criterium (several laps around a closed circuit) or a time trial. The date of his retirement coincided with the middle of the cyclo-cross season, and his home town of Yffiniac in Brittany was only a few kilometres away from the course at Quessoy. This meant at least that his local supporters would get to see him, with more than 15,000 fans attending the race to cheer him on. A makeshift museum featured displays of his jerseys, his trophies and even a stuffed badger, and an open sportive was held in his honour. There was also a concert, fireworks and a party in true Breton style. Everyone even got a slice of the Hinault's birthday cake.

After a few years away from the sport, building up his farm, Hinault returned to take charge at the Tour de France, at first helping to control the circulation of cars and motorbikes (including, no doubt, photographers) and plan the route. Nowadays, rather fittingly, Le Patron (as he was also known) is the VIP host at the Tour de France podium presentations.

# 1982
# TOUR DE
# FRANCE
---
# HARRY
# GRUYAERT

**The aim of Harry Gruyaert's photographs is true – uncannily true.
—Raymond Depardon**

'I dropped a camera at the Tour', Harry Gruyaert says nonchalantly, as we sit down for a chat at the Magnum offices in London. It's probably a cycling photographer's worst nightmare, especially on the Tour de France, when you need all your kit to be working and close at hand. It also highlights a challenge faced by all pre-digital cycling photographers on the road with the Tour: changing film while on the back of a motorbike. It was a bit of a headache at the best of times, but watching your camera roll down the road behind you must have been heart-stopping.

Since those days of complicated motor winds and fiddly film canisters, things have changed considerably. Dropping a digital camera is arguably less of a problem, although mention the scenario to any photographer and they'll wince: not only would it be expensive, but also a heavy camera flying down the road could create some serious problems for the riders. In 1982, when Harry covered the Tour, things were certainly very different, not least in terms of media attention. The scrum around the race wasn't as intense as it is today, and the press corps wasn't as big. Elf had contracted three photographers to cover the race, and the resulting work was presented in the oil company's annual photographic book of its sponsorship activities, which covered motor sports, sailing and cycling.

'I got the job completely by accident', Harry explains. 'I was working for Elf at the time, and they had this idea to follow Bernard Hinault at the 1982 Tour. I had already worked for the company – I did quite a bit in Formula One for them, with Jackie Stewart – and Elf were the co-sponsor of Hinault's team, so they set up three photographers [including the American Irwin Dermer] working on three parts of the Tour – a week each – and I got the last week.'

Several of the Magnum photographers who have covered the Tour de France have done so only once. I ask Harry if he had ever thought about going back to the Tour for a second time.

'Some jobs you fall into', he answers, 'they are just wonderful. But if you're not commissioned to do the Tour de France, you can't do it. You can't get in; you can't buy a car or a motorbike or whatever. So no. However, I must have been excited at the time when Magnum said, "You're on the Tour de France."

'I had just joined the agency and I think it was the first thing I did there, although the job didn't come from them. I'd worked at lots of Formula One racing with Elf, which paid me good money and which I was able to use to help fund my personal work – working in Morocco, in Belgium …'

In 1982 most of the Tour de France photographers were taking pictures for newspapers, which at that time meant working in black and white. As a result, there isn't a lot of colour work of that year's race. Harry, whose work is famed for its vivid colours, recognizes that he was fortunate not to have been 'attached' to the Tour, a role that would have required him to cover all the action – the sprints, the finishing lines, the podiums.

Those photographers who had to get pictures into the morning papers also had a much longer day. 'They would take it in turns', Harry recalls, 'to sit a day out from the race to drive from the stage start to the stage finish to set up a lab each day and they'd have a wire machine … It's incredible when you think about it, with the technology they have now. Today, they are going through so many files; maybe they shouldn't take so many pictures!

'It's a hard job still: now everybody wants the thing so quickly, and there's so much pressure [at the Tour]. It's not the type of job where you should be making decisions so quickly. I would hate it. But it's really amazing in the mountains – the guys go down at such speed with such small tyres, and near to each other. It's a miracle there aren't more accidents. I remember when [Lance] Armstrong left the road and was able to go across the field on the Col de Manse. The TV guys filming the race are really good, very aware, doing wonderful things.'

I ask Harry about the other photographers on the Tour. Were they friendly?

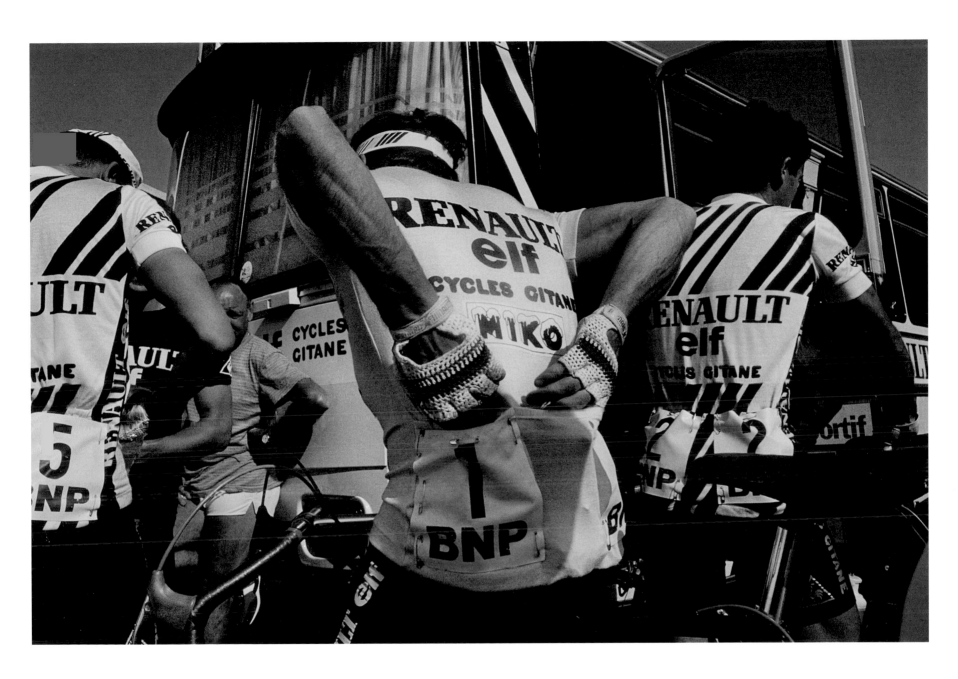

Bernard Hinault's Renault-Elf team was the reason for Harry Gruyaert's presence on the 1982 Tour. Elf sponsored many sporting events and teams, and it often sent photographers along to record the action. Here, flanked by his teammates Hubert Arbès and Lucien Didier, Hinault checks his pockets before the stage *dèpart*.

'I didn't really speak to them much,' he says, 'but I got friendly with the guys on the motorbikes. For journalists, it's a special race. What was fun was that those guys on the motorcycles had done many, many Tours. They knew all the good restaurants, so when we stopped in the morning we often sat on a terrace somewhere along the route, eating a very good meal. Then the cyclists came along and off we went again.'

Spending the day on the back of a motorbike can be a gruelling experience. Before joining the Tour, had Harry ever followed a cycle race in that way?

'I had never been on a motorbike. There were only a few of them on the Tour, five or six. *L'Équipe* had one, and the television of course, and the sponsors – they had their own motorbikes. The guy on the shared pool bike only wanted me in the mountains because he felt I was much more relaxed than the others. It's very difficult to do, because we have to turn and take pictures at the same time, so I did the mountains and luckily every day we arrived safe.'

To add to the difficulty of photographing cycle racing, the sport takes place in all weathers. While attending the Giro d'Italia in 2014, I was amazed to see that the television cameras never stopped: they just kept going – in the rain, the snow and, when the clouds parted, the blistering heat. In some respects they have it harder than the stills photographers. So what motivated Harry to join the Tour?

'I'm keen on all kinds of new experience. If I was asked to do something, I only looked at it if I thought it would give me a chance to learn about something new, to try to understand what was going on. When I was doing that type of work, it was much more interesting because there was no Internet and less television than there is right now. Back then, you could move around – at a motor-racing circuit, you could go into the pits. It was much more open than it is today; now, there's much more security, although what they are doing with small cameras in F1 is fantastic. But it was fun to do, and was a way of making a living as well.'

Harry's photographs of the 1982 Tour de France are certainly of an era. Indeed, it's likely that we'll never see their kind again, mainly because photographers are no longer allowed to take pictures from a motorbike 'inside' the peloton. They are allowed, at certain times, to go ahead of the peloton and take pictures looking back, but never from within the peloton. Also, there are strict rules in place – and officials on the course to enforce them – regarding when drivers can and cannot proceed past the peloton and the race convoy. In the 1980s, rider and crowd safety was much less of an issue as the convoy was much smaller.

Compared to much of the sports photography of the period, Harry's work from the 1980s has a distinctly alternative feel to it. It also demonstrates a clear understanding of bicycle racing, something that Harry sees as second nature to a Belgian.

'What interested me most was everything going on around the race – the people waiting, the whole atmosphere, the villages and the mountains and the motorcycles going down them at hundreds of kilometres an hour … it was so exciting. Being Belgian I had a bike and all the kit, and I followed racing on the radio, but I have never been racing myself. It's obviously a huge tradition in Belgium. Even now I feel if I don't have my bike then I'm not very happy. I love it: it's a way of looking at the world, extremely quickly.'

Harry has said of his work, in particular his photographs of Turkey taken in the late 1990s, that it's as though the pictures reveal something of his personality. Does he think that, as fellow Magnum photographer Guy Le Querrec has commented, his Belgian sensibility and sense of humour also come across in his photos?

'Strangely enough, yes, but that's related to culture, paintings, and obviously, when I go in front of a Bruegel or Flemish paintings, there's something … I know I've come from there. It's unconscious, but I know it's definitely there. I did so many seascapes – skies and horizons – and I was not aware of it for a long time. In the end we made an exhibition with them. People asked, why, why, why so many seascapes?

'But you know, there are so many Dutch and Flemish paintings of the sixteenth and seventeenth centuries with storms and heavy weather and things

like that. They probably interested me at the time but then I completely forgot about them. I think there's something like a Belgian … we take ourselves much less seriously than the French, that's for sure [laughs]. This sense of humour … Guy has a sense of humour as well, but it's pretty different.'

Speaking of Frenchmen, I was curious to find out what Harry had made of his subject at the 1982 Tour, Bernard Hinault.

'At first, I didn't know all of the names of the cyclists, so I tried to concentrate on Hinault, but I never talked to him. I had to follow him. I mean, it was *about* him, but it was nearly the end of the Tour and I knew he was going to win. I had no privileges with the team, and I think he couldn't give a fuck.'

As we were nearing the end of our time together, I asked Harry what it was like to arrive in Paris with the Tour, at the climax of the race.

'I arrived in Paris on this motorbike. I had to ride up and down the Champs-Élysées – it was a completely new experience for me, and a love story too, as a girl was waiting for me at the end. That was just the beginning [of our relationship], so you know, it was very exciting     and I'm still with her! Elf was happy too, and actually made an exhibition [of the work], with big projections on many different screens. They invited a lot of people for a big party … At the time it was only slides – there was no digital – but they had hundreds and hundreds of pictures. It made a fantastic show, using many different photographers. Strange, because I would never put up a picture of the Tour de France in an exhibition of my work, for sure. No. I mean, it's nice to do, it's a nice experience, but it's nothing really personal.'

Harry looks down at the transparencies spread out in front of us. There's a picture of Dietrich 'Didi' Thurau riding up a mountain, minutes behind the peloton, still bloody from a recent crash (see pages 118–19). It's one of the best pictures I've ever seen of a stricken rider at the Tour de France – all passion and hurt. 'Actually, this picture is not bad', agrees Harry. 'I haven't looked at this one for a long time. I'm wondering if I still have it …'

When I began my rummage through the vaults of the Magnum offices in Paris and London, a sheet of Harry's transparencies from the 1982 Tour de France was the first cycling-related item I found. Rescanning the transparencies was a revelation, with the faded and over-duplicated scans turning into beautifully sharp and colourful prints. They are instantly recognizable as Harry's work, the Kodachrome film generating rich, contrasting colours – bright reds and greens with deep shadows and bright highlights. The Tour de France has rarely looked so colourful.

A rider at the Tour de France can burn around 6,000 calories a day. Each stage of the Tour usually includes two 'feeding zones', where riders can pick up a musette, a small, fabric bag filled with cakes, sandwiches and drinks. Team leaders, such as Bernard Hinault, usually have their bags picked up for them by a *domestique*, a support rider from the same team.

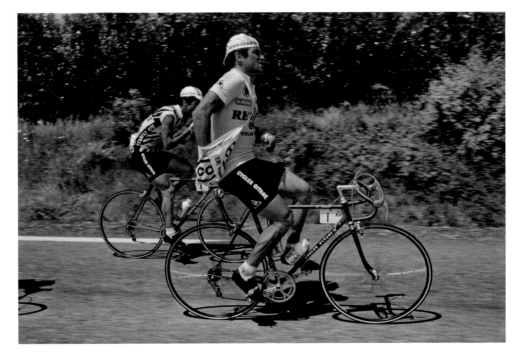

The 1982 Tour de France
started in Basel in Switzerland.
It also spent a day in Belgium.
Here, the peloton passes a
flock of sheep grazing on an
Alpine meadow.

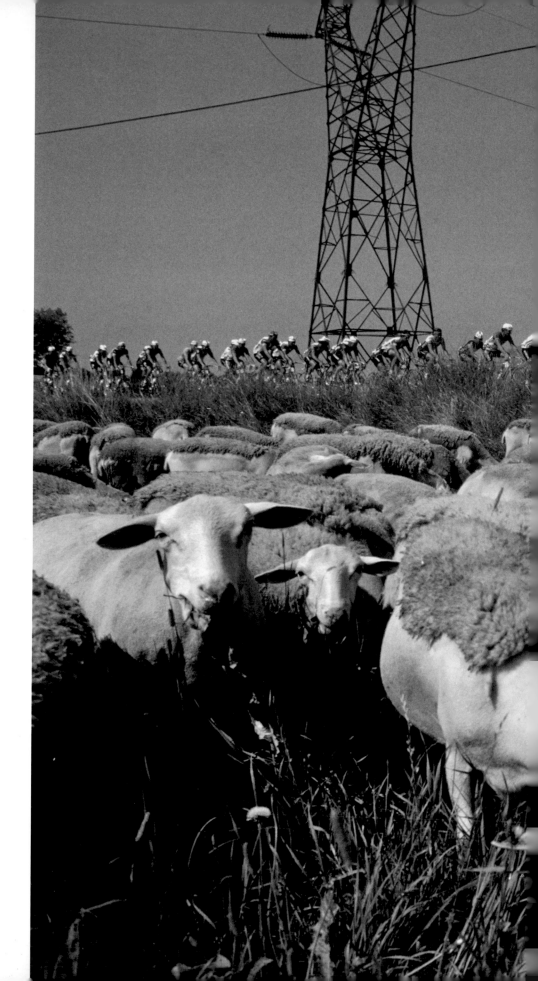

GRUYAERT: TOUR OF 1982

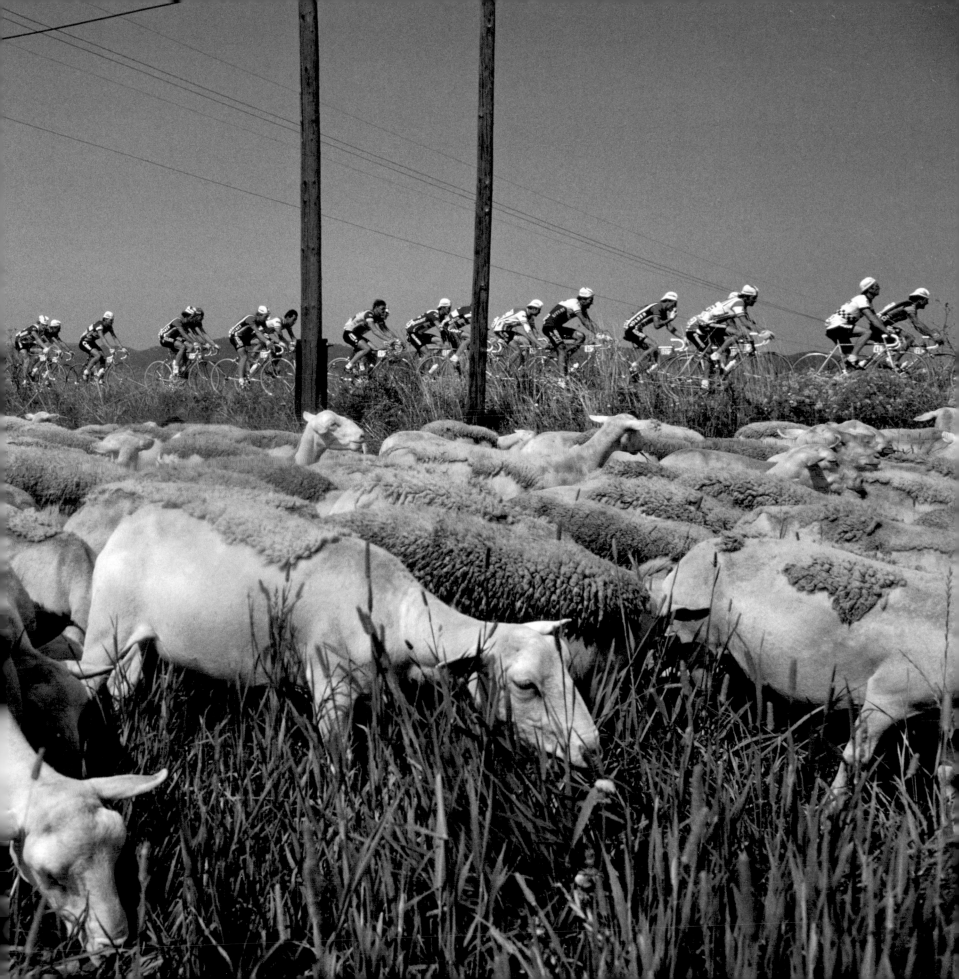

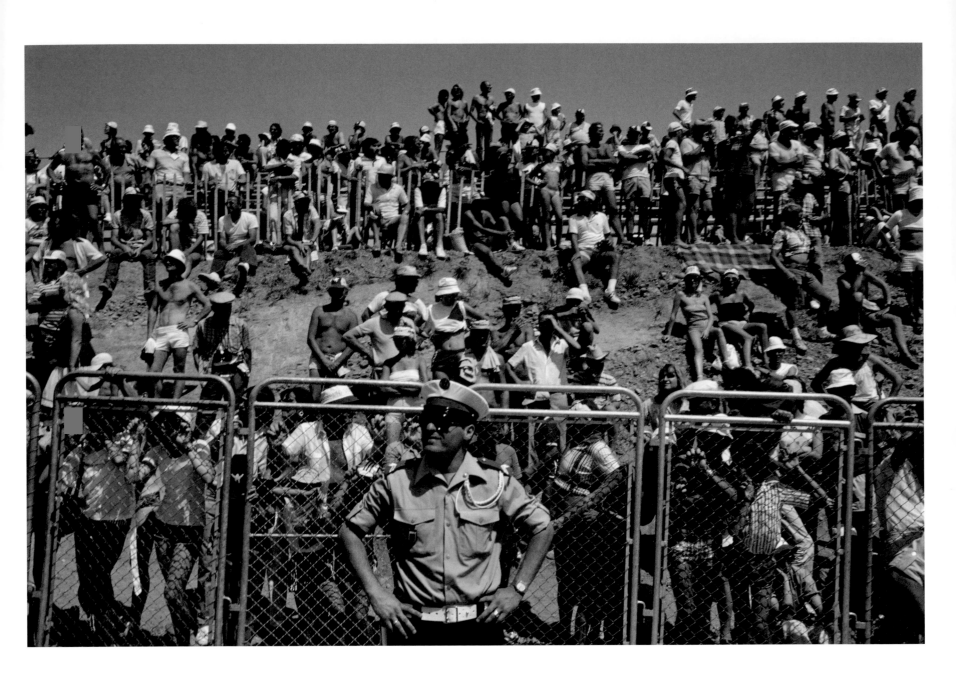

Policing the Tour has always been a huge undertaking, with officials positioned at every road junction. In 2015 the route was lined with around 25,000 police, gendarmes and members of the CRS (Compagnies Républicaines de Sécurité).

GRUYAERT: TOUR OF 1982

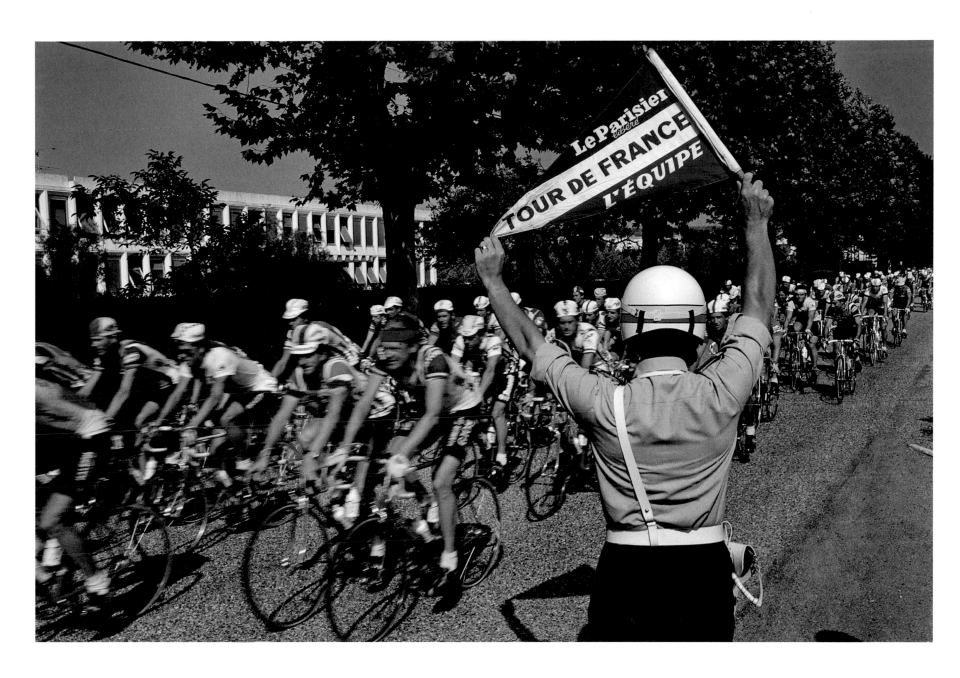

The motorcycle police at the Tour de France have always been selected from the Garde Républicaine, an elite group of well-trained motorcyclists who, for the rest of the year, work predominantly in Paris, acting as escorts at state events and providing security for visiting heads of state. For such bike races as the Tour, they are regarded as being among the best and most experienced racing marshals in the world.

101

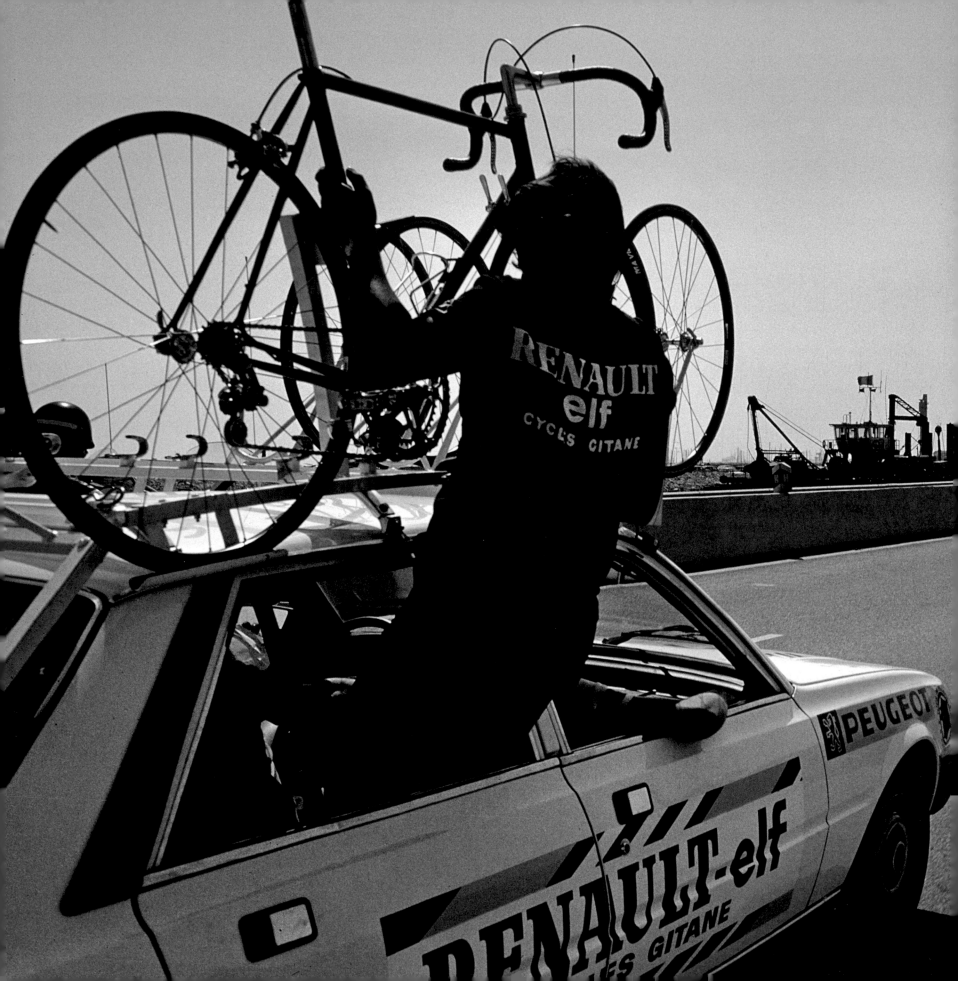

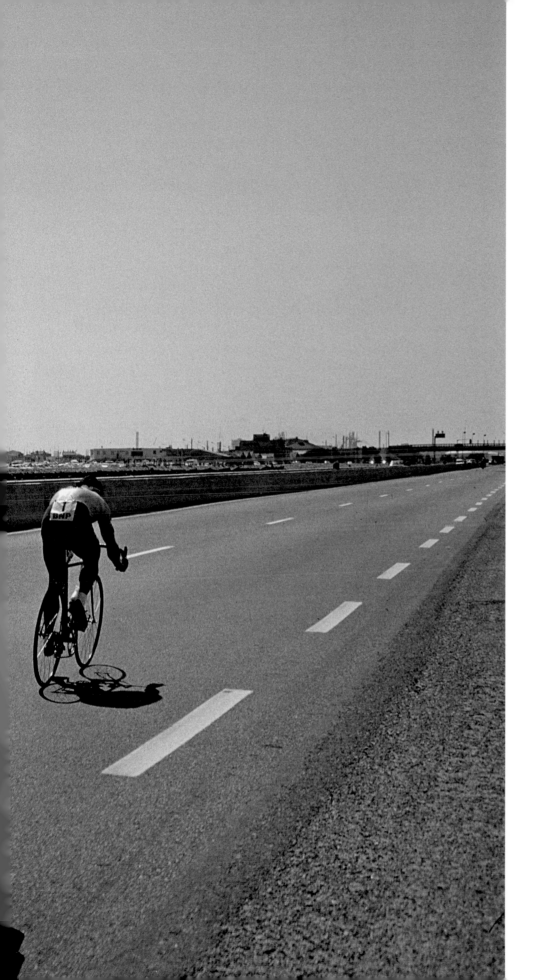

The 1982 Tour de France featured three individual time trials. Bernard Hinault won two of them, in Martigues and Saint-Priest; the third, Stage 11 in Bordeaux, was won by the Dutch time-trial specialist Gerrie Knetemann. There was also a prologue time trial, which in the early 1980s was treated as more of an exhibition stage than a serious time trial.

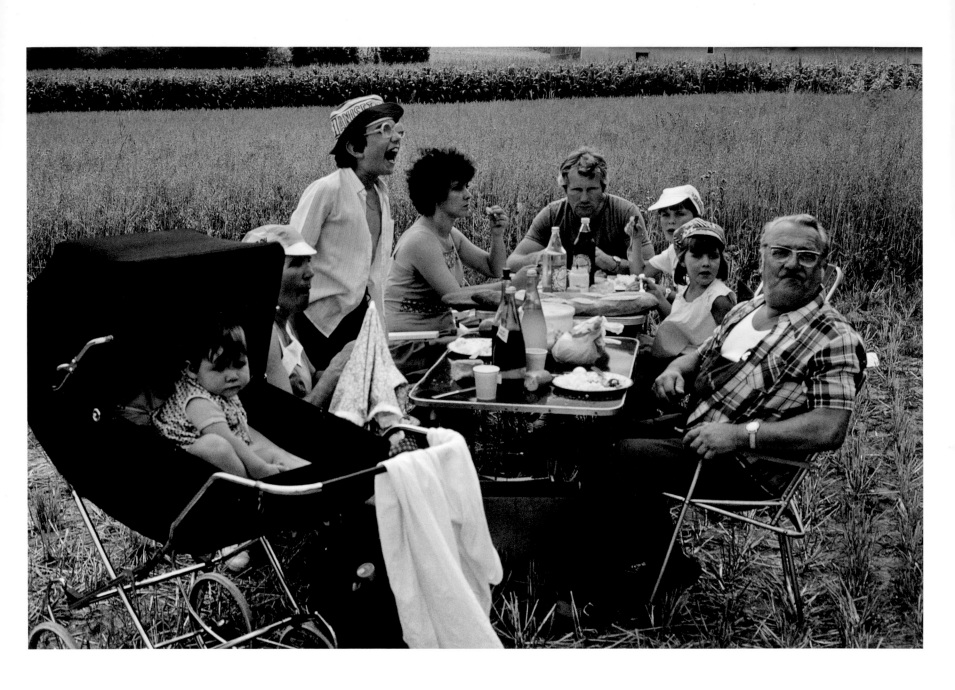

The Tour de France provides
the biggest setting for outdoor
dining in France. The average
time spent by spectators at the
roadside at the Tour is around
six hours – plenty of time for
a picnic.

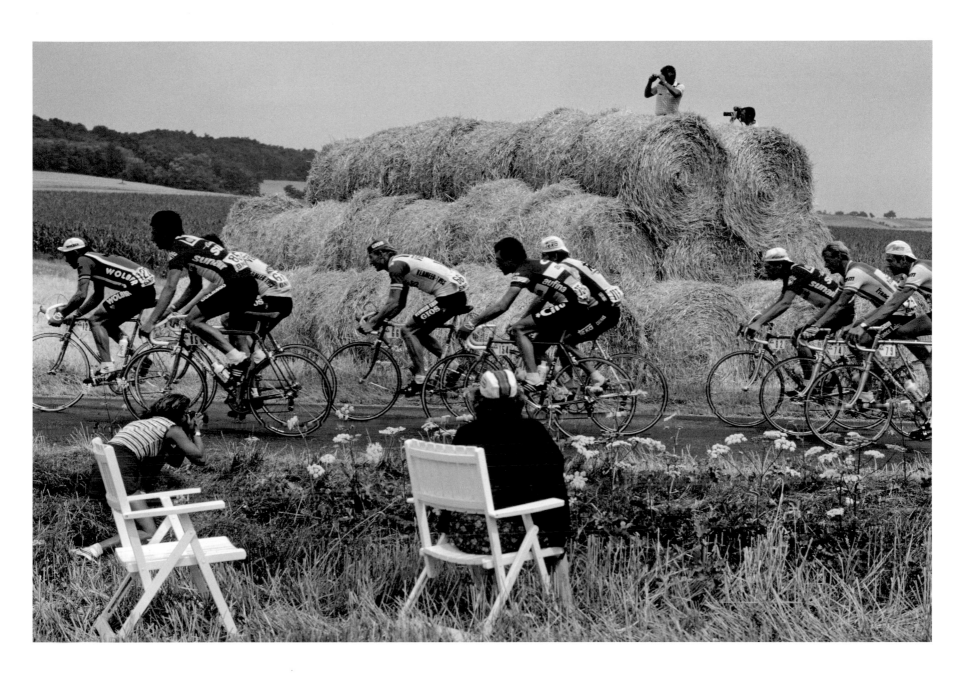

In 1982 the Tour de France consisted of 170 riders – seventeen teams with ten riders each. By 1987 teams could have only nine riders each, numbered 1 to 9, 11 to 19, 21 to 29, and so on. In 2015 there were twenty-two trade teams with nine riders per team. The leader of each team always wears the first of the team's nine numbers (i.e. 11, 21, 31, etc.), with number 1 itself being reserved for the defending champion, and 2 to 9 for the members of his team.

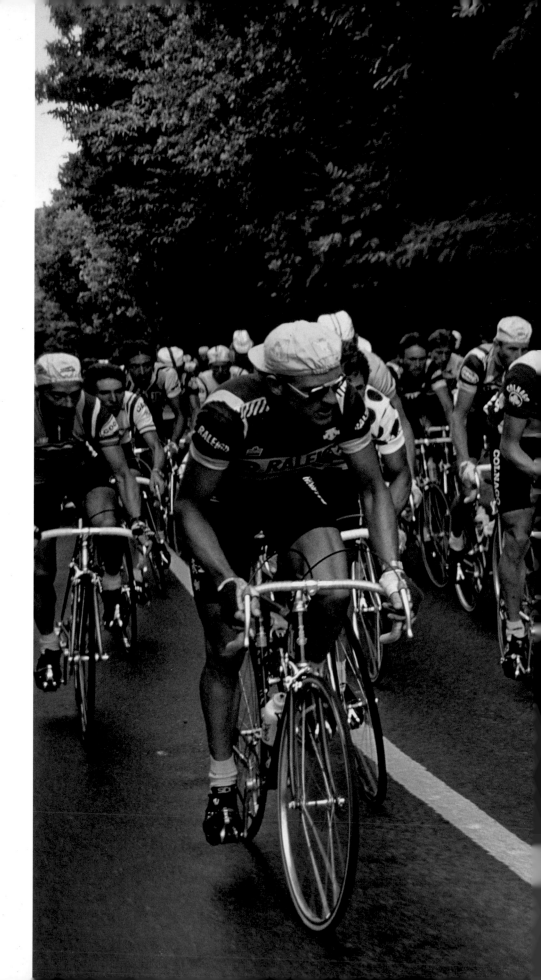

Seen leading the pack here are, from left, Jan Raas, the Dutch classics star; Patrick Bonnet, Bernard Hinault's loyal lieutenant at Renault-Elf; the Peugeot hardman Frédéric Brun; Hinault; and Marino Lejarreta, winner of the Vuelta a España earlier that year. Hinault is the only one of the five riders who is seated, a classic display of confidence – defiance, even – by Le Patron. The message? 'I am not in trouble.'

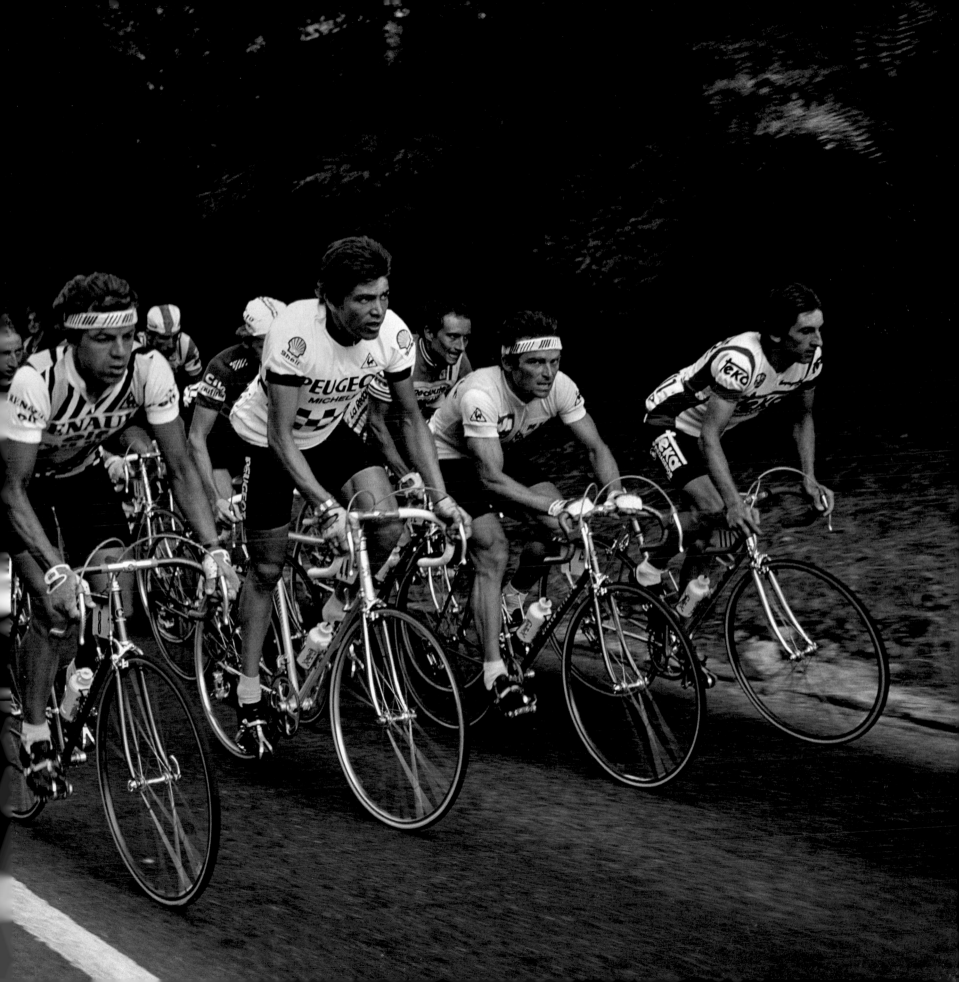

## FRENCH REVOLUTIONS: PROTESTS AT THE TOUR DE FRANCE

The Tour de France is often held up by demonstrations. For one thing, it's an easy target: the course is many hundreds of kilometres long, and therefore very hard to police. For another, in many countries the Tour is peak tea-time viewing, so what better way to get your point across to a large audience? Political parties, anti-nuclear protesters and even bus drivers have attempted to hijack the event, and every year there's usually someone – most often a union of some kind – trying to gain the attention of the French public. Only rarely, however, does the race grind to a complete halt.

The first delays occurred as early as 1904, when, in an attempt to guarantee a win for their local heroes, a group of supporters threw nails in the road to hold up the other riders. Such delaying tactics continued for some years, and sabotage of one kind or another has always been a problem. Even journalists have felt the need to revolt. In 1968 – that year of mass protests in Paris and beyond – they took umbrage at the criticism of their work by the Tour organizers, and blocked the road so that only the riders could get through.

The riders themselves have staged their own fair share of protests. In 1966, in response to the introduction of drug testing that year, they simply got off their bikes on Stage 9 and walked. In 1974 they held similar protests in reaction to the ludicrously long stage transfers and early stage starts. The organizers didn't listen, however, and so in 1978, with little having changed, it was none other than Bernard Hinault who led the peaceful protest, stopping the peloton en masse and demanding that the early starts and long transfers be brought to an end. Hinault wasn't always so well behaved, and in 1984 infamously threw punches at a group of striking miners who had stopped that year's Paris–Nice.

In 1982, the farmers who had brought the Tour to a standstill may have got Hinault on a good day. Whether it was because he was a farmer himself and therefore had some sympathy for their cause, or because the stage had not really started yet, or because Hinault was already wearing the yellow jersey, he decided not to start a brawl. Now retired, Hinault continues to protect and serve at the Tour, presenting the prizes after each day's stage. His presence on the podium is always welcomed by the (usually French) race sponsors, who are invited up to present the jerseys. On three occasions in the past few years, however, he has had to remove protestors from the podium, doing so in the same bullish spirit in which he raced – by simply pushing them off.

The riders are forced to take a break by protesting farmers. On the right of the photograph, in the French tricolour jersey of the national champion, is the late Régis Clère. He is also wearing the yellow cap of the leading team on general classification, which at that point was Coop-Mercier. The light-green caps, sported here by members of the Raleigh team, are worn by the team with the most points.

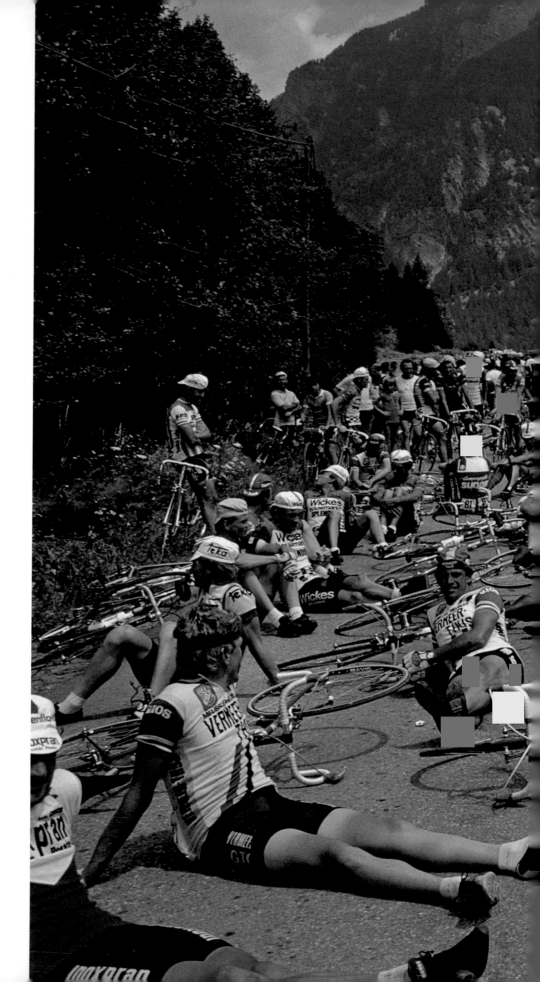

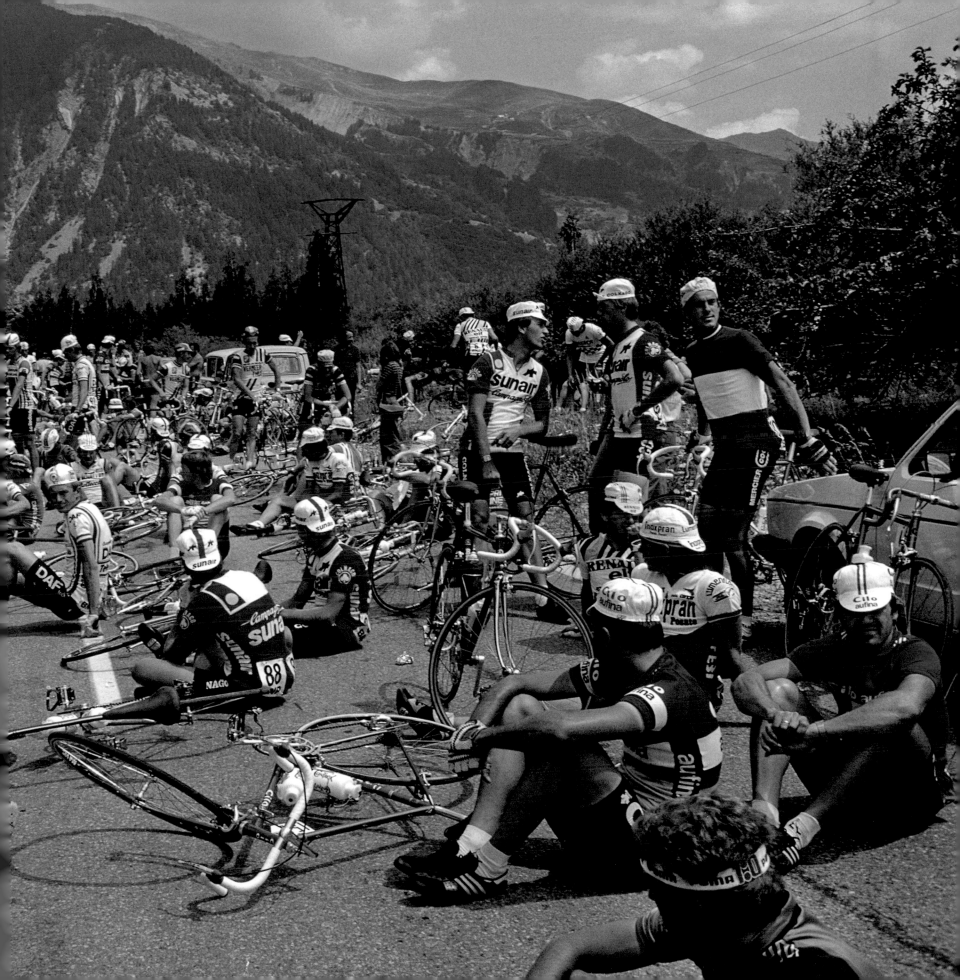

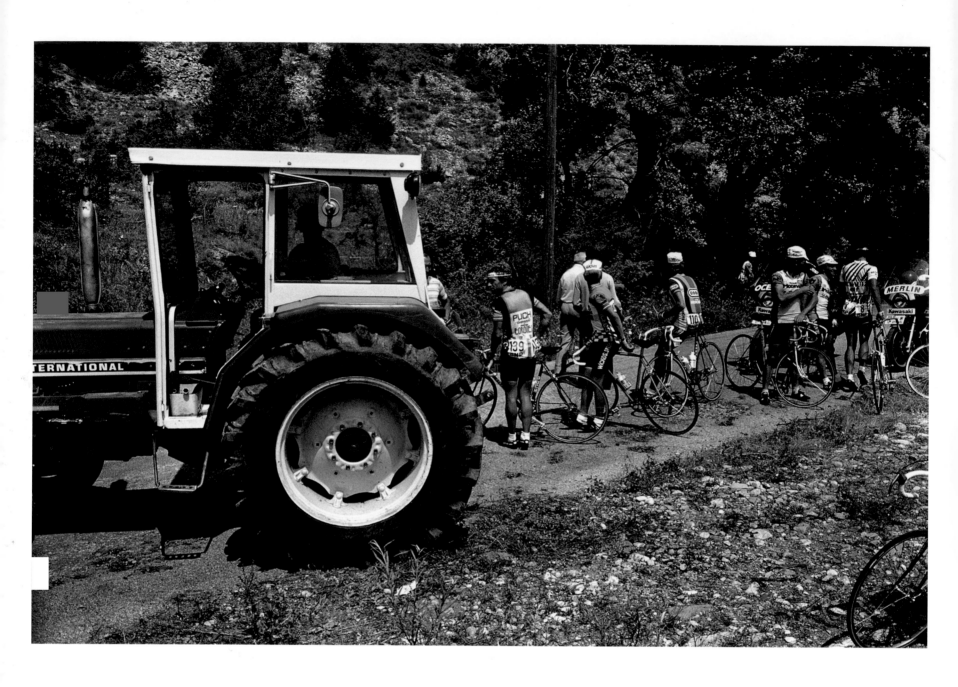

The protesting farmers had stopped the race just before the start of Stage 16, between Orcières-Merlette and Alpe d'Huez. While some riders posed for pictures with the farmers or sat on their tractors, most did what bike racers do when they stop: they laid down in the road and took a nap. After a short delay, the race was allowed to continue.

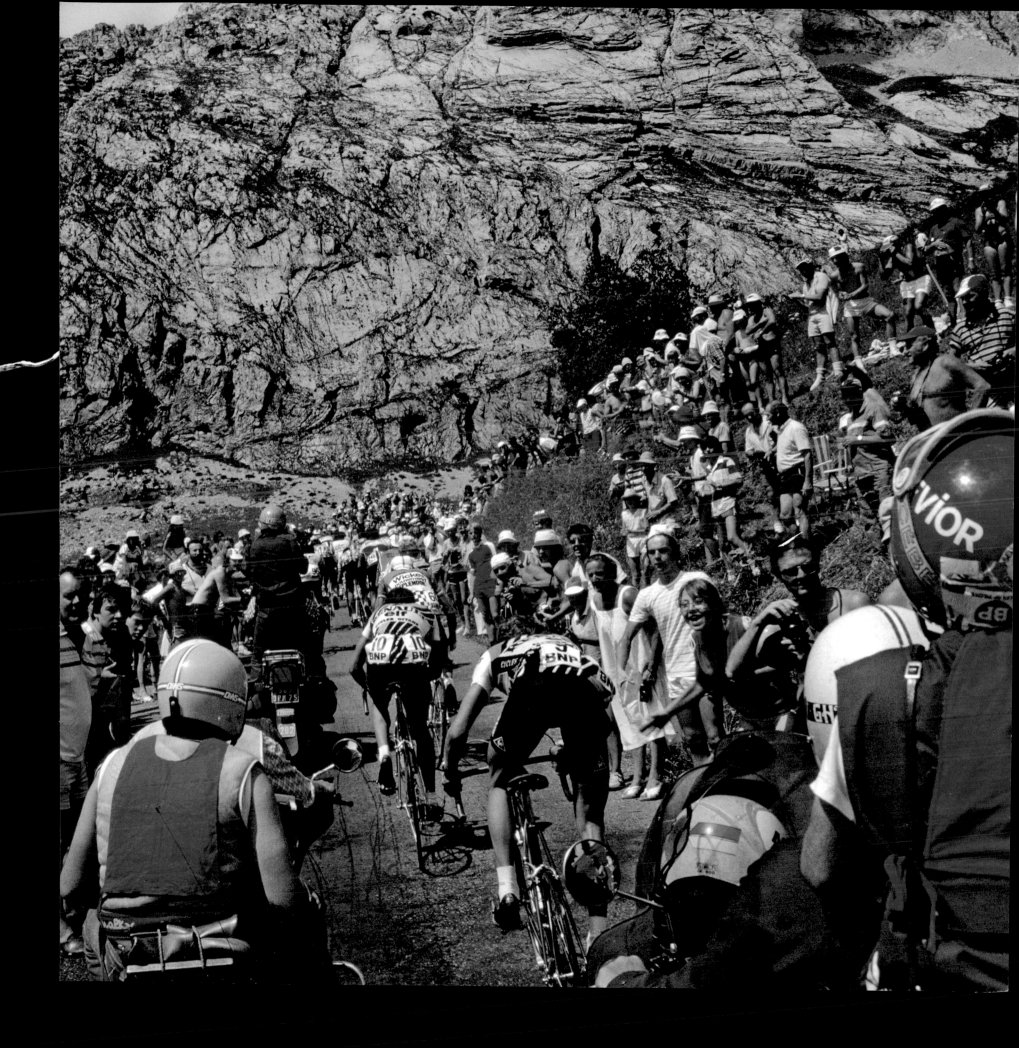

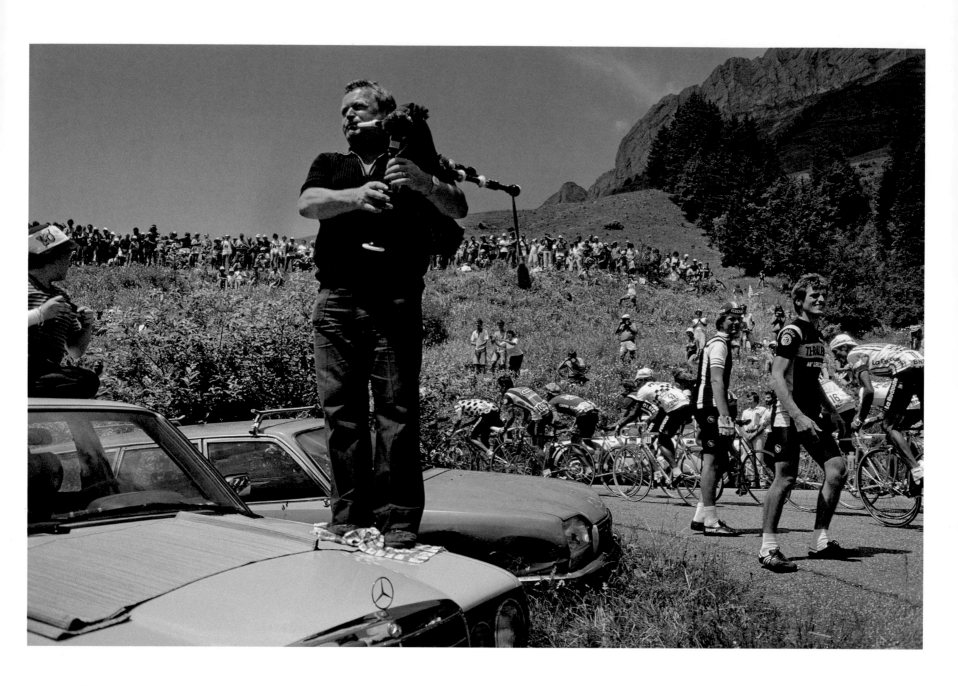

A lone piper performs on
the road to Alpe d'Huez while
two Dutch supporters in TI-
Raleigh colours await their
team. Since the early 1980s
the Alpe has been very popular
with Dutch fans, thanks in part
to the success of such home-
grown riders as Peter Winnen.

Spectators await the arrival of the Tour de France publicity caravan, a parade of decorated vehicles advertising major brands and giving out free gifts. Introduced in 1930 by Henri Desgrange, it is perhaps one of the main reasons why people come to watch the Tour.

The Tour de France is the world's largest live sporting event, with around 12 million spectators watching from the roadside every year.

GRUYAERT: TOUR OF 1982

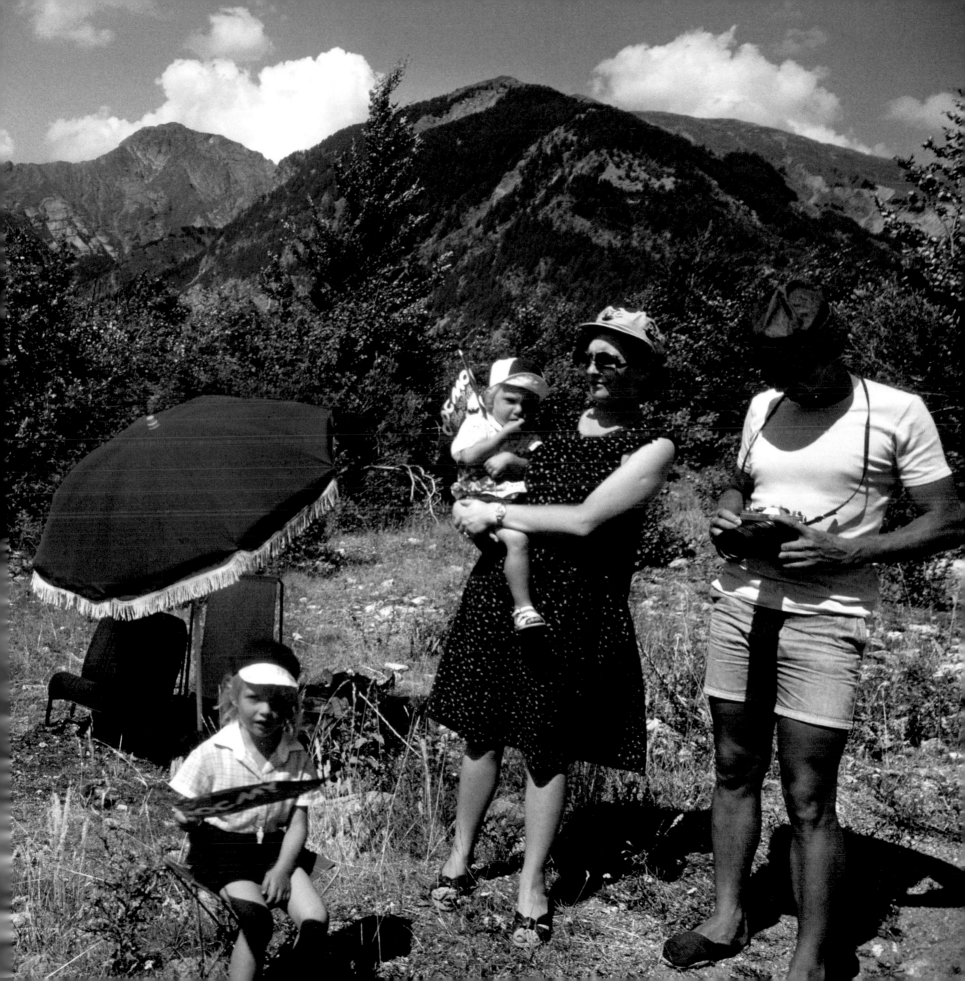

When Dietrich Thurau first competed in the Tour de France, in 1977, he not only won the prologue but also retained the yellow jersey for fifteen stages proper. Aged only twenty-two at the time, 'Didi' was seen as a star in the making. By 1982 he had found his real place in cycling, not as a stage racer at the Tour de France, but as a six-day track-racing specialist. He abandoned the Tour that year on Stage 20 – just one stage before reaching Paris – after succumbing to the injuries he had sustained in a crash. Here, you can clearly see blood on his handlebars and right leg, as well as a dressed wound on his left knee from a separate incident. His team, Hoonved-Bottecchia, had a pretty disastrous Tour in 1982, with only four of its ten-man outfit making it to the finishing line.

GRUYAERT: TOUR OF 1982

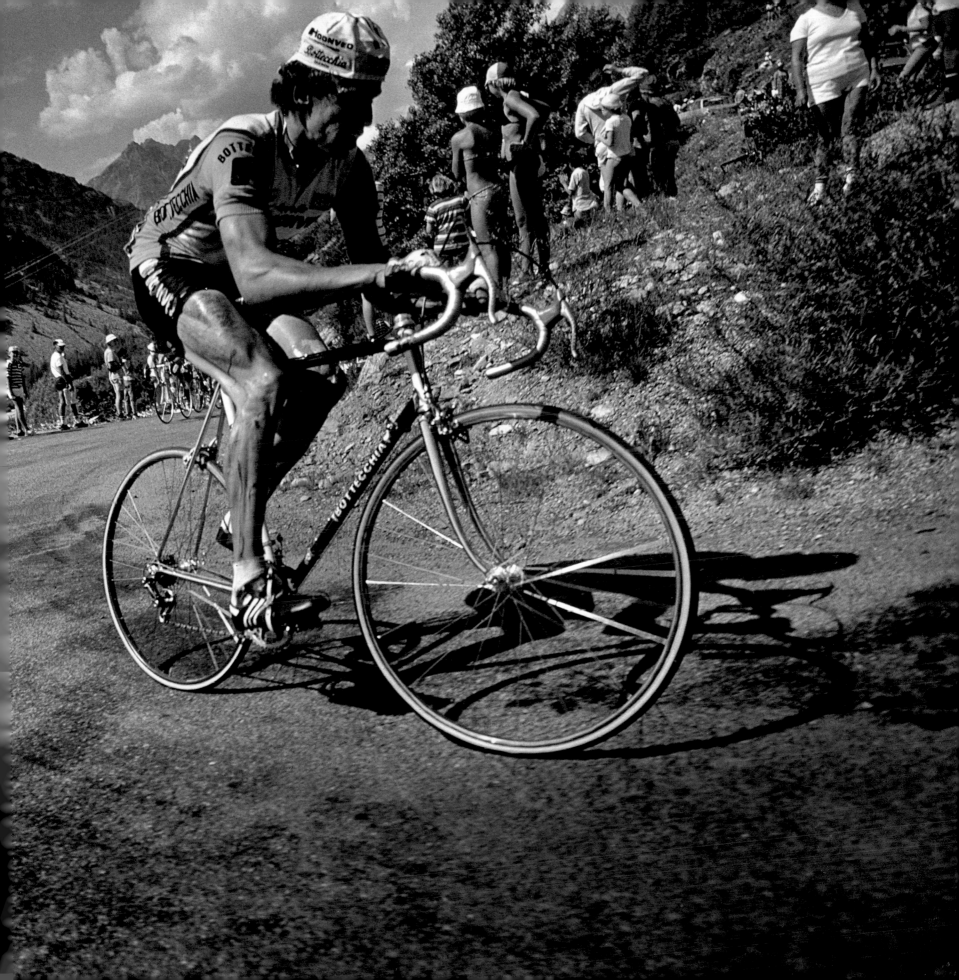

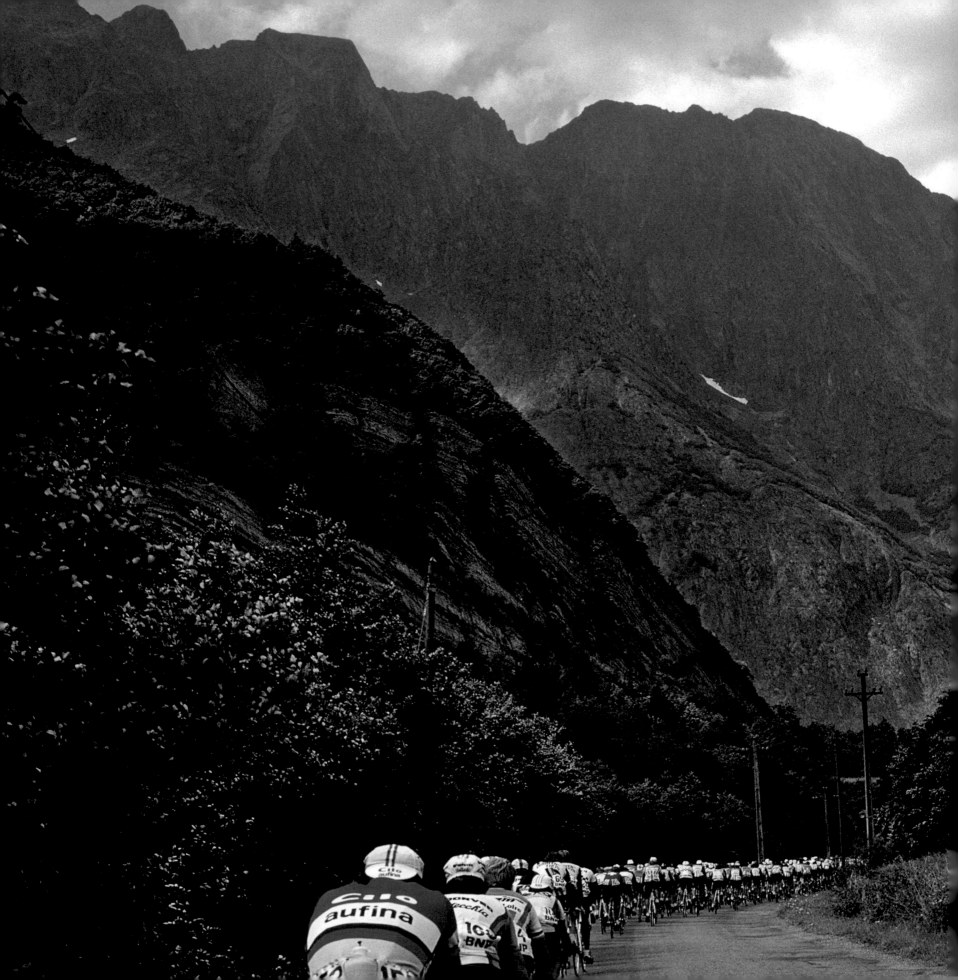

The seasoned Tour rider knows that the real racing starts some 20 km (12½ miles) from the end of each stage. On the flat sections, as here, this results in a speed increase to 'line out' the race. In the mountains, it usually means a long climb to the finish. After three weeks and 3,500 km (2,175 miles), a rider finishing the Tour will have shed several kilograms in weight and put in around 500,000 pedal strokes.

121

The *autobus*, also known as the *grupetto* in Italian and the 'laughing group' in English, is a group of team riders, *domestiques* and 'flat-landers' (non-climbers) who ride together on the mountain stages with the sole purpose of finishing within each stage's time limit and avoiding elimination. In 1980, with only 85 of the 130 riders who started the Tour making it to Paris, the organizers decided to do something about the drop-out rate. After 1982, riders had to prove that they couldn't continue; and if no proof was forthcoming, they would receive a fine, lose any prize money they were due, and not be invited back the following year. The rules have since been relaxed, but the point was made.

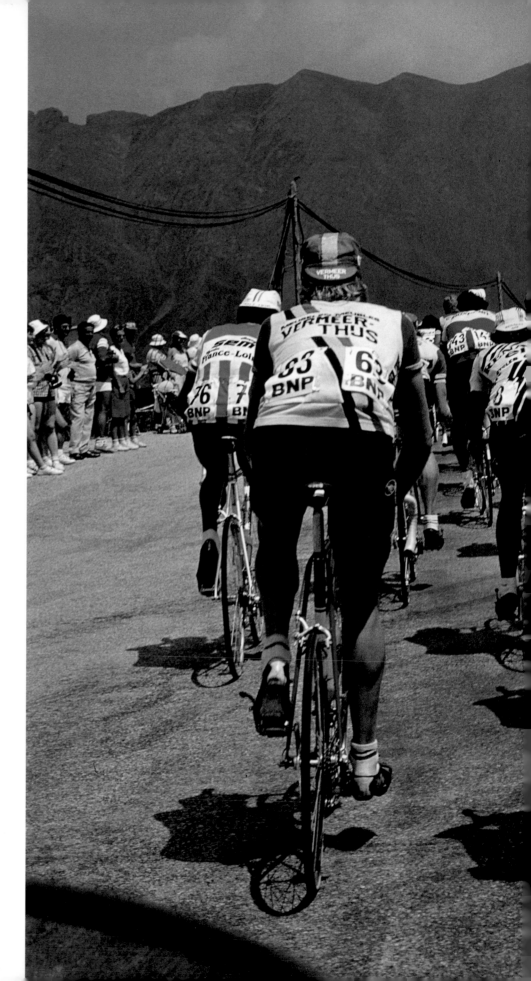

GRUYAERT: TOUR OF 1982

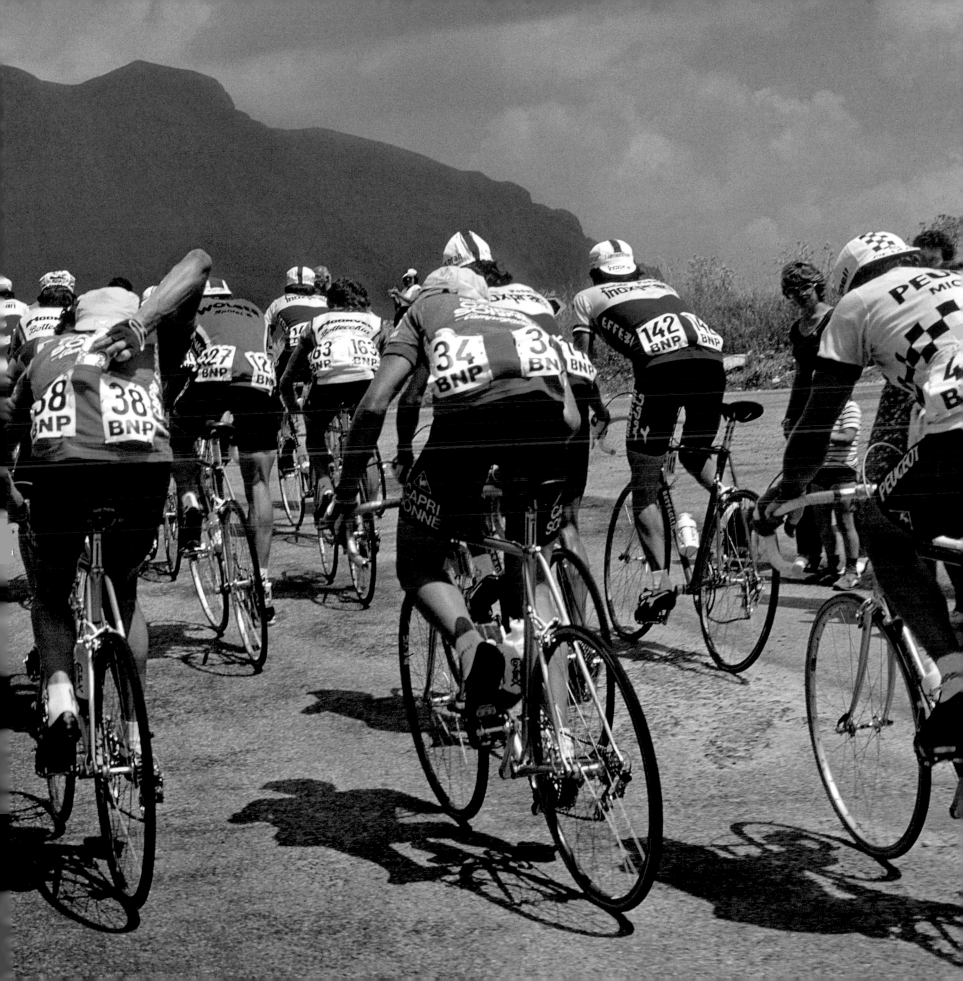

For most riders, the Tour is about survival. Prior to the rule changes in 1982, riders could drop out with no reason. From 1982 onwards, the new rules meant that riders had to have good grounds for going home, not just that they were tired and couldn't be bothered, or had to prepare for other races. Here, Austrian Harald Maier receives attention from the doctor's car, still the only convertible car allowed in the race convoy. Despite his injuries, the twenty-one-year-old Maier made it to Paris in this, his first ever Tour.

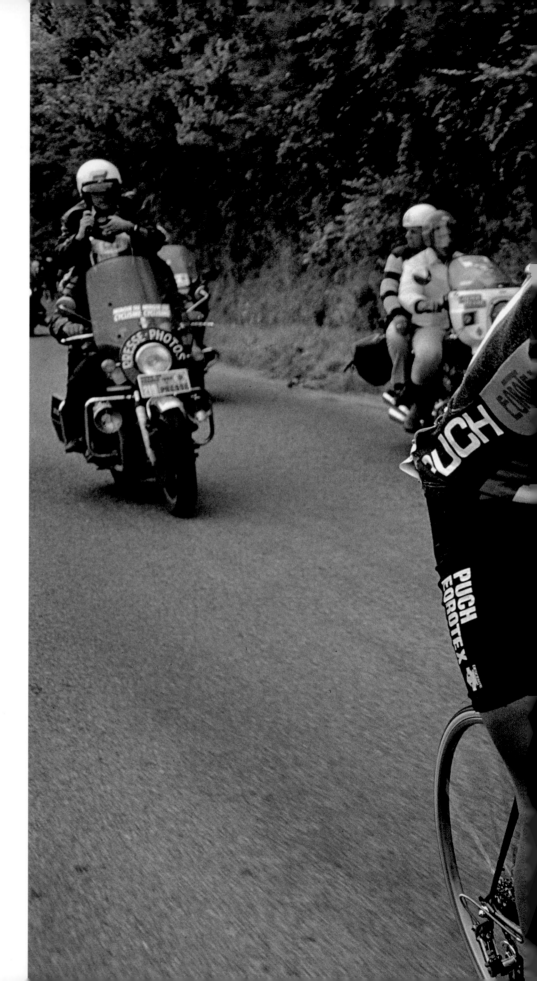

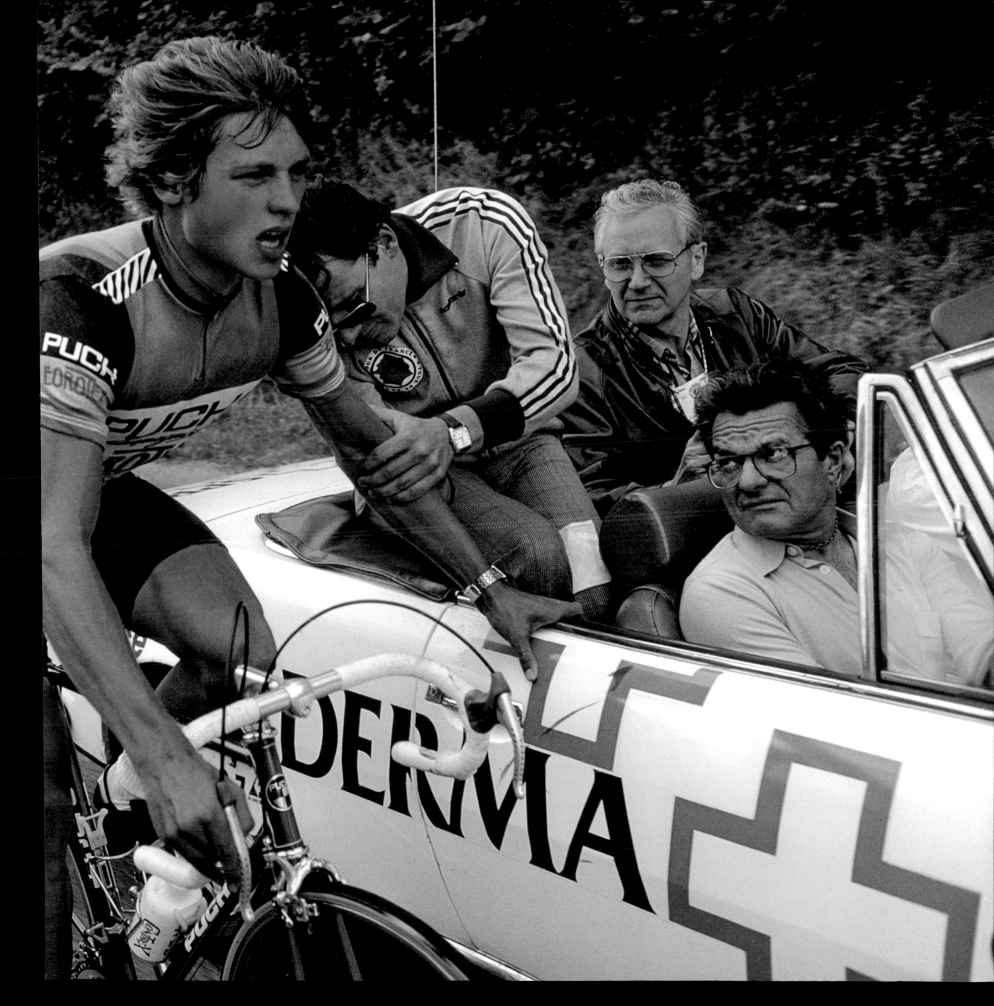

Bernard Hinault relaxes at the end of the Tour. Three years later, in 1985, Hinault would secure the last of his five Tour de France victories. More significantly, perhaps, it's now more than thirty years since a French rider has won the Tour.

As the Tour transfers from Saint-Priest to Sens via TGV for the final stage into Paris, Hinault puts his feet up, knowing that the race is won. All riders travel from one stage to another – be it by road, train or plane – together, thus ensuring that no one receives an unfair travel advantage.

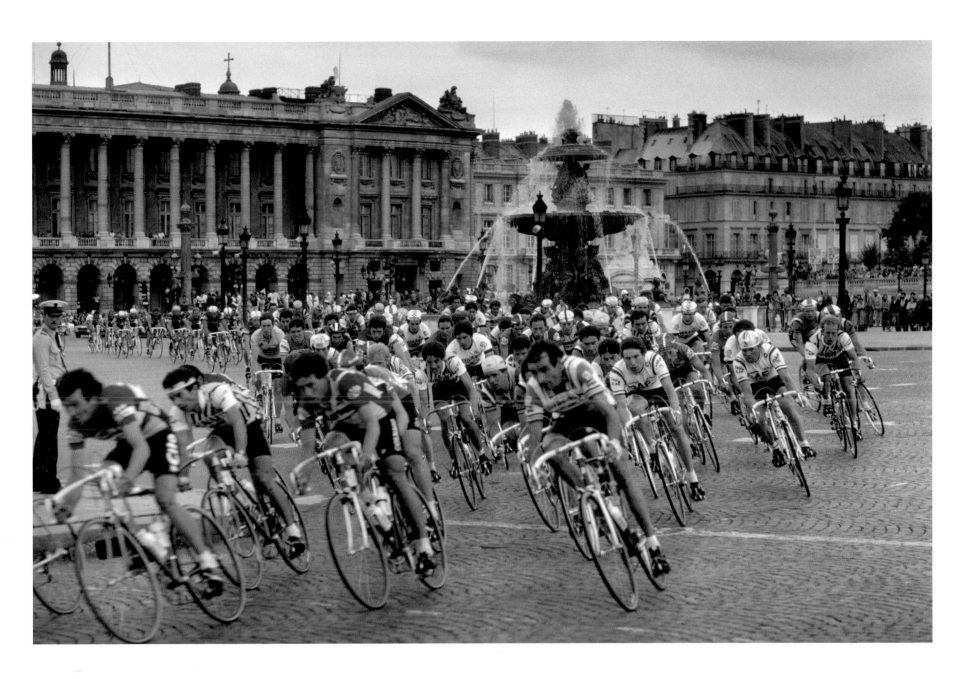

In Paris at last, the peloton sweeps past the Hôtel de Crillon on the Place de la Concorde, often the setting for the winner's post-race reception. All professional cyclists dream of competing in the Tour de France but very few get the opportunity; of those that do, most feel happy simply to reach the French capital. After three weeks of hard racing, the Eiffel Tower and the finishing line on the Champs-Élysées are very welcome sights indeed.

# THE
# VELODROME

**David Seymour** Frankfurt, Germany, 1947: At an outdoor velodrome, cyclists ride behind specially converted motorbikes, or 'big motors', which travelled around the track at speeds of up to 100 km/h (62 mph). Combining the thrill of a race with wall-of-death-type speeds, this kind of motor-paced racing was especially popular in post-war Germany.

**Cycle tracks will abound in Utopia.**
*—H. G. Wells*

Prior to the advent of radio and television, the only way to experience a bicycle race as it happened was to watch it in person. For many people this meant attending the races at their local velodrome, and for more than a century, from about the 1870s, track racing formed a major part of European sporting culture. Indeed, from its very beginnings, cycling proved an ideal racing activity: it was fun, fast and entertaining.

It was also very popular. Before racing cars and motorbikes took over, cyclists were the wheel-based sporting stars of the early twentieth century. The six-day race in particular (see page 136) was the Formula One or MotoGP event of its age, with velodromes selling out for the entire week of the race many months in advance. At the start of the twentieth century, the popularity of track racing had fuelled a boom in road cycling, which, in turn, spawned such new ideas and challenges as the Tour de France and several of the classic road races.

Velodromes come in a variety of shapes and sizes. The fastest tend to be indoor and have wooden tracks. The preferred wood for such tracks is Siberian pine, which, among other things, can be machined into sections of between 4 and 5 m (13 and 16½ ft) in length. It takes many weeks of expert carpentry to lay a typical wooden track, and more than a quarter of a million nails to secure it. All sections of the track are banked – the corners at a steep 40 to 45 degrees, the straights at about 20 degrees. The speed of the rider keeps the bike upright, with centrifugal force pushing them into the corners. Track racing is an exhilarating, compelling experience.

Outdoor tracks are usually made of concrete, with shallower banking. The majority form part of a multi-use sports venue, often encircling an athletics track or football pitch, and so tend to be a little longer than the indoor variety, measuring up to 500 m (1,640 ft) in circumference; by comparison, the length of a typical indoor track is 333 m (1,093 ft). Outdoor tracks are especially popular in Japan, which is home to around seventy velodromes. Indeed, track racing in Japan is a national obsession, being one of only four sporting events on which gambling is legal.

One of the most gambled-on track-racing events in Japan is the keirin, in which riders follow a motorized pacemaker for several laps before sprinting to the finish. Hugely tactical and strictly regulated, the keirin is nevertheless extremely popular with the Japanese, and is televised most days. Successful riders can make a very good living from the sport – often becoming household names in the process – and so rarely feel the need to compete outside Japan.

The Olympics have featured track cycling since 1896, and many of the events remain the same today as they were at the beginning of the modern era. Several of the events are aimed at sprinters and endurance riders, and many of the skills that these riders learn on the track can be transferred to the professional ranks and the road races. Track racing provides an excellent grounding in bike craft and race tactics, and some of the world's best road cyclists started out on the track.

Photographing track cycling can be a challenging experience. But with the races changing from second to second, it can make for some exceptional images. Factor in the crowds and the characters that support the racing, and you have the ideal subject for reportage photography.

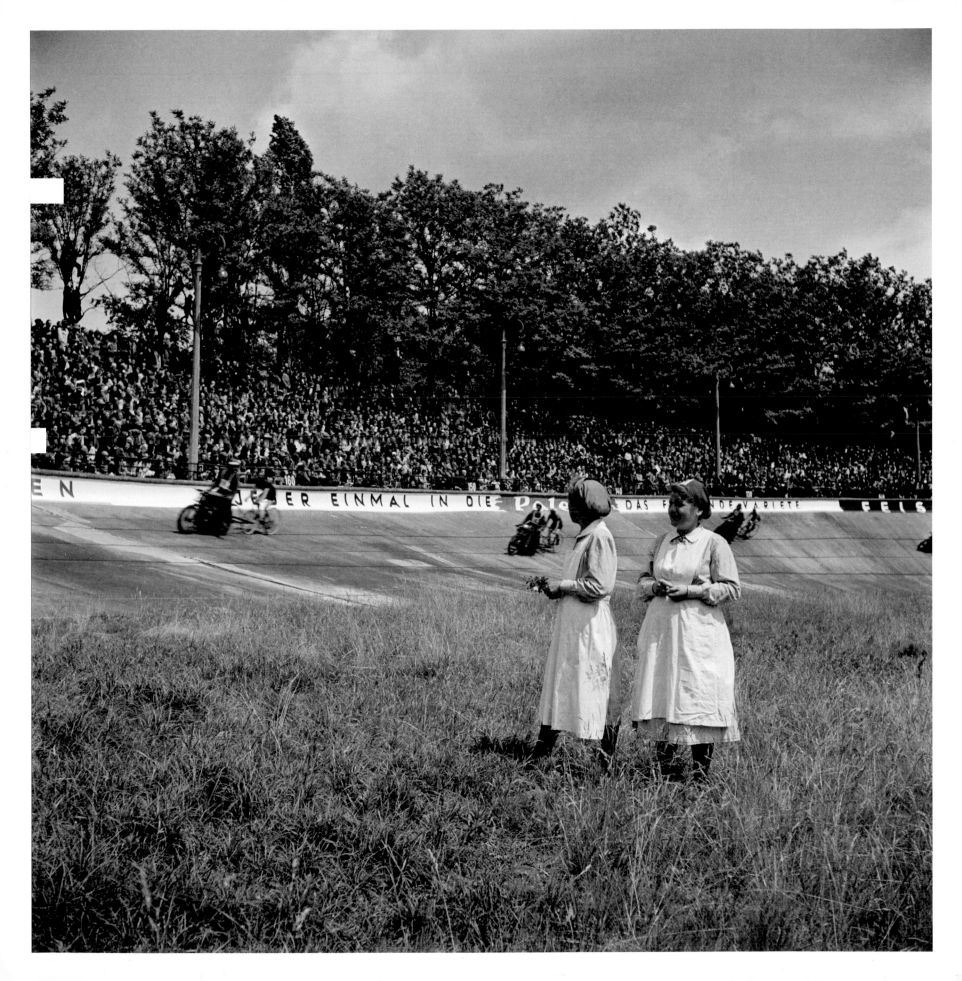

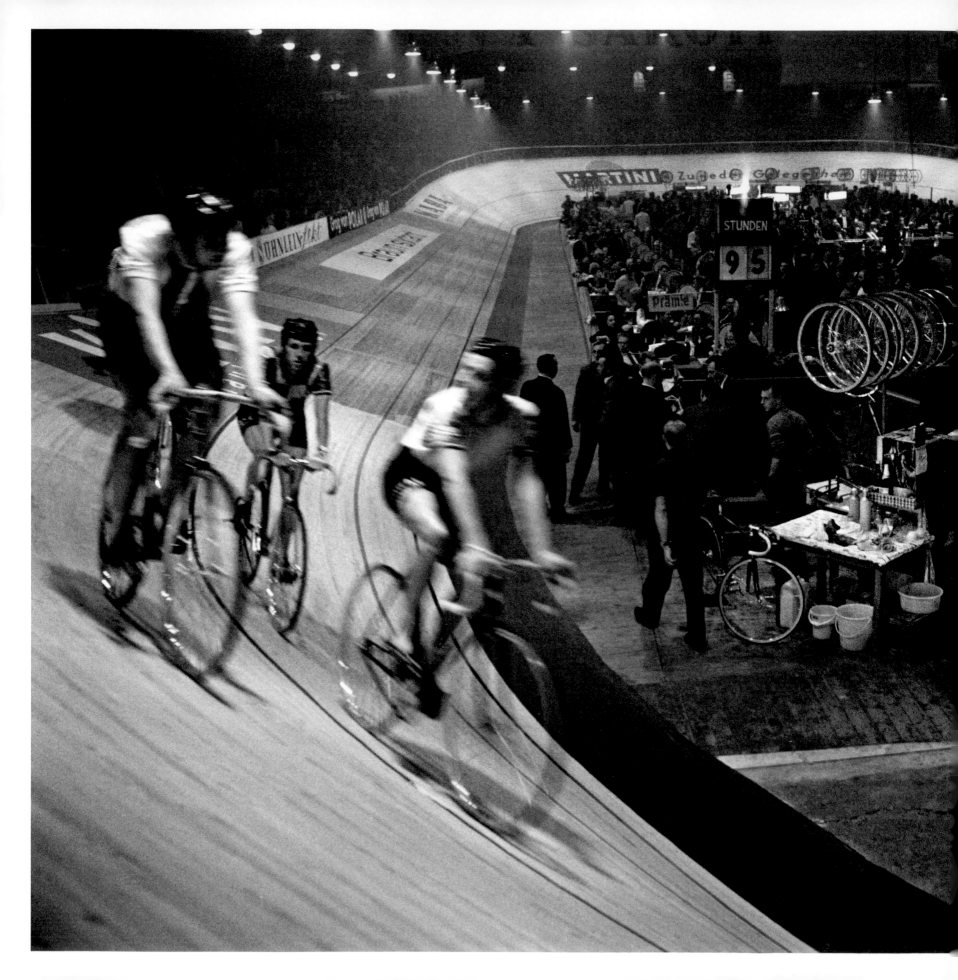

**René Burri**  The 1964 Berlin Six-Day Race was won by Dutch cyclist Peter Post. As can be seen here, the area inside the track was extremely cramped, with little room for the riders' cabins. Being a star rider, Rudi Altig had his cabin right next to the track, enabling the crowd to get a good view of the German as he prepared to race.

**René Burri** Burri's photos of the 1964 Berlin Six-Day Race were taken as part of his project *Die Deutschen* (The Germans). First held in 1909, the Berlin race is the oldest six-day still in operation, with the 2015 edition being the 104th. From 1911 to 1973 the race was held in the Berlin Sportpalast. Then, in 1999, after spending more than twenty years in the Deutschlandhalle, it moved to the Velodrom in the Prenzlauer Berg district of Berlin. Opened in 1997, the Velodrom sits on the site of the former Werner-Seelenbinder-Halle, where the East Berlin version of the race was held. Today, the event continues to attract enormous crowds.

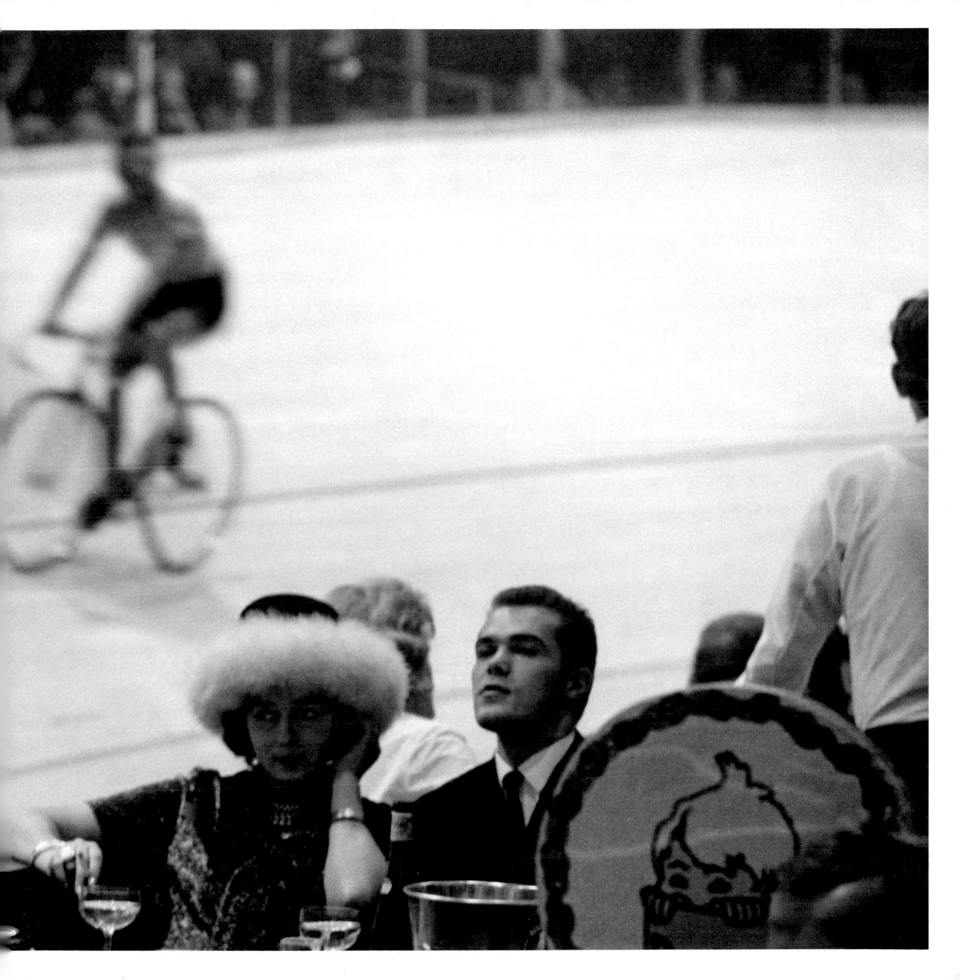

Long before the Tour de France and most of the classic road races came into existence, the track was where it was at. Of the various kinds of track racing, the six-day format is the oldest. It has its origins in the United Kingdom, where, as early as the 1870s, races and endurance events were held in such venues as agricultural halls. Originally, the riders would race for six days non-stop. The format became especially popular in the United States, with the world's top venue for track racing at the turn of the twentieth century being Madison Square Garden. It was here that the idea of having two-man teams, rather than a single rider pushing themselves to near collapse, was born; indeed, the madison, a team-based endurance event, derives its name from the New York venue. In northern Europe six-day racing became particularly popular in the winter, when the road-race season was closed and riders could continue to earn a living at the growing number of indoor tracks.

In the days when six-day racing was all about who was best able to deal with sleep deprivation, riders were known to bend the rules during the night, after the spectators had gone home. The celebrated British cyclist Tommy Simpson, for example, once asked his

*soigneur* (a rider's helper) to dress up as him – with a scarf obscuring his face – and carry on riding his bike through the night. The deception was discovered only when the race's organizer asked the impostor questions in French that he couldn't answer (Simpson spoke the language fluently).

Rules were one thing, but some of the races were fixed in favour of what was known as the 'Blue Train', or star riders – Le Train Bleu being a French luxury passenger train that operated from 1886 to 2003. The racing is also sometimes weighed in favour of local stars; it's not fixed as such – it's not wrestling – but it can be skewed to the advantage of particular riders. Owing to the endurance element of the racing, the taking of amphetamines used to be quite open, especially prior to the introduction of regular drug testing.

Even today, when individual riders actually race for no more than five or six hours at a time, the total distance covered by a single team is still usually more than 1,000 km (621 miles), at speeds of around 50 km/h (31 mph). The as-yet unbeaten record for six days' continuous riding was set in 1914 by the Australian duo of Alf Grenda and Alf Goullet, who rode a total of 4,440 km (2,759 miles) at a six-day race in Madison Square Garden.

As time went by, race organizers realized that having only a single objective – to complete as many laps as possible – was not only totally exhausting for the riders but also a little dull for spectators. Thus, the rules were changed to allow for different types of race within the overall competition, with riders scoring points as the event progressed. The racing became a lot easier to follow, and riders were a lot less likely to fall asleep. They still had to ride all day, but they were able to rest at night and even sleep for a while in small cabins in the centre of the track. Equipped with a mattress, as well as cooking and washing facilities, such cabins made the racing a far more civilized affair. A *soigneur* would prepare food, massage the rider's tired legs and make sure that they were on the track at the right time.

In the post-war period the 'real' racing started later in the day, around 6 p.m., and continued until 2 a.m. the following morning. These timings were intended to appeal to late-night revellers, and the races soon gained a reputation for being smoke-filled evenings of drinking and debauchery. In fact, evening racing grew so popular in the 1950s and 1960s that, eventually, race organizers put a stop to racing around the clock.

In addition to enjoying dinner and drinks while watching some of the best racing of the day, punters at these evening sessions would sometimes be entertained by acrobats, brass bands and, if they were lucky, a leading chanteuse of the day, such as Edith Piaf. Occasionally, the riders would be encouraged to sing too – and would be paid more if they did. Bing Crosby was a regular at the American six-days, and was notably philanthropic in the event of a crash, paying the hospital bills of the injured riders.

During the golden years of six-day racing, there were more than twenty events on the international calendar. Today, only seven major professional six-days remain: Amsterdam, Berlin, Bremen, Copenhagen, Ghent, Grenoble and Rotterdam. While more than fifty cities have hosted a six-day race since the format was invented, some of the better venues, such as Brussels, Antwerp and Paris, sadly no longer stage such events. These days, six-day racing is more family-orientated than it was in its heyday, with an emphasis on entertainment rather than pure racing. And although it's still regarded as part of the professional racer's calendar, only a few of the top road riders now take part.

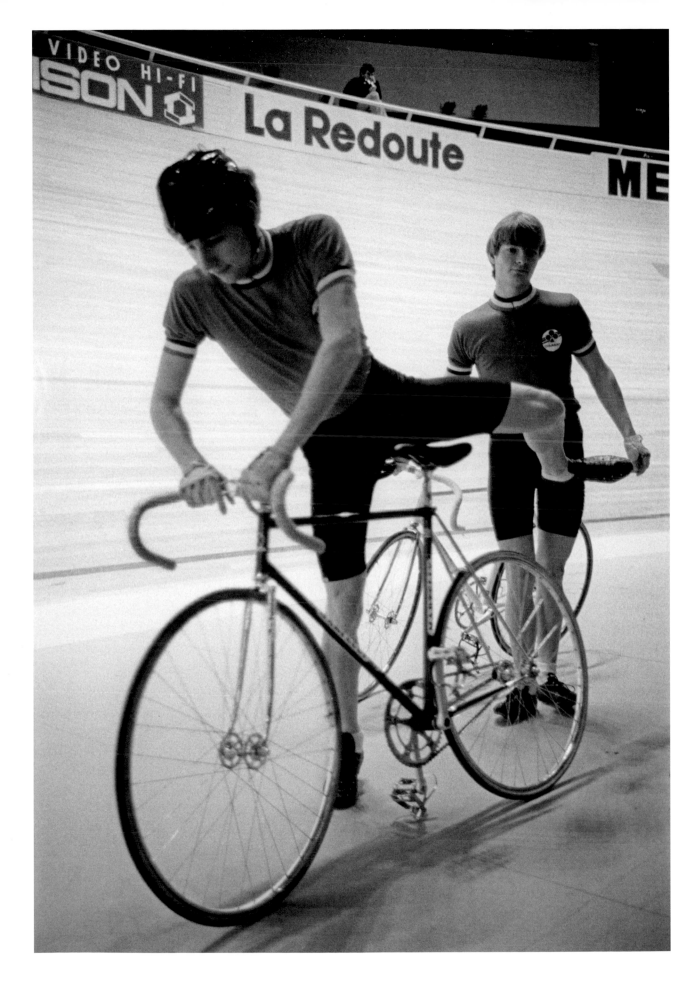

**Martine Franck** Riders at the 1984 Paris Six-Day Race, the inaugural event at the Palais Omnisport de Paris-Bercy. Opened in the February of that year, the Palais Omnisport was built specifically for indoor sporting events and music concerts. The French rock 'n' roller Johnny Hallyday has played the venue, now known as the Bercy Arena, eighty-seven times.

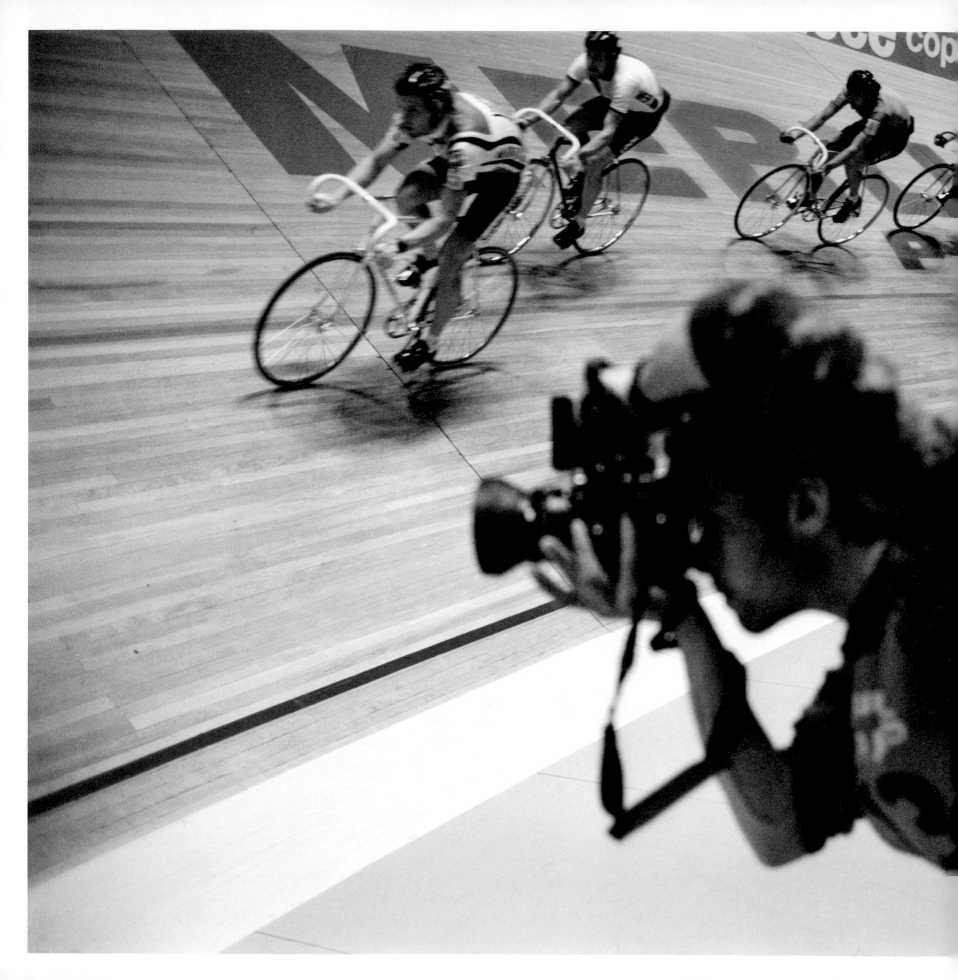

**John Vink**   The 1984 Ghent Six-Day Race. Mechanics at six-day races are mainly responsible for looking after a bike's wheels, as the bikes themselves are relatively simple. Riders do damage bikes, of course, but the frames are built for longevity and strength, so irreparable damage is rare. Tyres, however, need changing regularly, as grip is a key issue when racing at high speed on steeply banked wooden tracks.

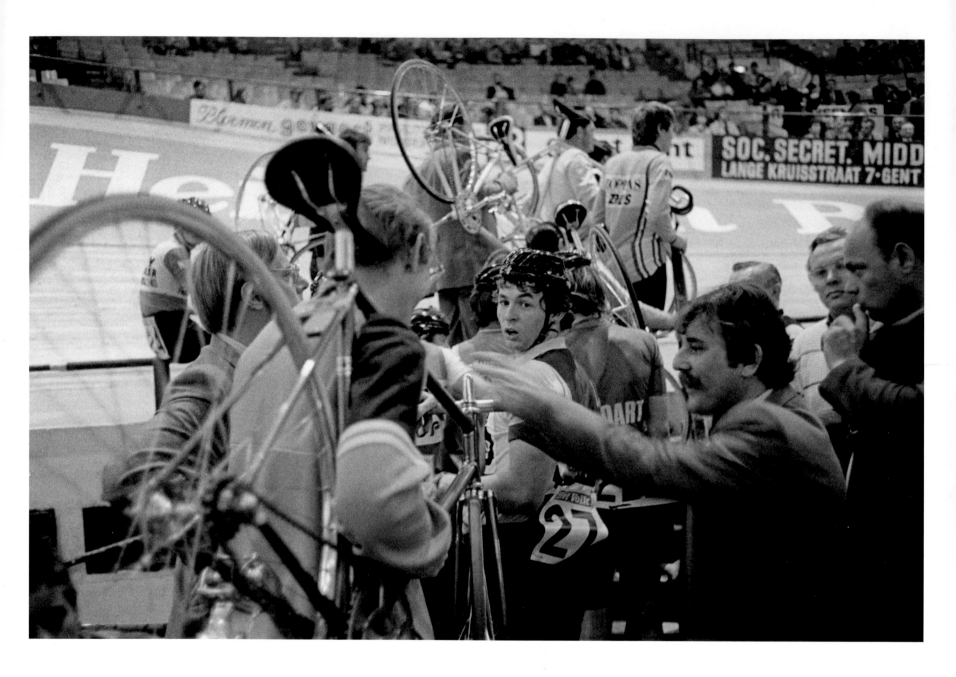

**John Vink**   Riders, *soigneurs*
and officials head onto the
track at the start of an evening
session at the 1983 Ghent Six-
Day Race. As with any race,
the early skirmishes in six-
days are fast and furious,
so riders often feel the stress
of the action ahead.

**John Vink** The Ghent Six-Day Race is one of only seven professional six-day races still held today. It is also one of the best attended, with the crowd at its largest in the hours before midnight, when the racing action really hots up.

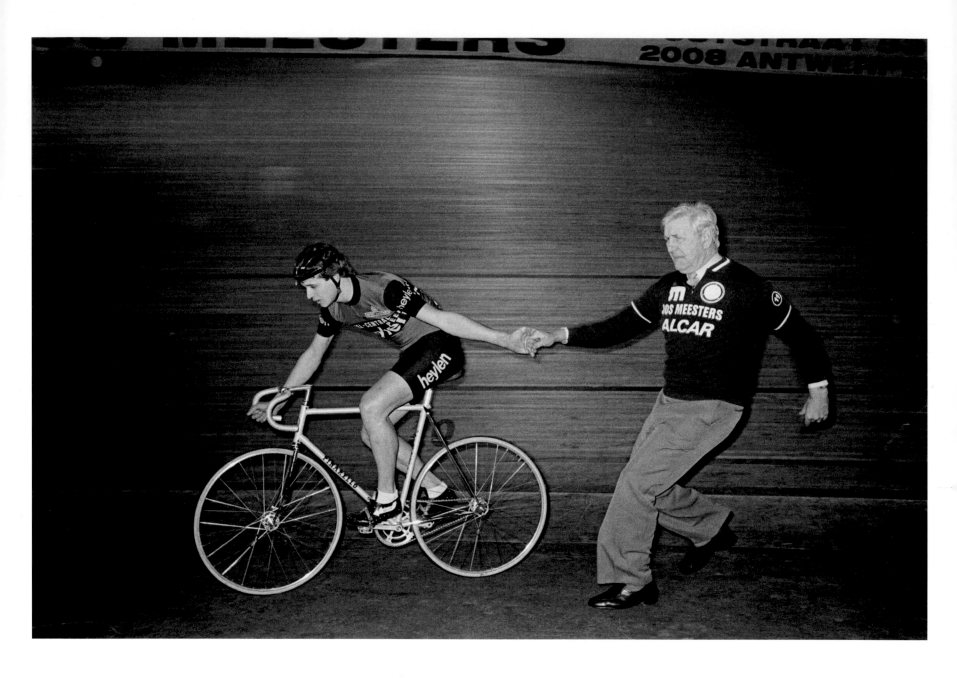

**John Vink** Antwerp,
12 February 1984: How do you
stop when you have no brakes?
Although riders will spend
a couple of laps slowing down
gradually before 'coming in',
a helper at the side of the track
will act as an anchor to bring
them to a complete halt.

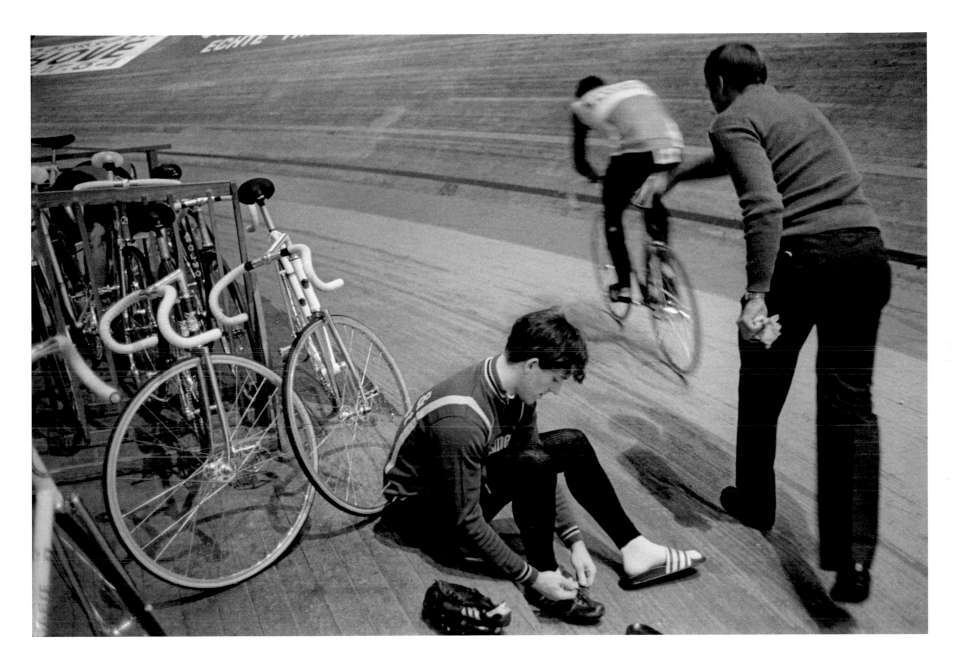

**John Vink** Ghent,
23 November 1984: A rider
is pushed into the action by
a *soigneur*. Because the single,
fixed gear on the bikes tends
to be quite high – to suit the
fast speeds of the track – the
pedals are very hard to turn
from a standing start.

**John Vink** Antwerp, 12 February 1984: Like other forms of motor-paced cycle racing, six-day races use motorbikes, or dernys, to set the pace. Here, three pacing riders make ready for the action. The leather suit worn by each rider helps create a slipstream for the cyclist behind them.

**John Vink** Antwerp, 12 February 1984: Pacing riders also wear special helmets with rear-facing ear holes in the sides, so that they can hear the cyclist's instructions. Although noisy, the motorbikes add excitement and speed to the whole spectacle.

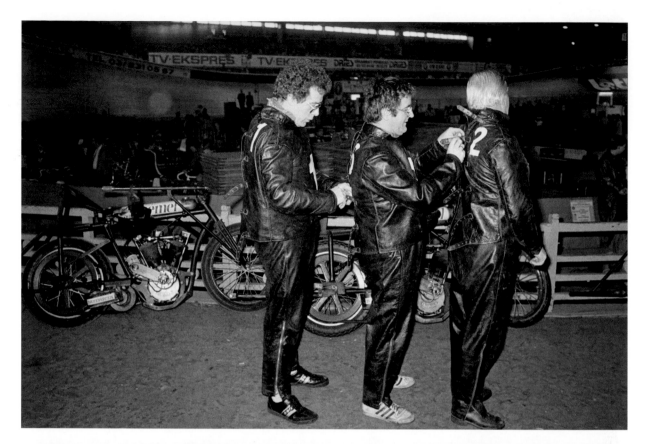

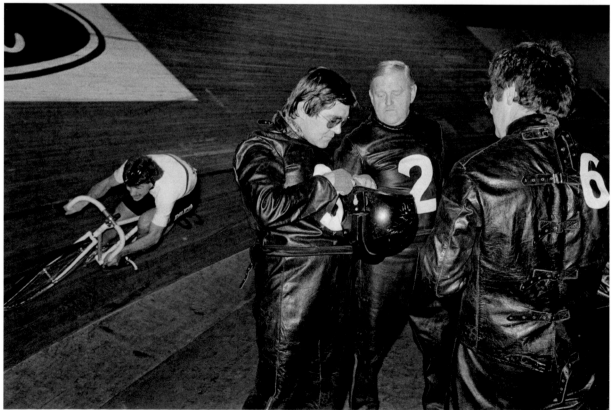

**John Vink**  A view of the track tunnel at the 1983 Ghent Six-Day Race. Such tunnels provides riders, *soigneurs*, mechanics and officials with access to the centre of the track when the racing is on. The gladiatorial references around six-day racing are many and significant.

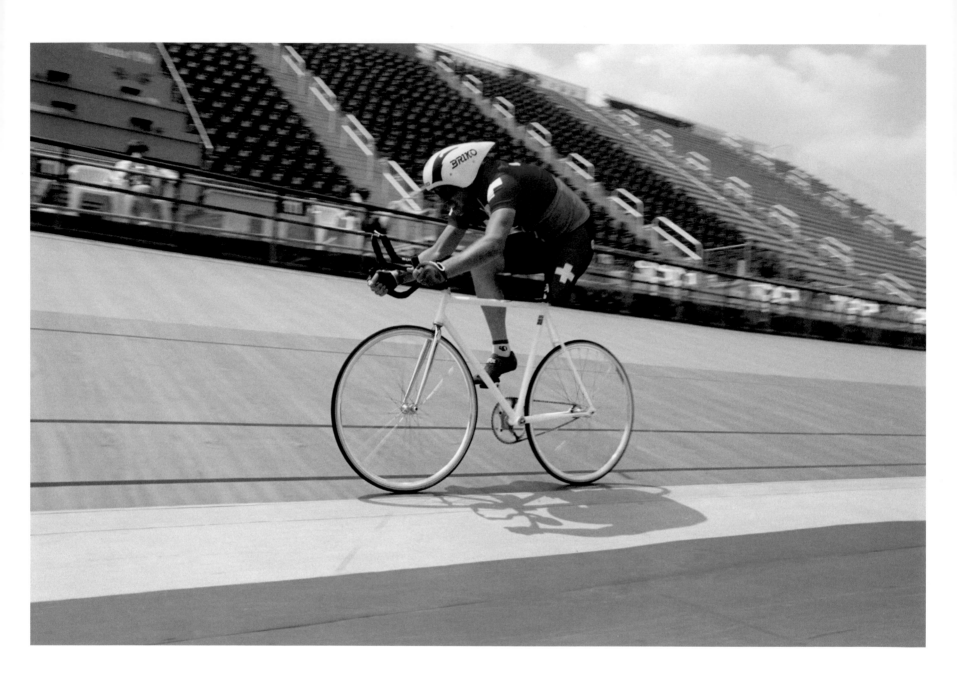

# CHRIS STEELE-PERKINS
## 1996 ATLANTA PARALYMPICS

**The important thing in life is not to triumph but to compete.**
—*Pierre de Coubertin*

Held in Rome in 1960, the first official Paralympic Games were centred around wheelchair sports: track and field, archery and some weightlifting. Cycling was not included. Over the following decades, however, the trailblazers for disabled sport pushed for equality, and by 1996 the Paralympics featured a full programme of Olympic events. Cycling had been a sport at the Olympics since the early days of the Games' modern era, so when the International Olympic Committee decided to broaden the appeal of the Paralympics, cycling became a central discipline.

For many years the Paralympics were seen as secondary to the Olympics, and it wasn't until 1988, in Seoul, that both events were held in the same city, using the same facilities. The 1996 Paralympics, in Atlanta, Georgia, were the first to be televised live and, as a result, the first to attract decent levels of commercial sponsorship. The movement had started to build up momentum: media interest was growing, the athletes were beginning to gain recognition, and a Paralympic medal had begun to mean something. In Atlanta, the Games were attended by some 400,000 spectators; for the 2016 Games in Rio de Janeiro, organizers estimate sales at 3.3 million tickets. With the international television audience for London 2012 numbering 3.4 billion, the Paralympics are quickly becoming big business.

In 1996 the British photographer Chris Steele-Perkins travelled to Atlanta, rented an apartment and set about covering the Games. The photographs he took are extraordinary. He covered several different sports and had little trouble photographing the participants up close, something that would have been extremely difficult at the Olympics a few weeks earlier. As Chris acknowledges himself, being able to get so close to the athletes was just one of the benefits of being an 'unofficial' photographer.

'I wasn't actually working for anyone', he explains. 'I figured that going to the actual Olympics would be a nightmare for a photographer, even if you get permission, which is a huge "if". And if you do get accreditation, you get herded into boxes far away from the action. So if you don't have a stupidly long lens, you're screwed.

'I'm not a sports photographer at all, but I am interested in sport as a part of culture. I'd done stories before on disability sports, and also on boxing and sumo, and I did a story with the *Observer* in 1992 on athletes preparing for the Paralympics, so I had some experience of shooting sport. But it was mostly curiosity.

'[The athletes at Atlanta] were in their own world, so you didn't sit down for dinner with them or anything. You'd talk to them and they wouldn't tell you to bugger off, and so it allowed you to take your pictures. It was all rather pleasant really. I stayed in an apartment nearby and just covered what was on that day and what I thought was interesting.

'And anyway, I thought that the Paralympics would be more interesting than the Olympics. They were certainly far more relaxed, and I was able to wander around from venue to venue and get close up to what's going on, rather than picking things off with a telephoto lens.'

The Swiss cyclist Beat Schwarzenbach competes at the Stone Mountain Velodrome in Stone Mountain, Georgia, during the 1996 Atlanta Paralympics.

In 1996 most prosthestic limbs used in disabled sports were versions of those used in hospitals. It would be another few years before carbon fibre transformed the world of prosthetics.

Atlanta 1996 was the first time that Beat Schwarzenbach (left) had competed in the Paralympics. Four years later, at Sydney, he would win a gold medal in the Mixed Individual Pursuit LC3, setting a world record at the same time.

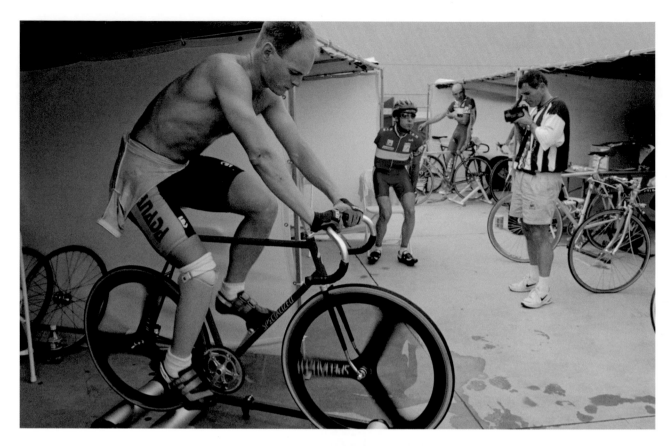

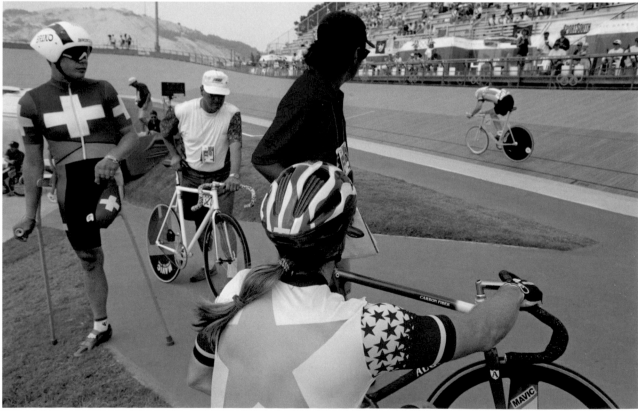

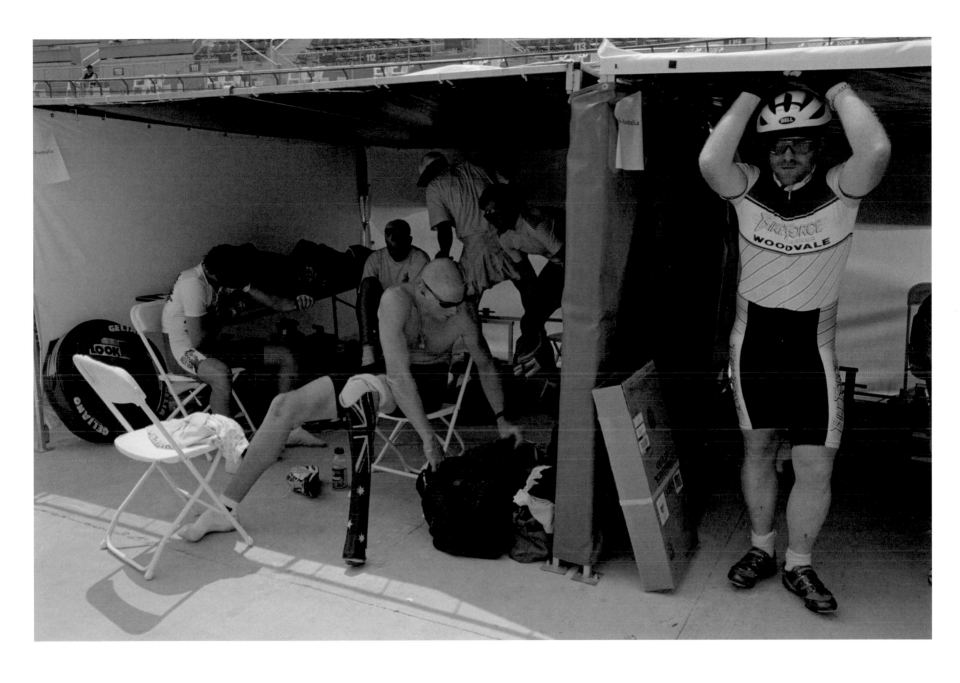

The Paralympics are now the
second biggest sporting event
in the world, the Olympics
being the biggest.

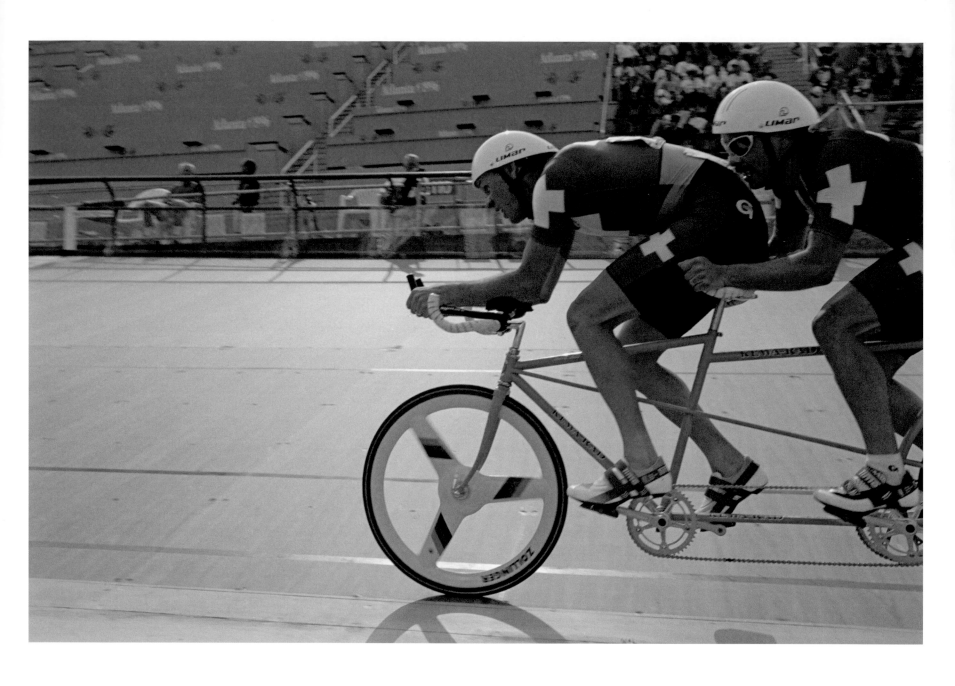

Tandem para-cycling, where
a sighted rider pilots the
bike from the front seat,
has enabled blind cyclists to
compete at the highest level –
and at the highest speeds.

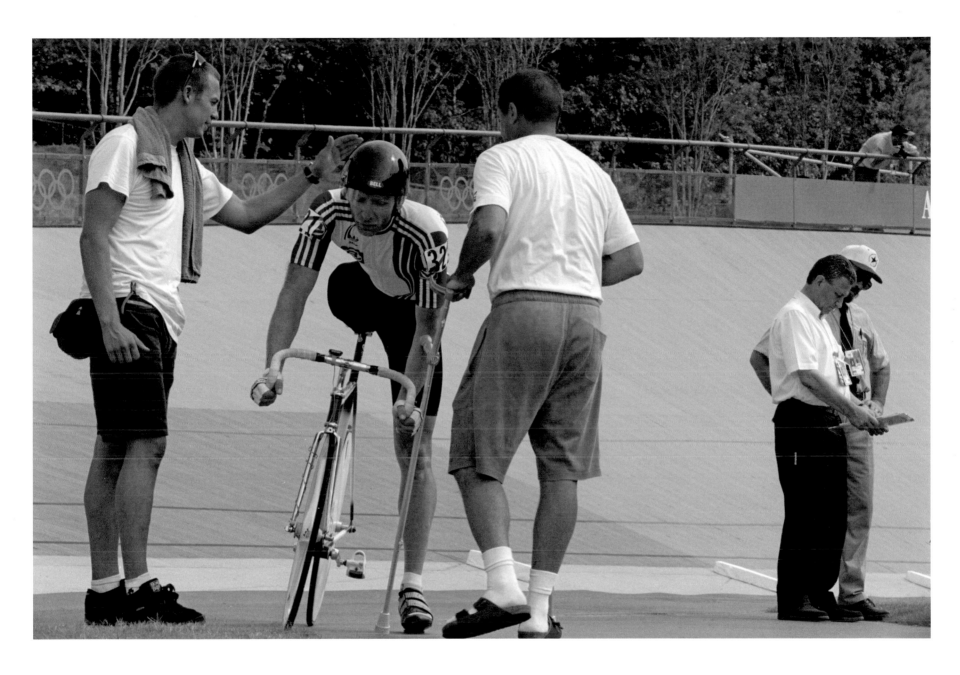

In 1996 there was little
specialist equipment available
to amputee cyclists. Bikes were
modified versions of standard
track-racing machines, with
the athletes making their own
supports and adaptations.

*Below*
In tandem para-cycling, the 'captain' or 'pilot' is often a former able-bodied racer, and the competition can be fierce. Atlanta 1996 saw the Australian duo of Eddy Hollands and Paul Clohessy win the 4,000-m tandem pursuit in 4 minutes and 35.987 seconds.

*Right*
The TV and media coverage of the Atlanta Paralympics opened up a new era of commercial sponsorship, enabling the Games to grow in terms of both audience and participation. In 1996 the Paralympics consisted of nineteen different sporting events contested by around 3,300 athletes. In Rio in 2016, nearly 5,000 athletes will compete in twenty-one different sports.

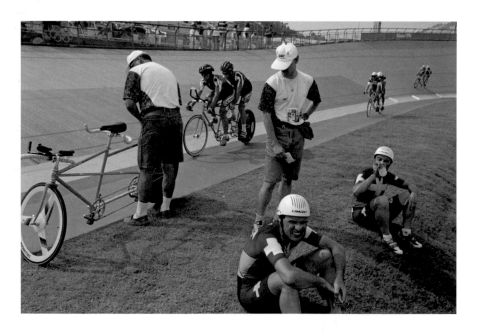

STEELE-PERKINS: PARALYMPICS

**We cannot develop and print a memory.**
*—Henri Cartier-Bresson*

Henri Cartier-Bresson always thanked his camera, saying that, without it, 'These images would have remained buried in an unreliable memory.' Indeed, he regarded his camera as his diary, taking it everywhere he went – including the velodrome. Although Cartier-Bresson's name might not be the first that comes to mind when thinking of sports photographers, the velodrome is in many respects the ideal subject for reportage and documentary photography, with the crowds providing just as much interest as the racing whirling around you. And unlike the Tour de France, you are permanently at the centre of the action. So it was that ten years after starting Magnum Photos with Robert Capa et al., Cartier-Bresson wandered into the Vélodrome d'Hiver in Paris, camera in hand.

A night out at the Vél d'Hiv, as Parisians knew it, was an evening full of social extremes – the seated diners eating oysters and drinking champagne contrasting with the late-night drinkers standing in the centre of the track swigging beer and wine from the bottle. It certainly wasn't a quiet night out. The social divisions among the spectators led to regular bouts of rowdiness, with bottles, food and other objects often being thrown from the stands. Indeed, the venue's owners had to install nets over the track to prevent any missiles from interrupting the racing. In many ways an evening at the Vél d'Hiv wasn't actually about the racing – to some it was merely a distraction – but together with the antics of the crowd, the gambling and the track-side entertainment, it provided a rich canvas for Cartier-Bresson and his camera.

The Vél d'Hiv attracted not only photographers but also writers. Ernest Hemingway, for example, was a frequent visitor in the 1920s, writing of 'the smoky light of the afternoon and the high-banked wooden track and the whirring sound the tyres made on the wood as the riders passed, the effort and the tactics as the riders climbed and plunged, each one a part of his machine' (*A Moveable Feast*, 1964). Other notable fans of cycle racing included Henri de Toulouse-Lautrec. In addition to working on several advertising posters for bicycle firms, including the Simpson Chain company, the French painter, printmaker and draughtsman could often be found sketching the racing at the Vélodrome Buffalo in the western Parisian suburb of Neuilly-sur-Seine. Although six-day racing was yet to start in earnest, Toulouse-Lautrec's enthusiasm for the new sport of cycling was certainly significant in bringing it to the attention of a wider audience.

By the time Cartier-Bresson visited the Vél d'Hiv in 1957 for that year's Paris six-day, the velodrome was looking rather run-down, with a roof that leaked when it rained. Despite the dilapidated state of the venue, the race itself was well attended, thanks in large part to the participation of national heroes and Tour de France winners Jacques Anquetil and Louison Bobet. Adding considerably to the excitement was the fact that the two rivals were racing against each other. Among Anquetil's support riders were French road sprinter André Darrigade and Italian track specialist Ferdinando Terruzzi, while Bobet's team included French track-racing stars Georges Senfftleben and Dominique Forlini.

After a few nights of chasing the lead, Anquetil's team eventually emerged the winners. The racing was

# HENRI CARTIER-BRESSON
# 1957 PARIS SIX-DAY RACE

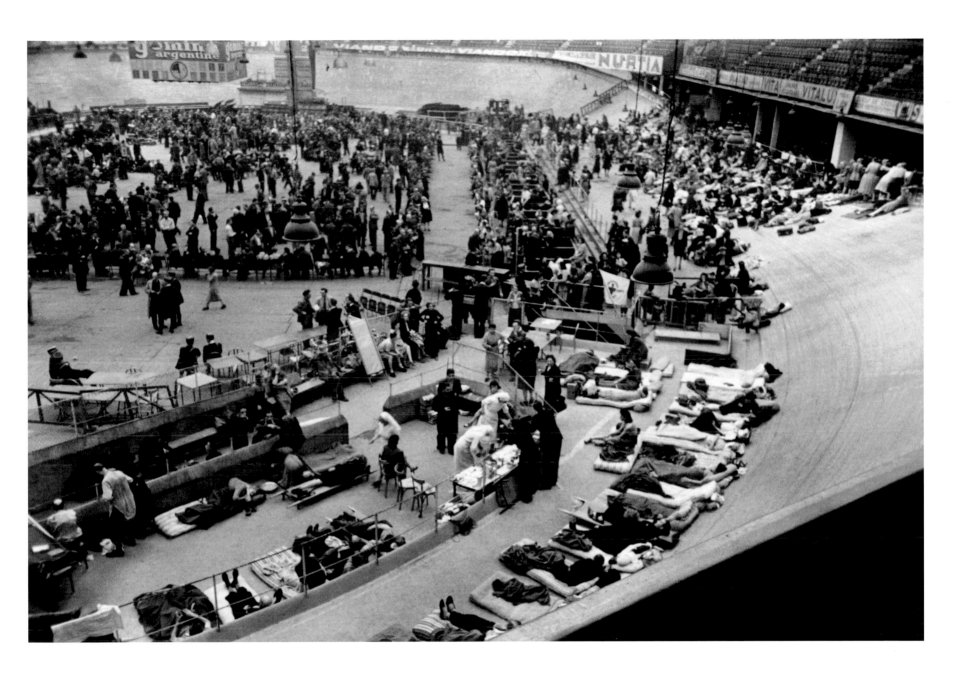

Some twelve years before attending the 1957 Paris Six-Day Race at the Vél d'Hiv, Cartier-Bresson had visited the velodrome shortly after the liberation of Paris by the Allies. At that time, the venue was being used as a makeshift prison for collaborators.

fast and furious. It was also entertaining, although a fair amount of play-acting went on. Bobet's team came second, with the rest of the field made up of regular track-racing stars and a smattering of foreign road champions. The latter, needless to say, were paid appearance money to play the pantomime villains: if a Belgian team had been allowed to win, for example, the spectators would have demanded a refund.

The Vél d'Hiv itself, however, had a more serious, chequered past. It was cold and draughty in the winter and hot and stuffy in the summer, so it often struggled to make money. As a result, the owners allowed anyone in to do whatever they liked as long as they could pay the rental fee. Most notably, it served as a venue for a series of political rallies, which varied in both scale and political persuasion. In 1936, for example, Dolores Ibárruri – the firebrand leader of the Spanish Republicans known as La Pasionaria – gave an electrifying speech in support of the struggle against fascism. At the other end of the spectrum, and notwithstanding Ibárruri's powerful anti-fascist message to the French nation, the Vél d'Hiv was also hired by the French fascist Jacques Doriot, who used the venue in the pre-war years to rally support for his Parti Populaire Français (PPF). A few years later, members of the PPF would be key players in one of the most notorious events in the Vél d'Hiv's history.

In mid-July 1942 French police, assisted by some of Doriot's followers, rounded up and arrested more than 13,000 Jewish men, women and children in a Nazi-directed operation codenamed 'Spring Breeze'. More than half of those detained were held in the Vél d'Hiv, giving rise, therefore, to the common name for the operation: the Vél d'Hiv Round-Up. Inside the building, conditions quickly became unbearable, with rising temperatures, no fresh air or access to the lavatories, and limited supplies of food and water. Most of the detainees were held in the Vél d'Hiv for five days before eventually being transported to German extermination camps. It is said that, of those interned at the Vél d'Hiv, only 400 survived the war.

Such events reflected badly on the Vél d'Hiv's owners. At the time of the round-up, the track was owned by Jacques Goddet, chief reporter at *L'Auto* and long-time director of the Tour de France. Goddet had taken over from the venue's original owners – his father, Victor, and Henri Desgrange – who had opened the track in 1903. The circumstances under which the Germans had obtained the keys to the building have never been made entirely clear, and the round-up merits only a passing reference in Goddet's own memoir. In a bizarre twist of fate, during the Allied liberation of Paris in 1945, Nazi collaborators were rounded up themselves and held, albeit in slightly more humane conditions, in the very same building.

After the war, the Vél d'Hiv briefly returned to hosting leisure pursuits. But, as the writer Jack Thurston explained in an article for *Rouleur* magazine, it was the beginning of the end for the venue:

In the years it was open, the Vél d'Hiv staged such events as cycle racing, ice hockey, wrestling, boxing, basketball, the Olympic Games of 1924 as well as bullfights, roller-skating endurance events and a sad spectacle in which a hundred circus lions were imported for a bizarre show billed as a lion hunt. Much to the displeasure of the American promoter Jeff Dickson, the lions turned out to be entirely un-ferocious and lay about sleeping. He ordered stagehands to attempt to arouse them by beating them with sticks, at which point children in the audience began to cry and parents shouted angry protests. The lions were led out of the arena and replaced by a number of camels that refused to walk in a line as Dickson had envisaged. The animals were eventually sent to a zoo near Hamburg. In 1959 a fire destroyed part of the building and the rest was subsequently demolished. In a final night's performance on 12 May 1959, the surrealist artist Salvador Dalí exploded a scale model of the Eiffel Tower, a crowning absurdity in the history of an arena that had for years been the biggest indoor assembly space in France.

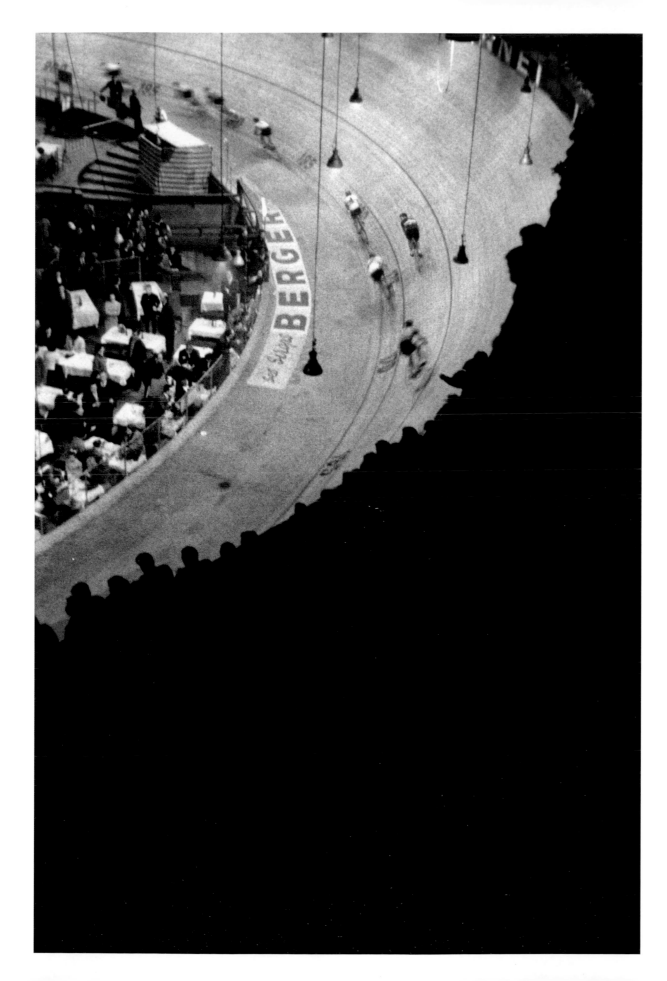

Although cheap, the stands at the Vél d'Hiv were basic, poorly lit and provided an awful view of the racing. The best place from which to see, and in which to be seen, was the dining area in the centre of the track.

The racers' cabins were close to the action; those belonging to the star teams displayed the names of the individual riders, so that the fans could keep an eye on their favourites. The dotted line on the track indicates the safety zone. Crashes were frequent and added to the excitement.

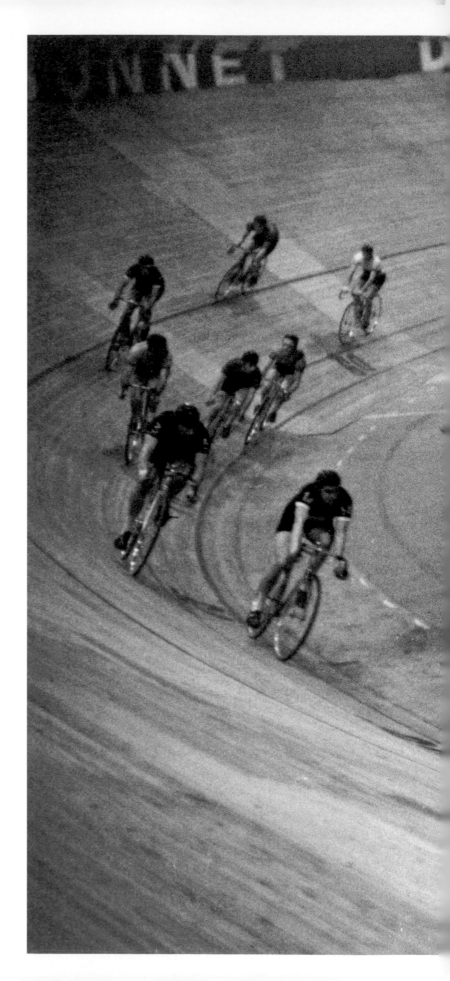

CARTIER-BRESSON: PARIS SIX-DAY

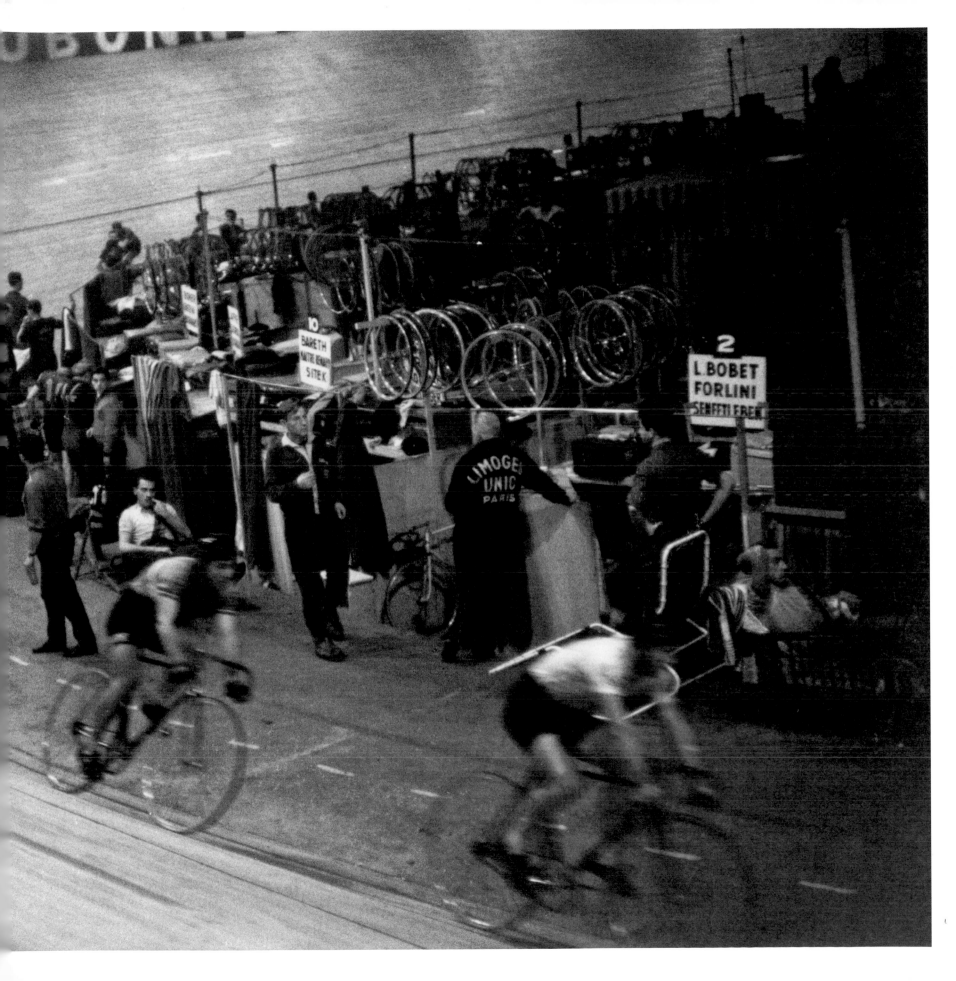

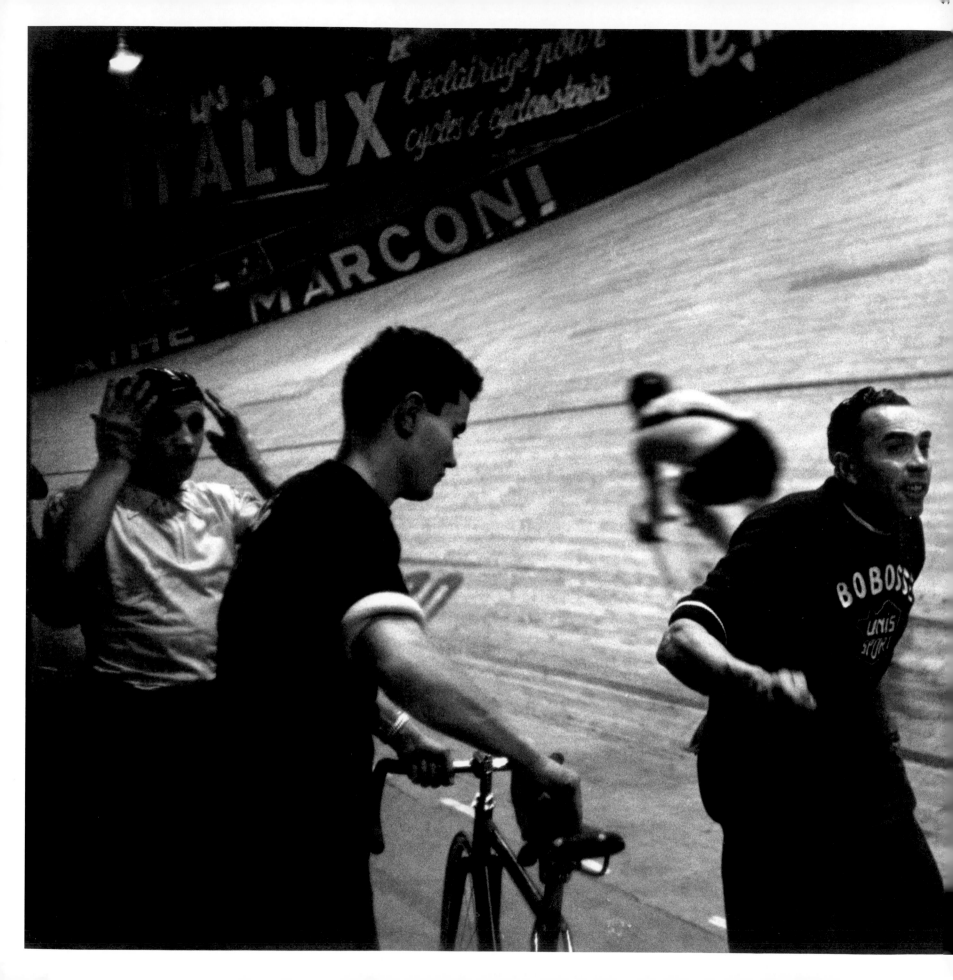

It's hard to appreciate the steepness of the banking until you are standing next to the track. Indeed, in the early days of banked tracks, it was not uncommon for inexperienced riders to fall off.

With the racing taking place over six days, many spectators would simply pop in on their way home – some of them via the boulangerie – to see who was in the lead. However, by 1957, the racing at the Paris six-day was no longer non-stop.

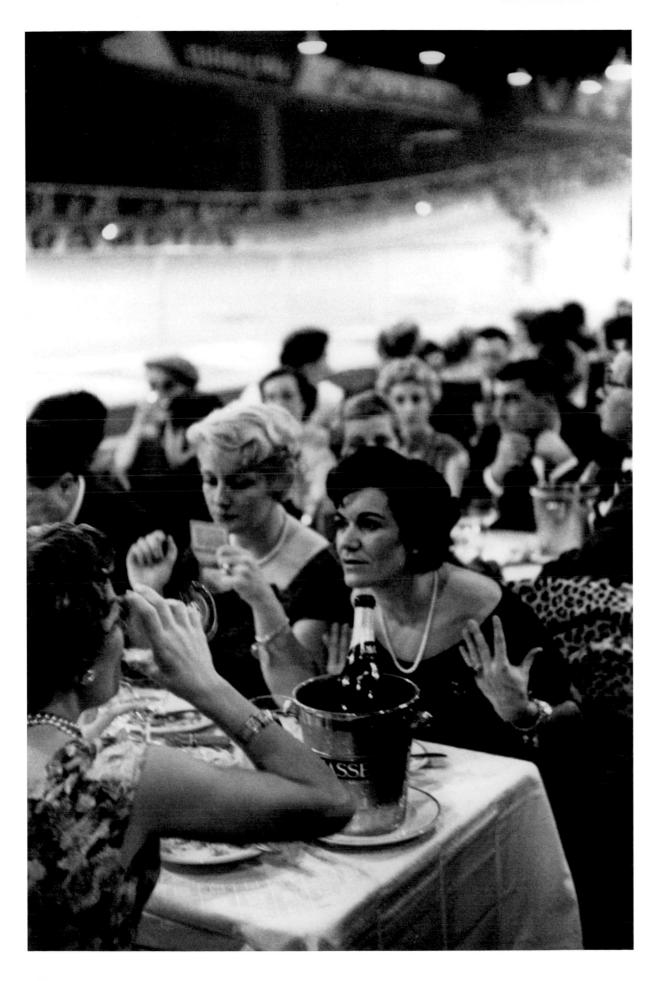

To Parisian high society, six-day racing was much like horse racing in the summer months: a fashionable form of entertainment. It was especially popular in the post-war years, and the slightly rowdy nightclub feel added to its attraction.

It was cold in the Vél d'Hiv during the winter months, so spectators would keep their coats on, dropping in to see the racing at various times of the day.

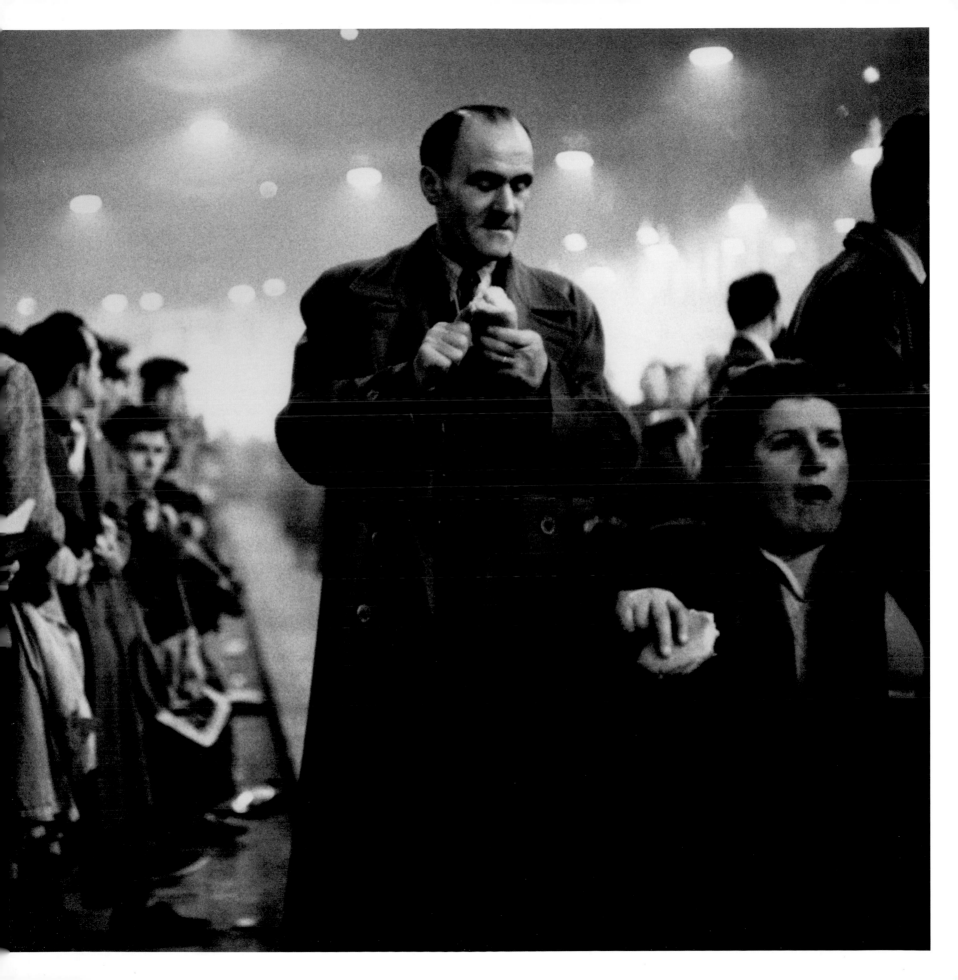

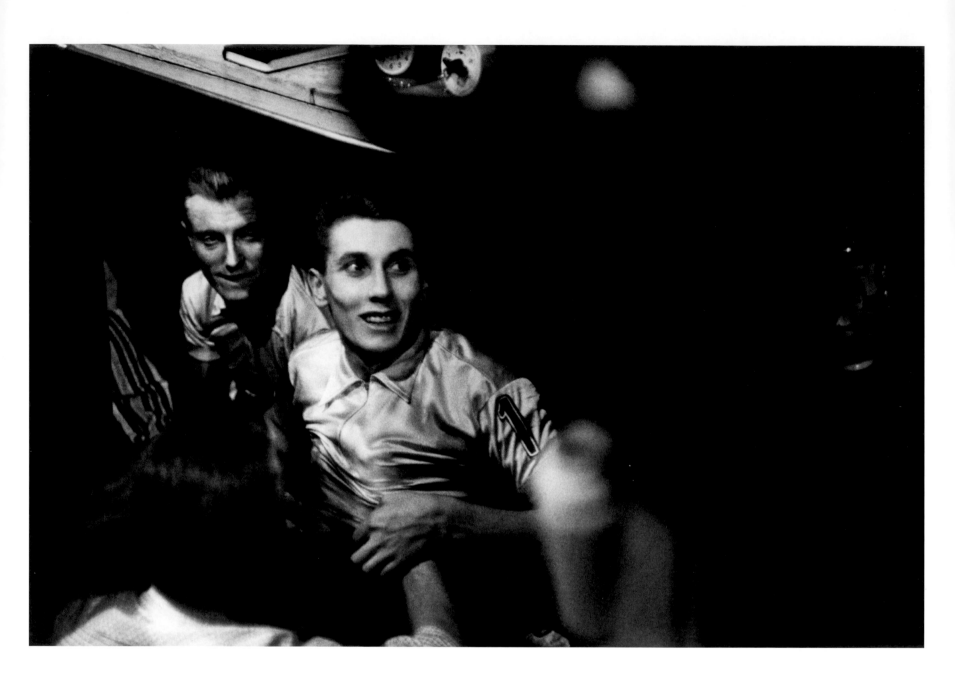

Jacques Anquetil (right) and André Darrigade take a break in their track-side cabin. In addition to winning many six-day races, Darrigade won numerous one-day road races, becoming world champion on the road in 1959. Anquetil won the Tour de France five times, as well as the tours of Spain and Italy. In 1959 he broke the world hour record.

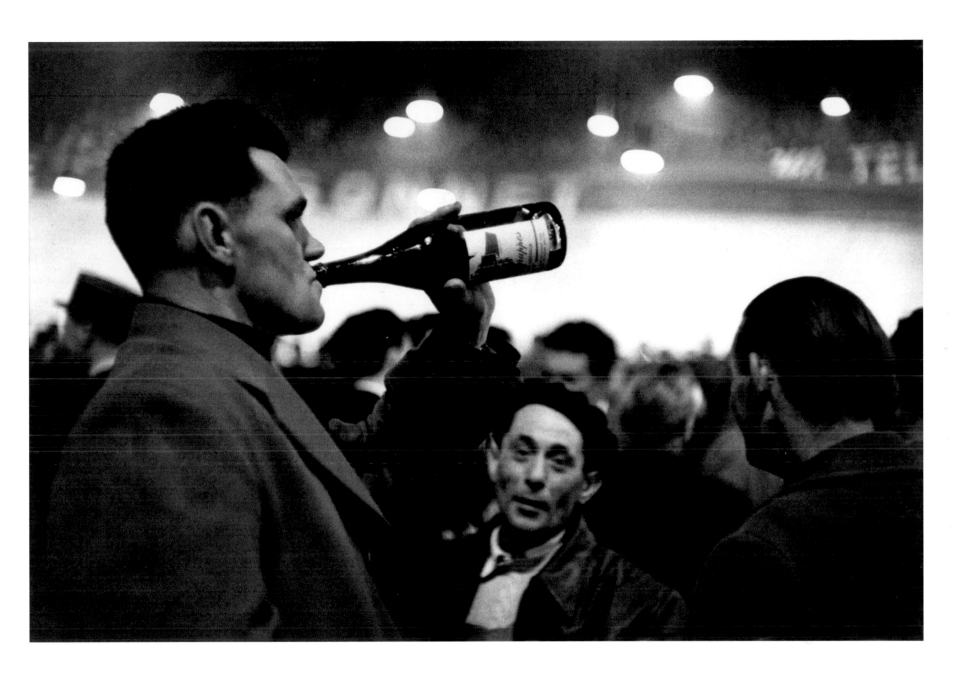

In the first half of the
twentieth century, six-day
racing became synonymous
with heavy drinking. The
booze was cheap and the
venues were always open,
making them ideal places
to meet up with friends for
a wild night out.

The Vél d'Hiv was popular with Parisians of all ages and social backgrounds. It was also popular with the French capital's artistic community. Ernest Hemingway, who lived in Paris in the 1920s, was a regular visitor – not least, perhaps, because there was a nightclub next door that opened once the racing had finished. By all accounts he also found the velodrome a good place to work, and it is said that he started writing *A Farewell to Arms* (1929) in the press tent in the centre of the track.

CARTIER-BRESSON: PARIS SIX-DAY

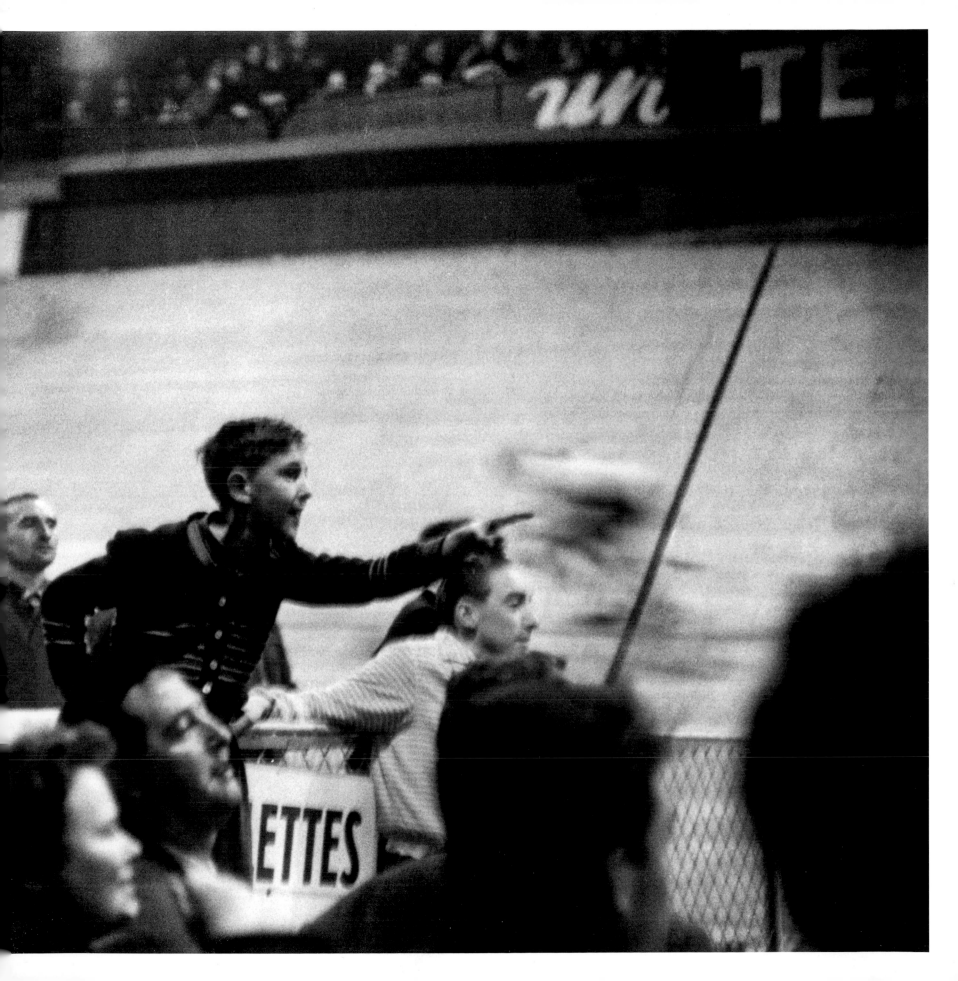

When not racing on the track, six-day riders would make the most of whatever kind of seating they could find. The racing was relentless, but the *soigneurs* made sure that the riders had everything they needed.

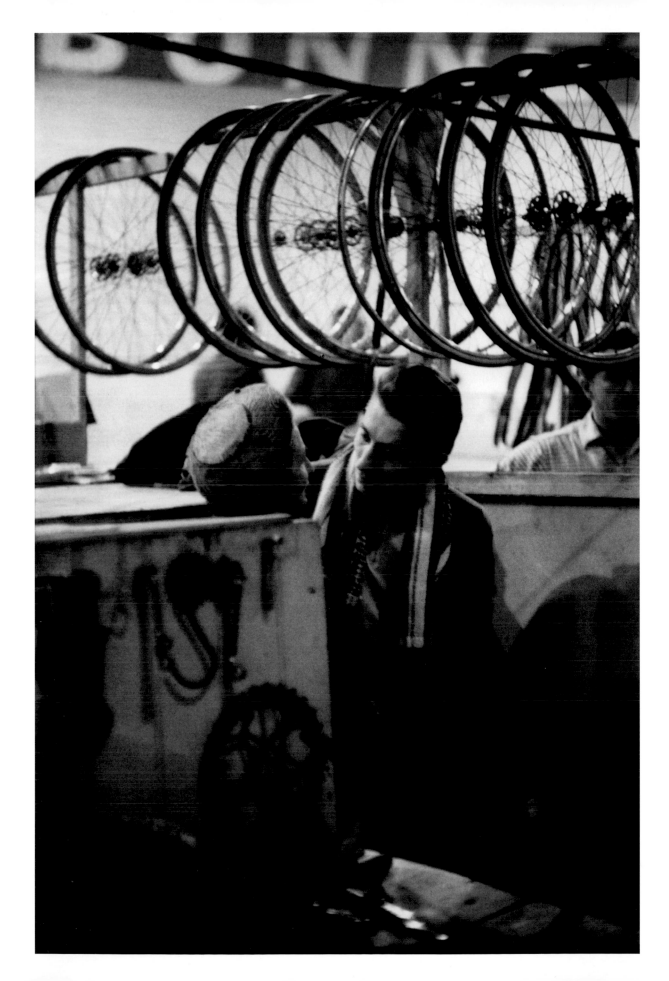

Jacques Anquetil and companion leave for the evening. Wheels were stored above the cabins on joists, where they were easily accessible. With the racing taking place for several hours at a time, they needed to be changed fairly regularly.

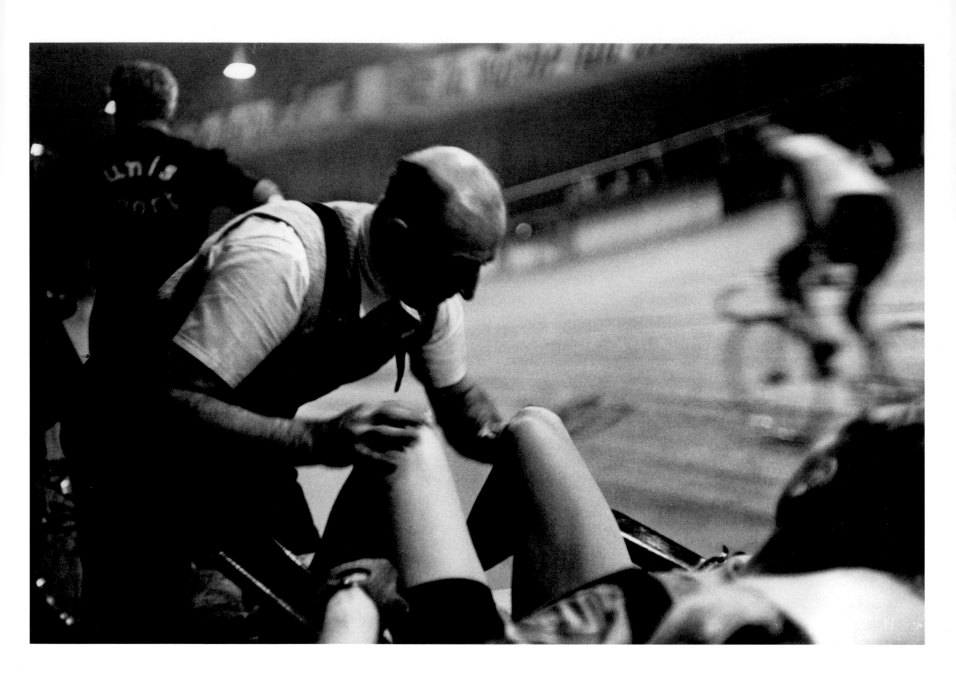

The *soigneur* was a key
member of the six-day team,
helping to prepare the riders
for the next session. Massage
was essential to preventing
aching limbs from seizing up.

CARTIER-BRESSON: PARIS SIX-DAY

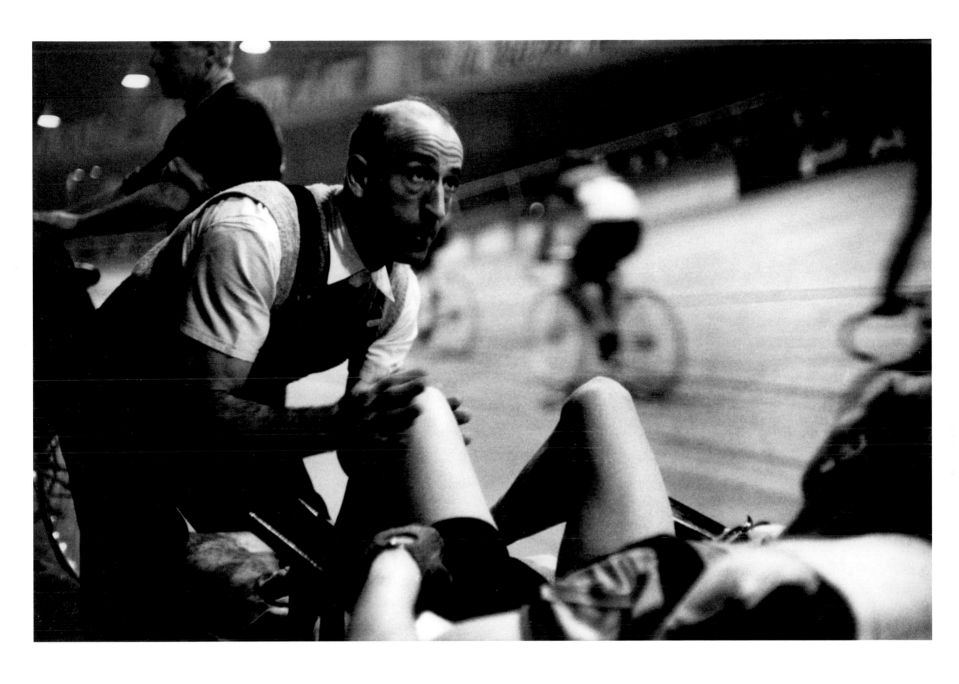

The most exciting point of any six-day race would be the final evening. In order to keep the stands full and the media interested, the racing would usually be kept quite tight up until the last few laps. The MCs for the evening would help build the anticipation.

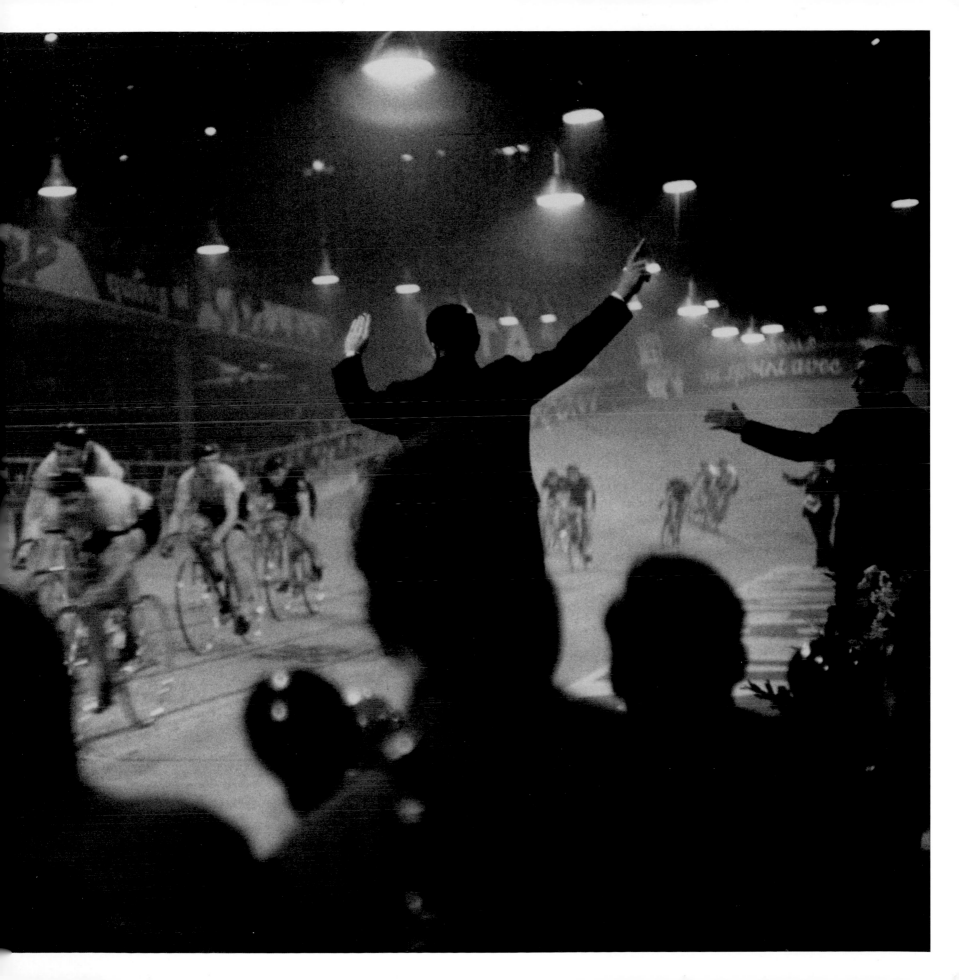

Sleeping at a six-day race was
impossible for the riders when
the racing was at its busiest,
so they would take a nap
whenever they could. Many
riders of the time said that
a six-day event was more like
a sleep-deprivation contest
than a bike race.

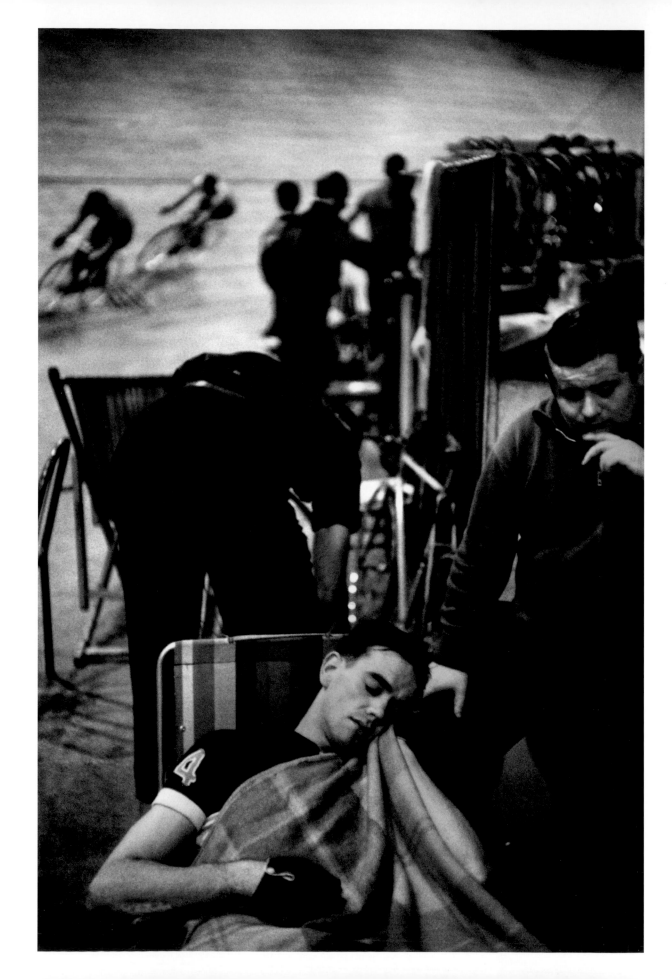

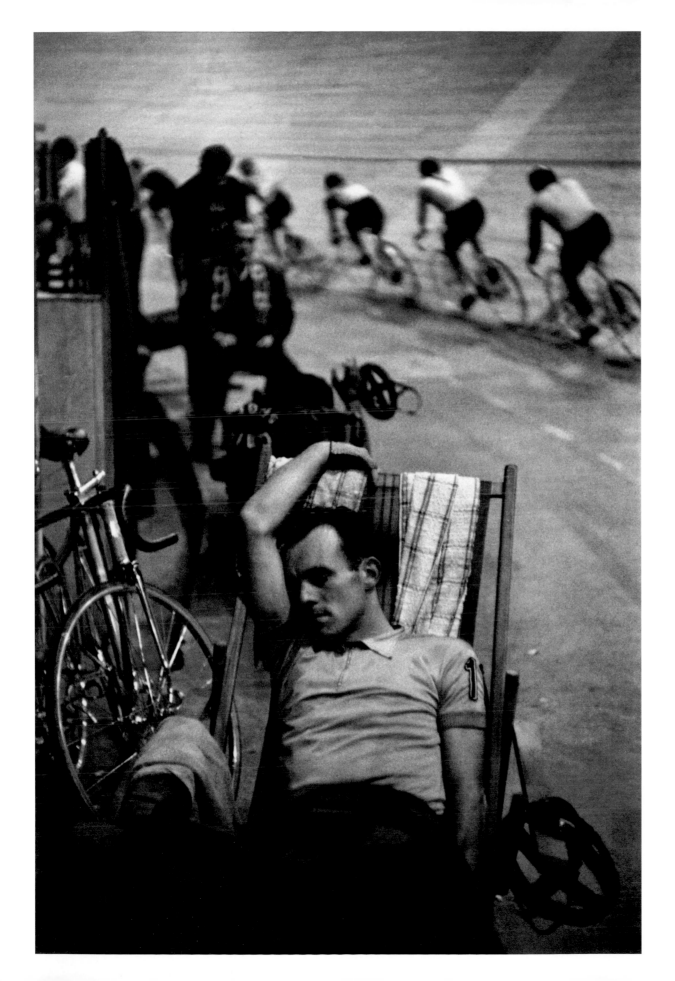

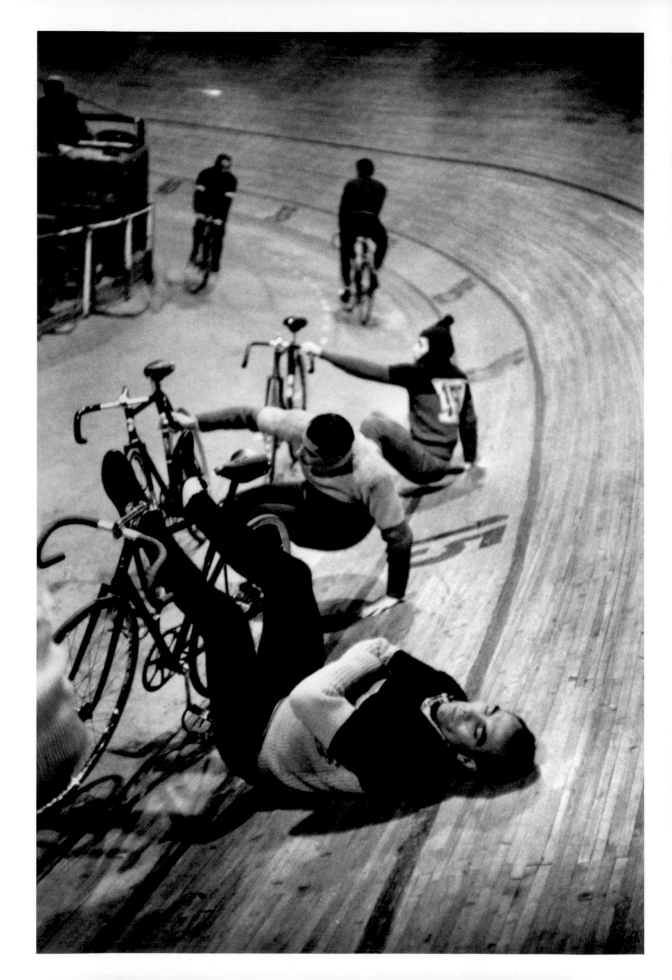

Wrapped up warm against the cold, a group of riders make the most of a break in the action. Six-day racing was a travelling circus of sorts, and the riders all knew one another well.

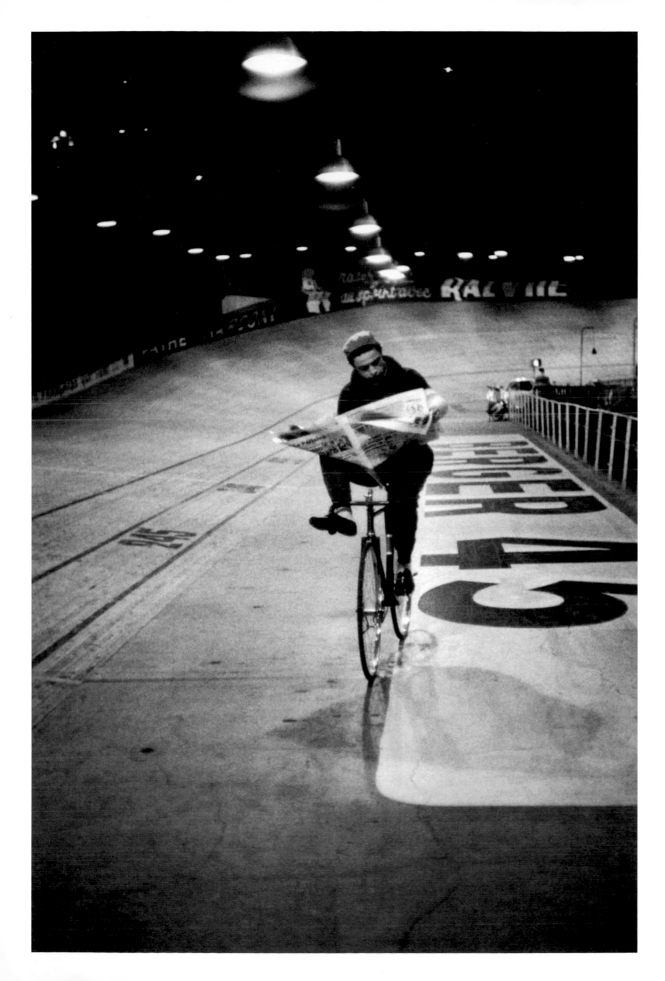

During their downtime, the riders developed some fairly impressive skills. Allegedly, they could even sleep on their bike while riding, if supported by a teammate on either side. Such skills as riding backwards and standing still for minutes at a time were regularly shown off at the track centre.

181

CARTIER-BRESSON: PARIS SIX-DAY

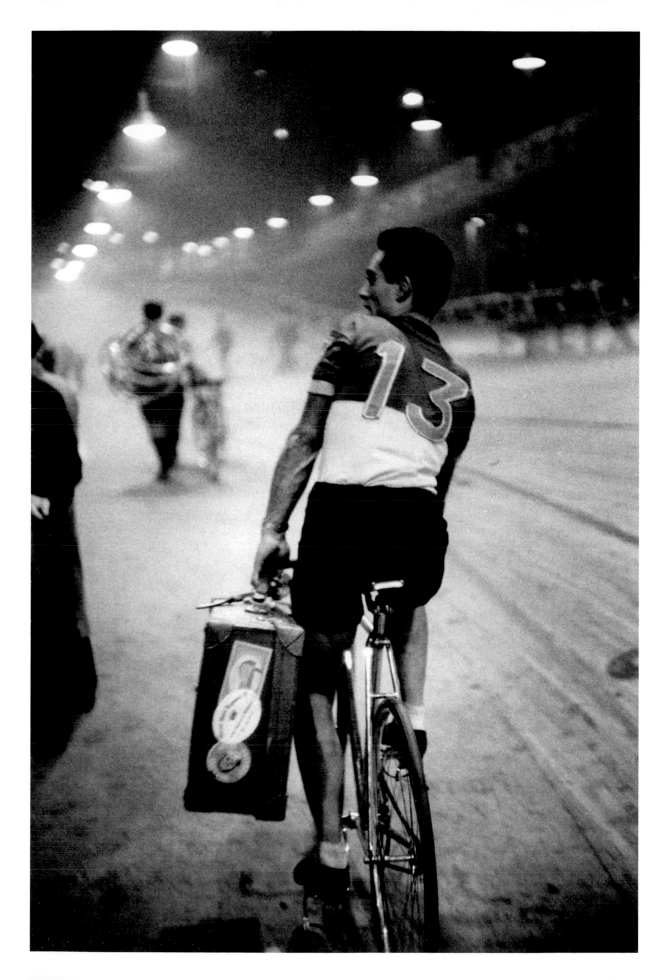

The stars of six-day racing, such as Louison Bobet (pictured) and Jacques Anquetil, would no doubt be staying in a nice hotel nearby. Only the jobbing track-racing professionals would have to sleep in the cabins in the centre of the track. It was a hard way to make a living.

183

# 1985
# TOUR DE
# FRANCE

## JOHN
## VINK

**It distinguishes itself, the Tour de France, from the other stage races – like the Giro d'Italia and the Vuelta [a España]. It cannot be denied; it's the biggest. Because of the richness of its history, of its legends, its mythology. There are more stories connected to the Tour de France – there is more craziness, more beauty and more poetry connected to the Tour de France than to any of the others. It has this long history of great champions, who braved the conditions and who created unforgettable moments.**

**You have your ideas – everybody has an idea of what will happen in the Tour de France – but it's unforeseen what happens everywhere, and it's because the conditions are so tough that they can break riders and they can smash dreams. And that's what we want, we want this uncertainty. The teams want their best people to be in their top shape for the Tour de France because that's the big theatre, that's the big media attention. They come with their secret plans, their own personal schemes. There, you see: it's make or break, for all of them. And that is the beauty of the Tour de France.**
**—*Jørgen Leth***

John Vink followed the Tour de France – the biggest, toughest sporting event anywhere in the world – in 1985. For any photographer or journalist, covering a Tour is a huge undertaking. For one thing, it's a constantly moving circus, never staying in the same place for more than a night, and the early starts and late finishes make it a bewildering existence for all but the hardiest of journalists. And even with a constantly

changing landscape, there's no time to take in the view: just as the Tour is an endurance event for the cyclists, so too is it a test of mettle for those not competing. It's a unique experience, and not much can prepare you for the logistical problems, ever-changing weather and creeping exhaustion that slowly but surely catches up with you as you near the finishing line in Paris. But despite that, it's a blast.

The Tour is a road trip around France where the route has already been decided for you. Which, for a photographer like Vink, must have seemed quite strange. Many of his personal projects stretch over years, not weeks, and see him travelling to the far corners of the globe. He very much decides what he wants to do and where he wants to go. So, when I met up with him at the Magnum offices in Paris, almost 130 contact sheets from his time on 'La Grande Boucle' spread out before us, the first of my questions had to be: how did you end up on the Tour de France?

'It was an assignment from *Libération*, the French daily newspaper – I was still living in Belgium at the time and trying to find ways to work in France. So I went to *Libération* and told them I had two projects I'd like to do. I was working a lot in Italy and I asked to spend a summer there and give them one picture a day about Italy. They said, "Interesting, but why not do the Tour de France instead?" because I had also shown them the Tour pictures I had taken in Belgium. So I ended up following the 1985 Tour de France.'

It must have been quite an adventure, travelling round the French countryside chasing the world's biggest bike race.

'Yes, but you don't have any time to appreciate it. You rarely have time to appreciate the scenery, the

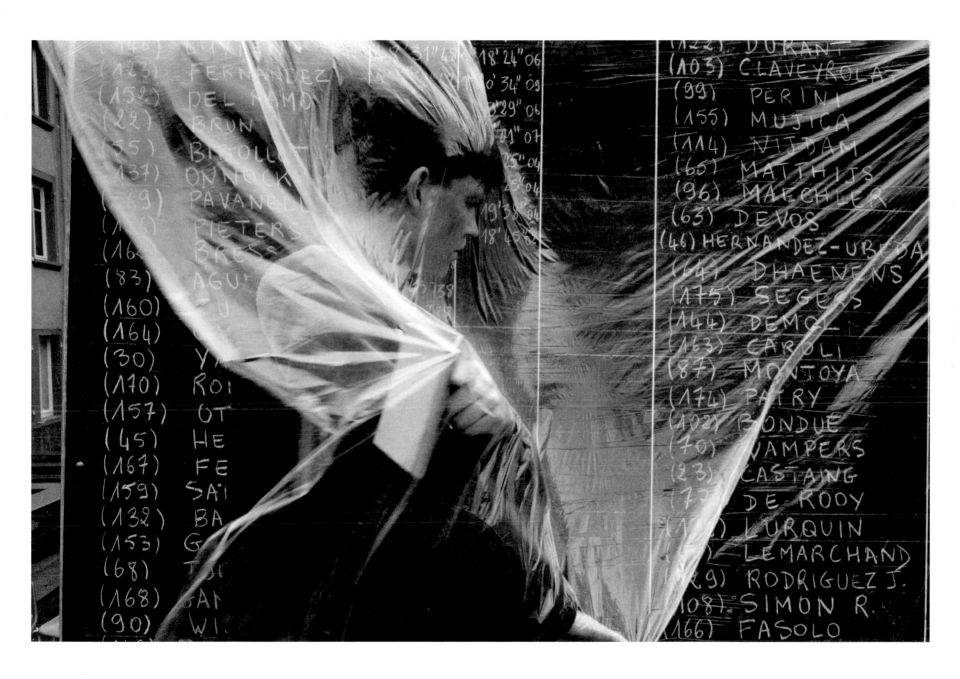

Stage 8, Sarrebourg to
Strasbourg time trial,
6 July 1985: If the top of the
results board were visible,
it would show that Bernard
Hinault had dominated the
day, beating his nearest rival,
Stephen Roche, by a massive
2 minutes and 20 seconds.

roads – but you do see what a beautiful country France is. You cannot appreciate the towns and cities much, not in the context of the Tour.'

Who were you travelling with and how did you prepare for the complex logistics?

'I was with a team of three or four writers. We had two cars – we would sometimes follow, or sometimes go ahead of the peloton – so, because I was not on a motorcycle, it was a bit complicated to shoot any action. But the purpose really was to show what it was all about. The public, the preparation, the massages, the starts, the set-up, the hanging around, the publicity caravan … And every night I had to file a picture to the editor at *Libé*, which, at that time, meant sending it by wire like the other photographers on the Tour. They had a caravan where they would process the film, then they would collect the photographs and wire them into the picture desks across the world. I think it was AFP [Agence France-Presse] who were kind enough to let me process my photographs after they had processed theirs. But I only did this a couple of times; mostly I sent the film every night by courier to Paris, and the next day one of my photos was in the newspaper.

'Very often this meant that I did not really agree with the edit – it was often quite different from what I would have done. I had no control or say because it was happening in Paris; on the race I was moving ahead already. It was a frustration but on the other hand providing pictures day to day was great fun.'

With all that post-race activity – processing the photos and getting them to Paris – each day must have been very long.

'My days were shorter than most, especially if I could send the films back, because I think I wired pictures on only two out of the twenty days, and on the others I would send unprocessed film – I just had to find a way of getting it to Paris. So, at the Tour, I would have a courier going back and forth. I covered the World Cup in Mexico in 1986 too; there, I had to go to the airport every day and find someone who was going back to Paris … You can't do that any more – nobody will carry something for you on a plane! It's too tricky.'

There are a lot of rules for journalists and photographers on the Tour. Did you have any experience of cycle racing before you started the assignment?

'I knew a little bit about cycling – I didn't really follow the Tour on a regular basis. I was biking myself a bit, and had been taking pictures of the small races in Belgium, but not so much to talk about cycling – more because it's an integral part of the scene in Belgium. As for the racing rules – all the unofficial rules, of how to behave … But my target was quite atypical – I would not disturb the work of the pros, who needed the shot of the guy falling, or winning, or on the podium. Mine was more the things on the side. I got accepted fairly easily. Then I had the *Libération* writers, who had been on the Tour several times and were well known. *Libération* is a popular paper, so it was not a big issue. But anyway, I was not in the same place as the real professional sports photographers.'

I take it, then, that you didn't do much shooting on the finishing line?

'Not much – a little bit. Again, that was not my turf – all the really factual things were for the professionals, the guys who were really following the Tour. So we worked separately. I was not interested so much in having a picture of the winner or loser – it was not an assignment to do specific things. [It was a] dream assignment, to do whatever I wanted. They had to have the atmosphere; if there was one of a winner too, then all the better.'

So that was the daily routine over three weeks?

'Pretty much, yes: ship the films, sit in the car and drive to the hotel. Eat, rest and in the morning drive to the start line. I didn't really have time to rest – even during the rest day we would work. Sometimes I was in the race, sometimes not. We were in a car – at one point in the mountains we could go from all the way back to the front. It nearly took the whole stage just to reach the front.'

And that would have entailed taking all sorts of risks on the narrow mountain roads and tight corners. Did you ever get in trouble with the commissaires or the police?

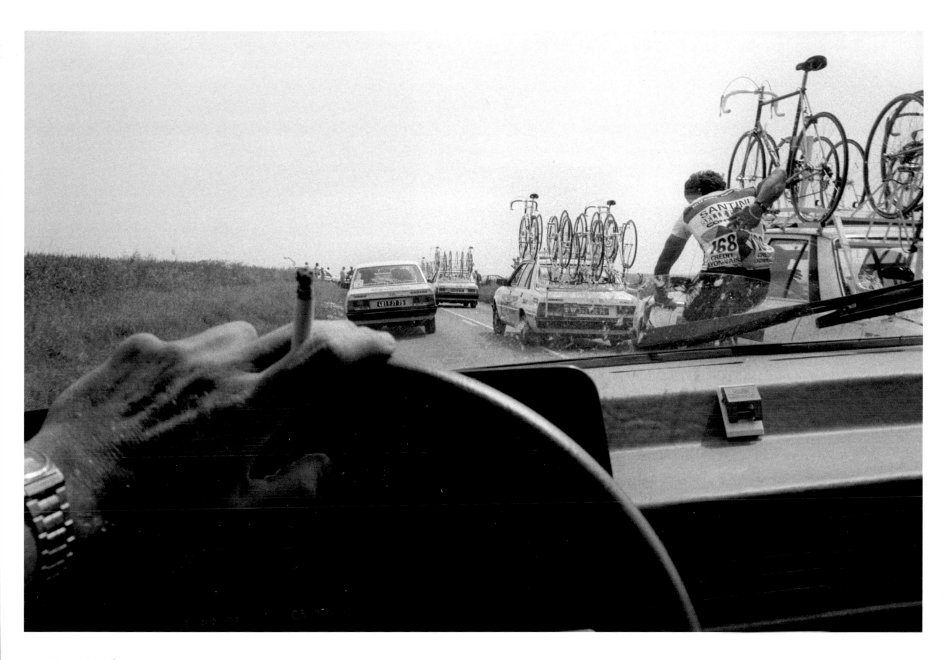

Stage 6, Roubaix to Reims,
4 July 1985: Navigating
through the team cars takes
skill and daring. Riders are not
allowed to hold on to the cars
or use their slipstreams in
order to gain an advantage and
return to the peloton. If they
do, they are given a fine and
may be disqualified.

Stage 5, Neufchatel en
Bray to Roubaix, 3 July 1985:
A La Redoute rider sorts
through his snacks while
his teammate Jérôme Simon
prepares his body for the
next stage.

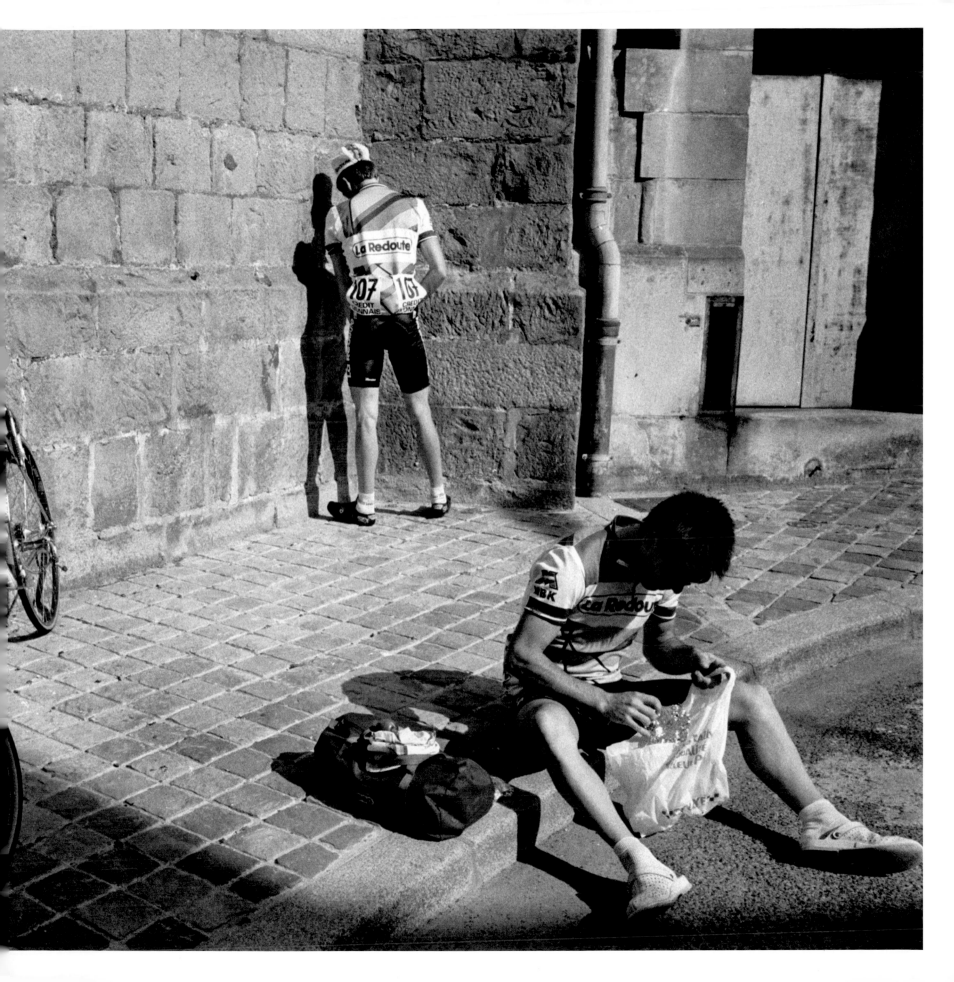

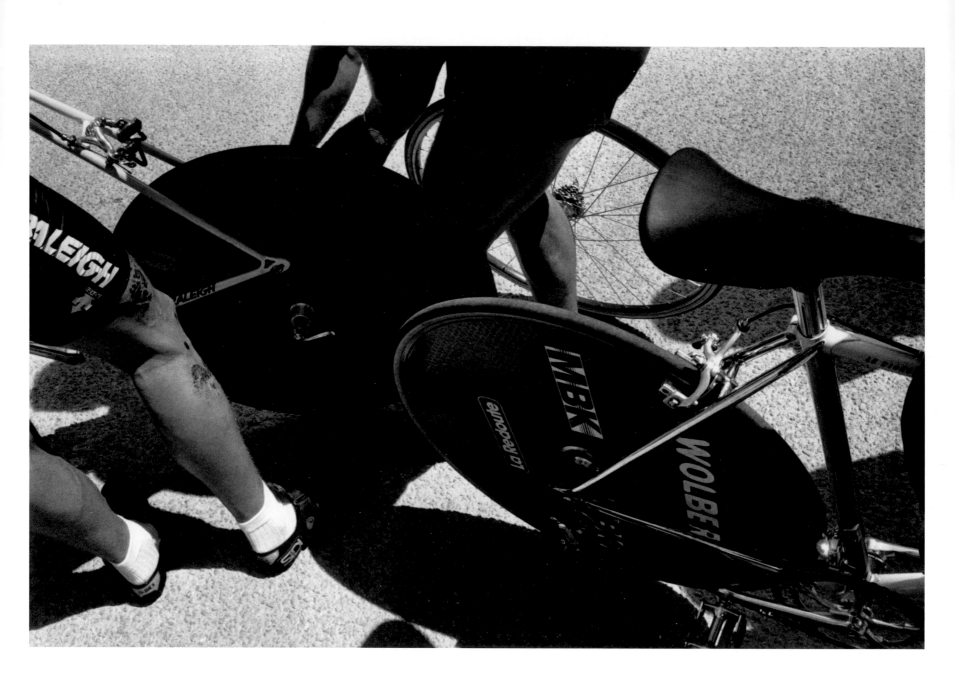

Prologue time trial, Plumelec,
29 June 1985: The prologue
was eventually won by Bernard
Hinault, who would also go on
to win the second time trial in
the race. The aerodynamic disc
wheels used in time trials are
fitted by the mechanics after
the warm-up.

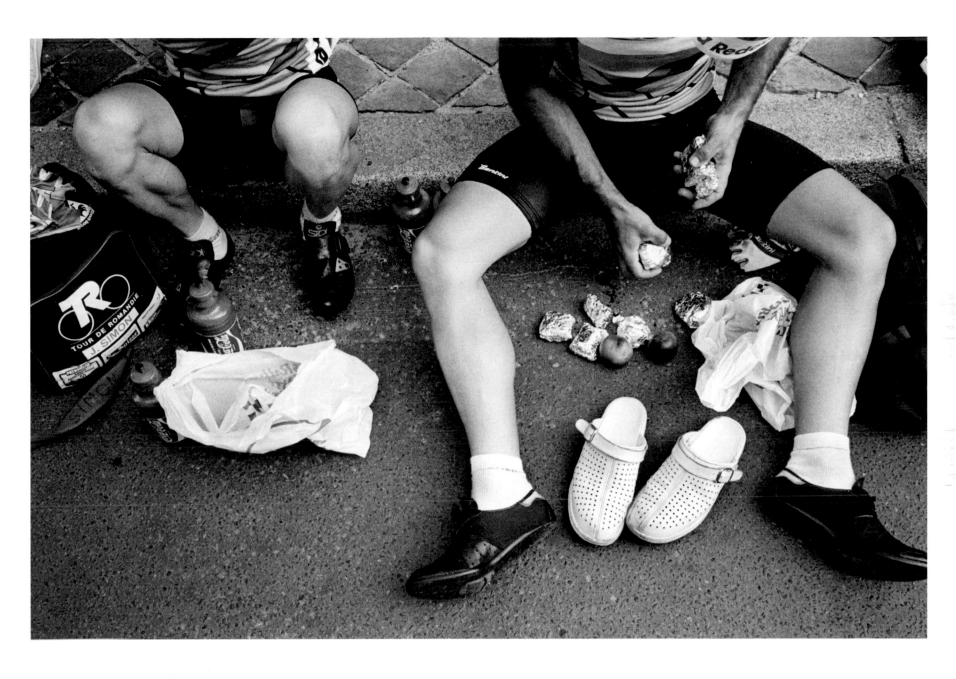

Stage 5, Neufchâtel-en-Bray
to Roubaix, 3 July 1985: Riders
prepare their snacks for a
forthcoming stage. Small, bite-
sized sandwiches and cakes are
pre-prepared and wrapped in
tin foil to keep them dry and
easily accessible.

195

Stage 19, Montpon,
19 July 1985: In the days of
film cameras and morning-
newspaper deadlines,
photographers would process
their film in a specially
equipped 'laboratory van'
that accompanied the Tour.

Stage 8, Sarrebourg to
Strasbourg time trial,
6 July 1985: Dutchman and
one-time yellow-jersey wearer
Hennie Kuiper warms up
behind the scenes before
the Sarrebourg time trial.
He would finish 113th.

VINK: TOUR OF 1985

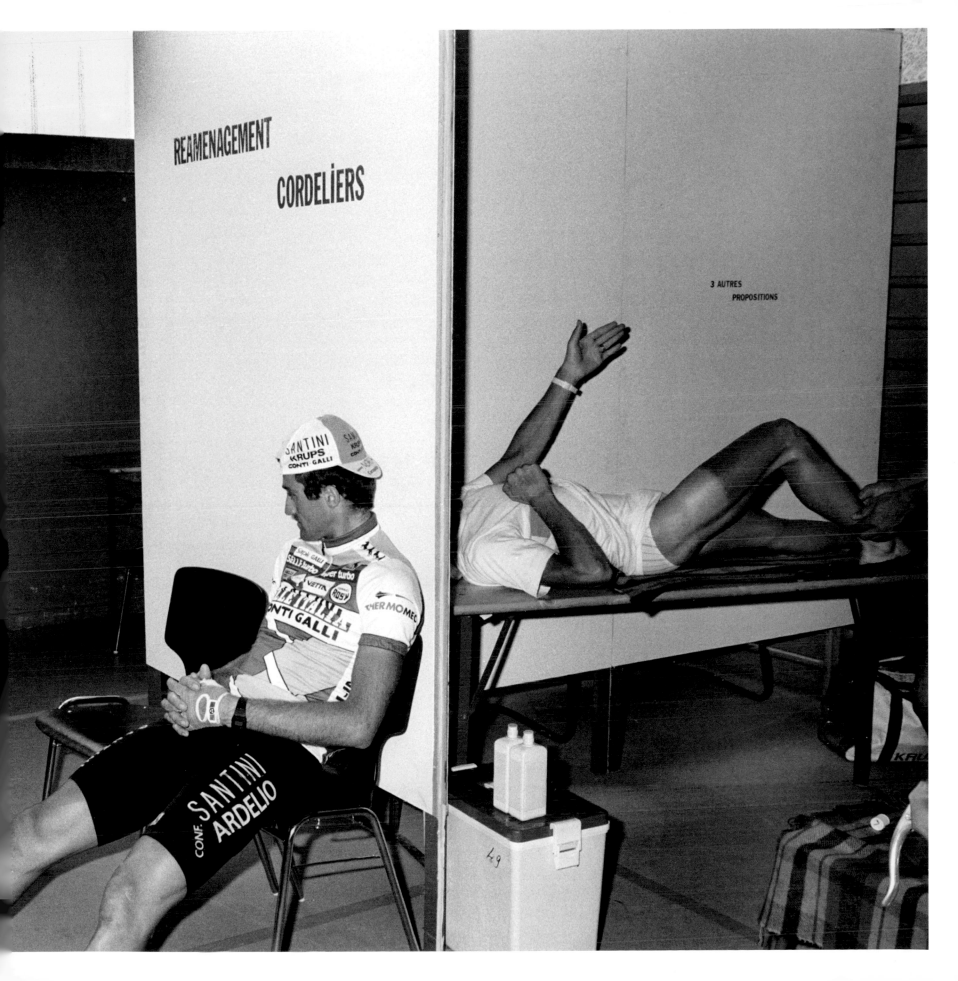

Stage 18a, Luz-Saint-Sauveur to Col d'Aubisque, 17 July 1985: The Colombian climber Luis Herrera rides up the Col d'Aubisque through a sea of fans. Herrera's nickname was 'El Jardinerito', or 'The Little Gardener', for the simple reason that he had run a small nursery prior to becoming a professional cyclist.

Stage 10, Épinal to Pontarlier, 8 July 1985: Spectators at the summit of the last climb, just before the finish, cheer on French rider Bernard Vallet.

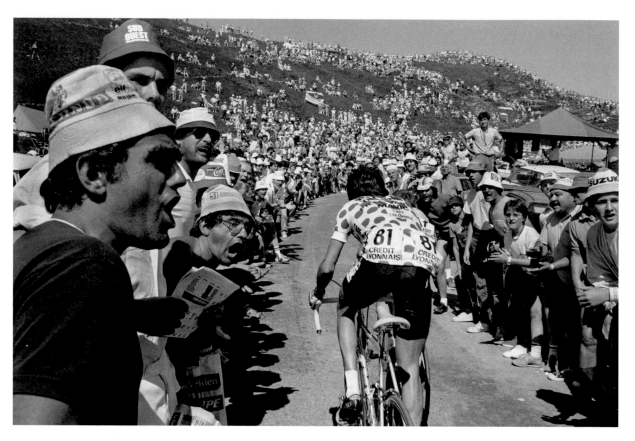

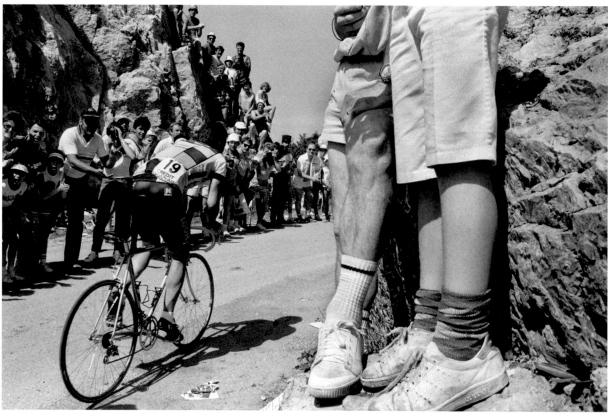

Stage 17, Toulouse to
Luz Ardiden, 16 July 1985:
Two members of the Skil team,
Irish sprinter Sean Kelly (left)
and Frenchman Éric Caritoux,
await the start of the stage.

Stage 5, Neufchâtel-en-Bray to Roubaix, 3 July 1985: In the Nord–Pas-de-Calais region of France – home to the town of Roubaix – cycling is extremely popular. Indeed, the region is synonymous with the Paris–Roubaix spring classic, also known as L'Enfer du Nord (Hell of the North).

Stage 13, Villard de-Lans, 11 July 1985: Spectators enjoy the sunshine during the second time trial of the Tour. Riding past is the Italian Giancarlo Perini, in what was the second of his ten Tours de France. At the end of the day he would be in 48th place.

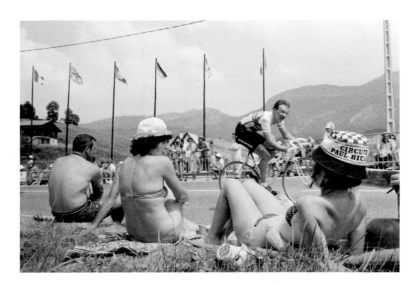

Stage 9, Strasbourg to Épinal, 7 July 1985: Luis Herrera wears the polka-dot jersey of the King of the Mountains. The jersey is worn by the leader in – and overall winner of – the mountains classification.

Stage 20, Limoges, 19 July 1985: Herrera, the eventual winner of the mountains classification in 1985, is rewarded with a prize bull. In rural areas, where bike races are frequently sponsored by animal-feed companies or other types of agricultural business, a farm animal is often presented to a winning rider.

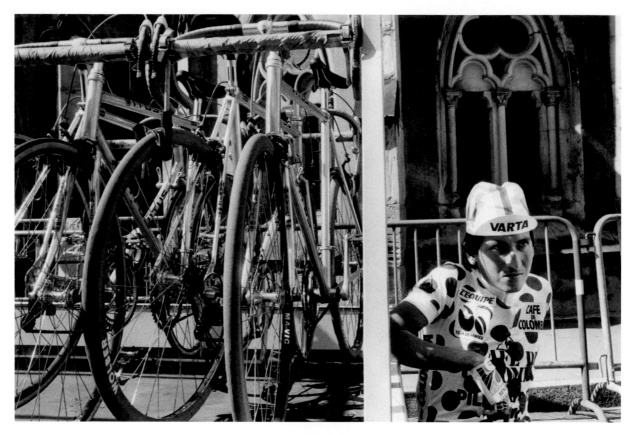

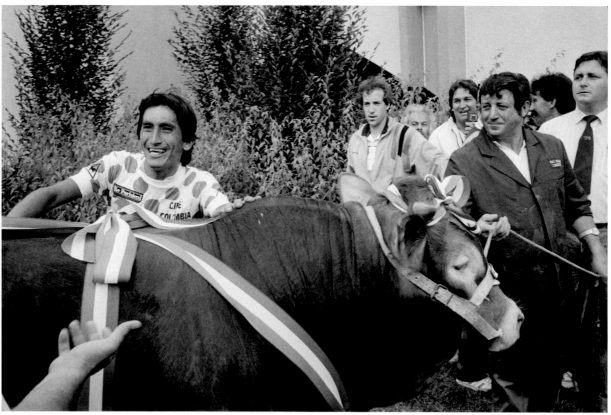

202

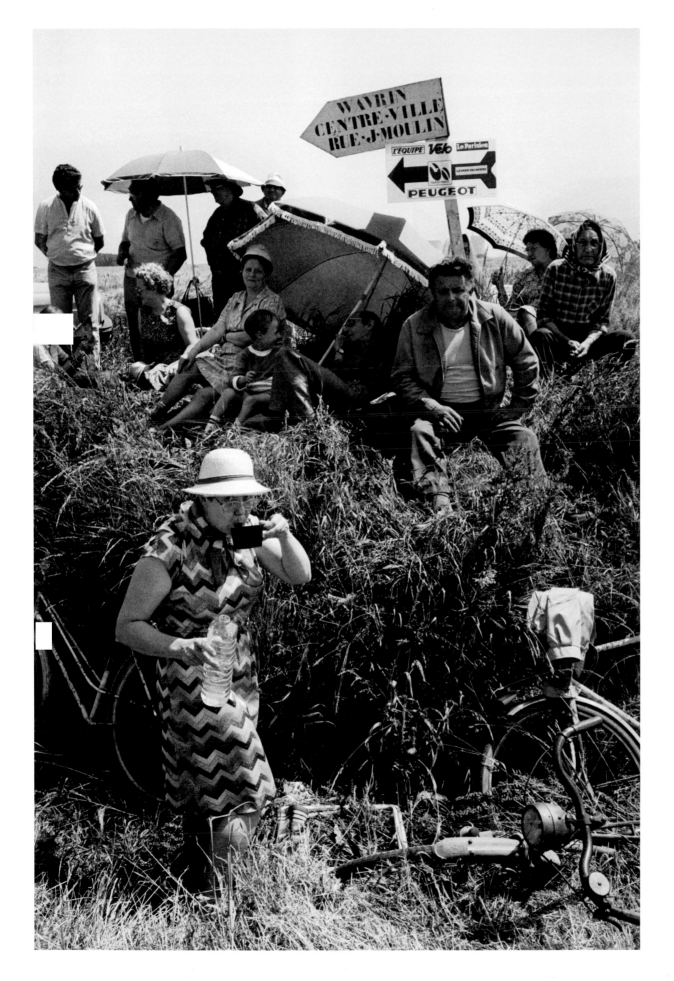

Stage 5, Neufchâtel-en-Bray to Roubaix, 3 July 1985: Spectators near the town of Wavrin wait for the Tour to arrive.

Bernard Hinault's victory in the 1985 Tour de France – his fifth in seven years – would be his last; it was also, perhaps, one of his hardest-fought. The man who had bludgeoned all comers in 1982 was beginning to show his age, and after the 1985 Tour he probably realized that enough was enough. His domination of the race had as much to do with the fear he instilled in his rivals as it did with his talent as a rider. His style was always aggressive and attacking, sometimes to the point of self-destruction: he simply didn't know when to stop. In 1985 he had already won that year's Giro d'Italia, and when he arrived in Plumelec in the heart of Brittany – just to the south of his home town of Yffiniac – to start the Tour, he was in fighting form.

The big personality behind Hinault's big team, La Vie Claire, was the controversial French business tycoon Bernard Tapie. A sometime singer, TV presenter, screen actor, government minister and football-club owner, Tapie made his fortune by acquiring ailing companies (of which Adidas is perhaps the most famous), turning them around and selling them on for profit. To many, Tapie is more wheeler-dealer than businessman, and in 1993 his unusual business activities landed him in hot water when he was accused of match-fixing while owner of Olympic de Marseille football club. He was found guilty, and in 1995 spent eight months in jail. More recently, the controversy surrounding his receipt of compensation from the French government over his sale of Adidas in 1993, the so-called Tapie Affair, continues to generate headlines. But whatever his shortcomings, he succeeded in building one of the biggest and most successful cycling teams of all time.

In many respects the 1985 Tour de France represented a sea change in how the race was won. Hinault's victory was masterminded by La Vie Claire's maverick Swiss sports director, Paul Köchli, whose approach to the race could be regarded as the forerunner of Team Sky's 'marginal gains' concept, where every detail is considered and improved upon. Köchli introduced meditation and relaxation into the team's preparations, and envisaged victory in terms not of the individual but of the team – an idea that would eventually create some friction within the team.

The new technology used by La Vie Claire also took the cycling world by storm. It seems like an obvious thing to do these days, but Köchli approached the race in a highly scientific manner. He introduced specially built climbing bikes, aerodynamic time-trial helmets, aerodynamic disc wheels, different tyres for the various road conditions, and a new clipless pedal system made by team sponsors Look (another Tapie company). The team's jerseys were also innovative: featuring a radical, Piet Mondrian-inspired geometric pattern, they made use of a new material and printing method pioneered by clothing company Santini. Cycling jerseys would never be the same again.

The race itself began fairly quietly but became very dramatic towards the end. Hinault crashed heavily in Saint-Étienne, breaking his nose and making a mess of his face with his Ray-Ban aviator sunglasses. But a facial injury was never going to stop the Badger, and his swollen nose and black eyes made him look even tougher. Hinault was supported by a strong team of riders – the emerging talent that was Greg LeMond among them – and they would all play a part in his victory.

The 1985 Tour saw the participation of the first professional team from South America, Café de Colombia. Having raced and trained in the Andes, the Colombians were a revelation in the French mountains, with the diminutive Luis Herrera and his young teammate Fabio Parra winning stages at their first Tour, and Hererra going on to win the mountains classification. Both men would be the first in a long line of Colombian racers to make the move to Europe, with Nairo Quintana being the most recent to race at the Tour.

The 1985 Tour demonstrated that, in cycle racing, it isn't always the strongest rider who wins. Towards the end of the Tour, LeMond's strength was obvious, even to Hinault. He probably wouldn't admit it, but Hinault knew that LeMond was more than just his understudy. On Stage 17, from Toulouse to Luz Ardiden, LeMond had a good chance of finishing in first place and taking the Tour away from Hinault. But Köchli told him to wait for the Frenchman. Afterwards, LeMond was furious – although a relieved Hinault publicly stated that he would help LeMond win the Tour the following year. A few days later, in Paris, a slightly disgruntled LeMond finished in second place overall, but won both the combined points competition and the final time trial. Thus, regardless of Hinault's promises, LeMond came out of the 1985 Tour ready to win in 1986 – a victory that would turn out to be quite a story in itself.

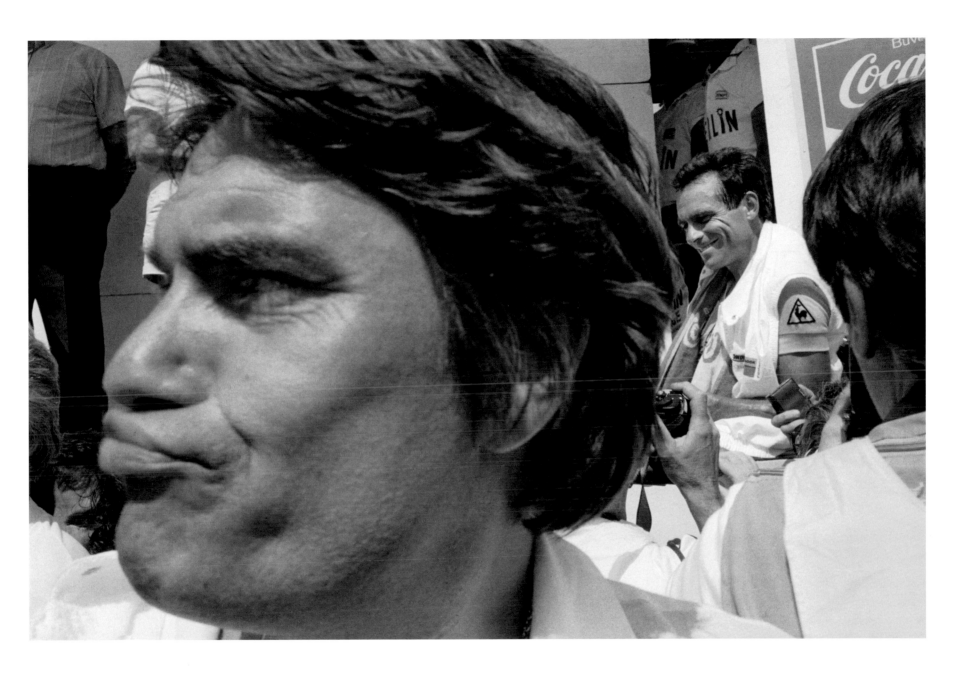

Stage 11, Pontarlier to Avoriaz,
9 July 1985: Bernard Tapie
(foreground), the owner of
Bernard Hinault's team,
La Vie Claire, at the exit of
the doping-control caravan.

Stage 19, Pau to Bordeaux, 18 July 1985: Tour director Jacques Goddet checks the route for the following day. It was Goddet's forty-ninth year in charge of the Tour de France, yet he still needed a map. The following year, 1986, would be his fiftieth and final Tour.

Stage 4, Fougères to Pont Audemer, 2 July 1985: Journalists file their copy in the makeshift press room at Saint-Pierre-sur-Dives. In 1985 several telephonists and switchboards were in operation every day, with engineers having to lay acres of cable to get them up and running at each site. Second from left is the French writer Jean Hatzfeld.

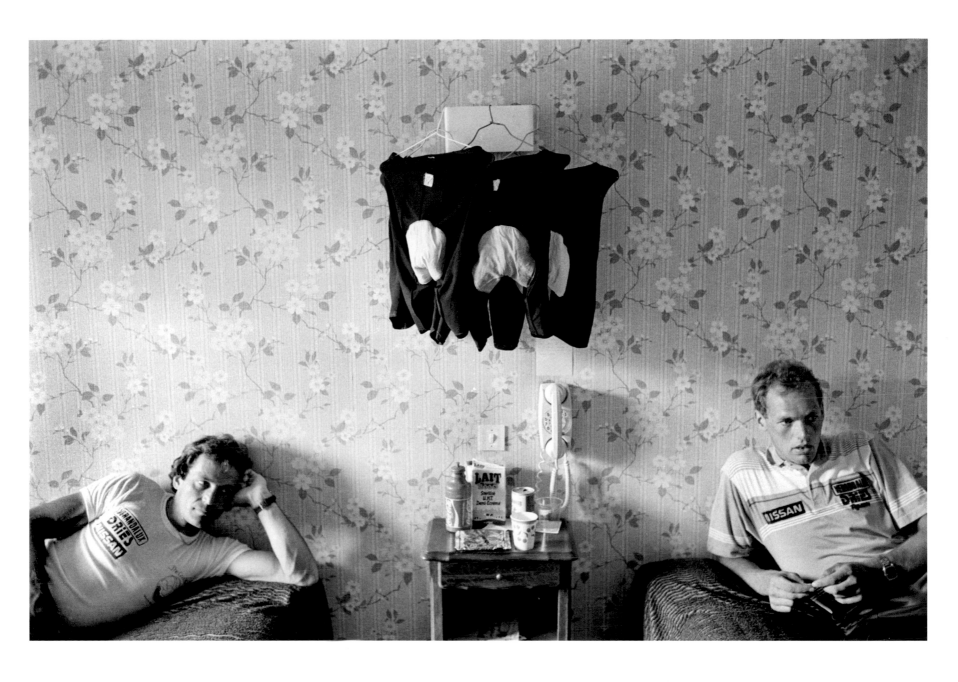

Rest day, Saint-Nizier,
12 July 1985: Jos Jacobs (left)
and Jan van Houwelingen of
the Verandalux team relax in
their hotel room during the
only rest day of the 1985 Tour.

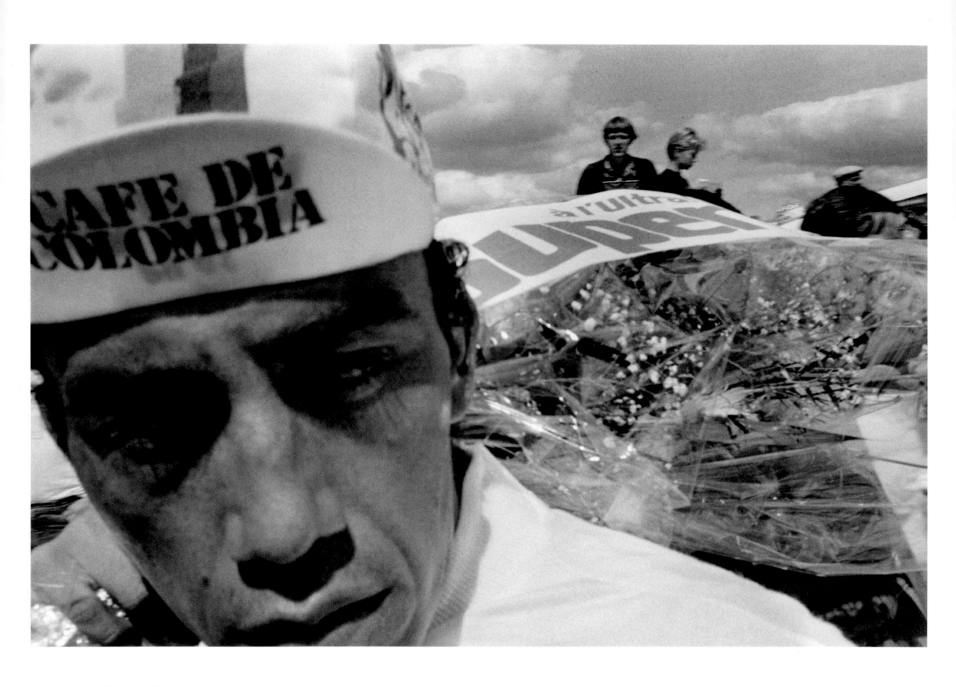

Stage 21, Lac de Vassivière
time trial, 20 July 1985: The
Colombian rider Fabio Parra,
known to his fans as 'The
Condor of the Andes'. Despite
the 1985 Tour being his first
ever, Parra won not only Stage
12 but also the white jersey for
best young rider.

Stage 21, Lac de Vassivière
time trial, 20 July 1985: The
time trial at Lac de Vassivière
was won by Greg LeMond.
It was his first win at the Tour
de France and the first time he
had beaten his team leader and
great rival, Bernard Hinault.

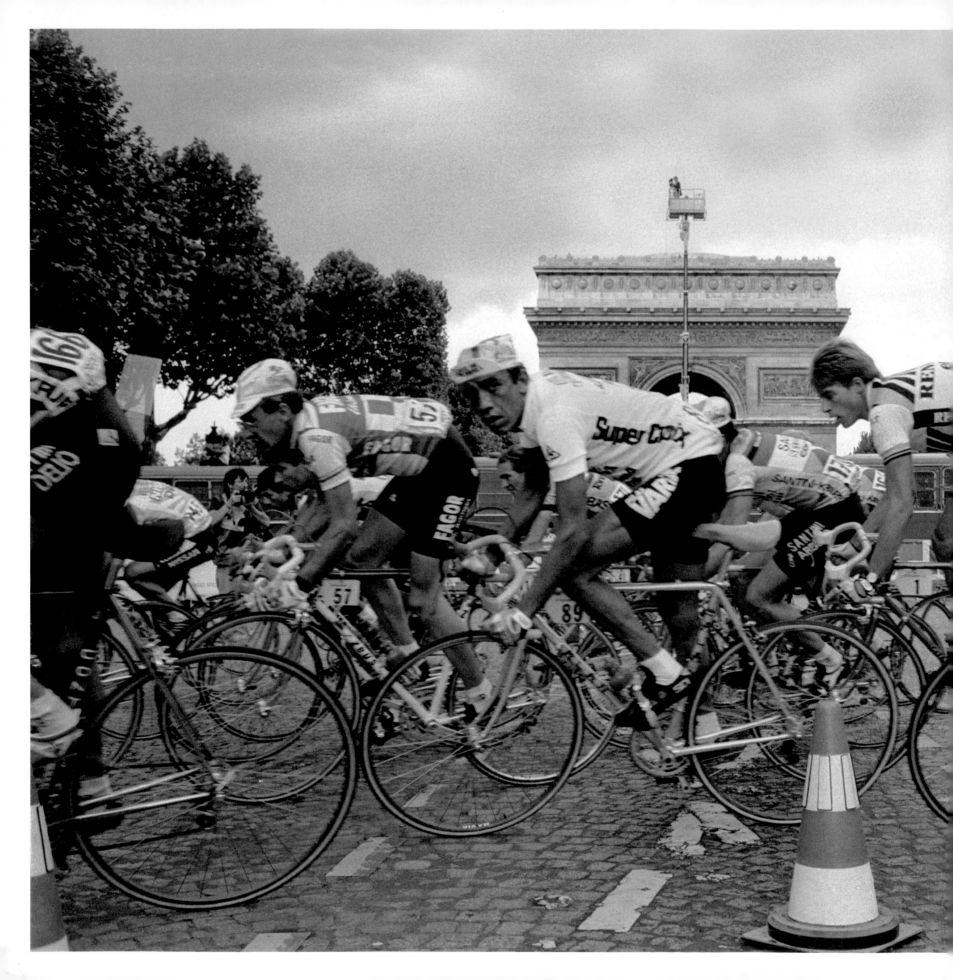

Stage 22, Orléans to Paris,
21 July 1985: With the Arc de
Triomphe in the background,
Fabio Parra looks down the
Avenue des Champs-Élysées,
the final stretch of the Tour
since 1975. The winner that
day was the Belgian sprinter
Rudy Matthijs.

> **The riskiest thing you can do is get greedy.**
> —*Lance Armstrong*

Cycle racing, like all sports, has experienced its fair share of cheating. In the early days of the Tour de France, for example, competitors were known to employ such underhand tactics as jumping on trains, accepting lifts in cars and even letting down a rival's tyres. And then there were the drugs, with riders ingesting various concoctions of heroin, cocaine and strychnine in their attempts to win the race.

At the turn of the twenty-first century, cycling – if not all sport – was only really interested in one thing: Lance Armstrong. At the time, the story of Armstrong's recovery from cancer, his return to the highest level of sport and his record-breaking seven straight Tour de France victories between 1999 and 2005 was the stuff of fairy tales. With the subsequent revelation of his involvement in the biggest doping scandal sport has ever seen, it could be said that the story did indeed turn out to be too good to be true.

Christopher Anderson's photographs of Armstrong were taken in the run-up to the Tour of 2004, the year in which the 'Livestrong' yellow wristbands were launched. Produced in their millions, they were sold for a dollar each to raise money for the cancer charity that Armstrong had helped to launch. Although his charity work and fund-raising are seen by some as a smokescreen for what was really going on in his life, he was recognized by others as being a role model for cancer survivors and an inspiration to cyclists the world over. Ultimately, however, it would be revealed that his dazzling career was in fact the result of a monumental fraud. The subsequent legal battles and lawsuits continue today, and there is no doubt that the sport of cycling is still reeling from the scandal, its reputation in tatters.

The year 2004 also saw the publication of David Walsh's book *L.A. Confidentiel: Les secrets de Lance Armstrong*, co-written with the French journalist Pierre Ballester and published just weeks before the start of that year's Tour. In many ways it was the beginning of the end for Armstrong. With its allegations that the American had used performance-enhancing drugs, the book certainly generated some drama in the lead-up to the race. Armstrong, however, seemed not to let it bother him; indeed, he went after the publishers and authors in the courts, and won. Then, rather than take it easy on the Tour and try to play down the suspicions, he went out and won three stages back to back – a feat that hadn't been achieved since 1948, when the Italian Gino Bartali had claimed three mountain stages in a row. Armstrong went on to win another three stages, as well as a record-breaking sixth Tour overall.

Armstrong's career was reaching its zenith. In 2005 huge sponsorship deals through his newly rebranded Discovery team and personal endorsements were making him a very wealthy man. Also that year, having won just about every international sporting prize on offer, he was awarded the Légion d'Honneur, making him one of only a handful American sportsmen to receive France's highest decoration (he would be stripped of the honour in 2014). Meanwhile, his book about his recovery from cancer, *It's Not About the Bike: My Journey Back to Life*, published in 2000, had become an international bestseller.

# CHRISTOPHER ANDERSON
## THE LOST TOURS

The mountain stages of
the 2003 Tour de France
were dominated by Lance
Armstrong's team, United
States Postal Service (later
Discovery Channel).
Armstrong would win
the Tour overall.

In late 2003 Armstrong had started dating Sheryl Crow. The American singer, songwriter and actress had a house in the Hollywood Hills, and it was there in 2004 that Christopher Anderson had caught up with Armstrong, who was staying at the house ahead of that year's Tour. When I met up with Christopher, I was curious to know how the shoot had come about, and in particular the picture of Armstrong and Crow in the latter's swimming pool (see page 216).

'This whole thing was for *Esquire* magazine', he explains, 'and it was months in negotiation. [Armstrong] had never really done a "behind the scenes" story before – perhaps for good reason. He was going for win number six at the Tour de France, and he was going to break the record of all-time wins. The media had never done a "who is Lance Armstrong" and a look inside his life, so it was supposed to be me in his hip pocket for two weeks and it turned out to be a couple of training rides. I hung out at the house for a couple of days, but like everything, it was way more tightly controlled than it was supposed to be.

'So he was dating Sheryl Crow and using her house as a training base during the summer before he went to Europe for the Tour de France. He'd been out for a long ride in the morning and we were sitting out by the pool, just Sheryl and him and his trainer. I had not been given permission to photograph her. I was photographing him in the pool and then she jumps in. They were all very couple-y, and at one point she says, "Hey, it's cool – you can take pictures." At the time, something that intimate of him and Sheryl Crow was pretty rare, at least without being surrounded by bicycles. It was a real moment.'

Armstrong was renowned for being difficult with photographers and journalists, so how did Christopher get on with him?

'He and I are both from Texas so we had a lot to talk about. He was interested in the fact that I had been to Iraq and Afghanistan. At the time, I am sure he was getting a lot of people saying, "after you win this year you should think about a political career", and of course he was then buddies with George Bush.

He was quite annoyed with the Iraq War, and was interested in what I thought about Texan politics, so we had this political discussion. We just had this very relaxed afternoon. The pool photographs were an unguarded moment with this uber-celebrity couple: he was a big deal and she was too, so it was rare. At the time I was very aware that I was witnessing something special.'

The resulting photograph has a sense of intimacy that, in the mid-2000s, was rare in images of sports stars. Given that Christopher was able to spend a few days with Armstrong, watching him train and eat and recover from training, I was interested to find out what his impressions of the cyclist were.

'I was so disappointed. He was really brash and had this jaw-clenched ambition. OK, so I guess he'd earned the right to be a little bit cocky, but he came across as an arrogant prick – and I said that at the time too. I was a big fan going into [the shoot], and I didn't want to believe all the stuff about him in the press at the time. I followed the Tour and I'd been to the race the year before to photograph it, so this was a cool assignment for me. Afterwards, I was supposed to spend a week with him at the Tour of Georgia, but his team really jerked me around – I stood outside the bus waiting for them for days and it was pretty much a waste of time.'

I suggest to Christopher that, given what's happened since, it must seem a little strange looking back on those times now.

'It was a rare opportunity for me early in my career', he replies, 'and in some ways I wish I'd made more of it. Now he's just a pathetic character. We are used to falls from grace, but this one made us all a little bit jaded – it made it impossible to believe in the impossible. He's a flawed character, although he lied because that's what everybody did. But the worst thing about it was the way he went after people and was so vicious about it – he just went too far.'

215

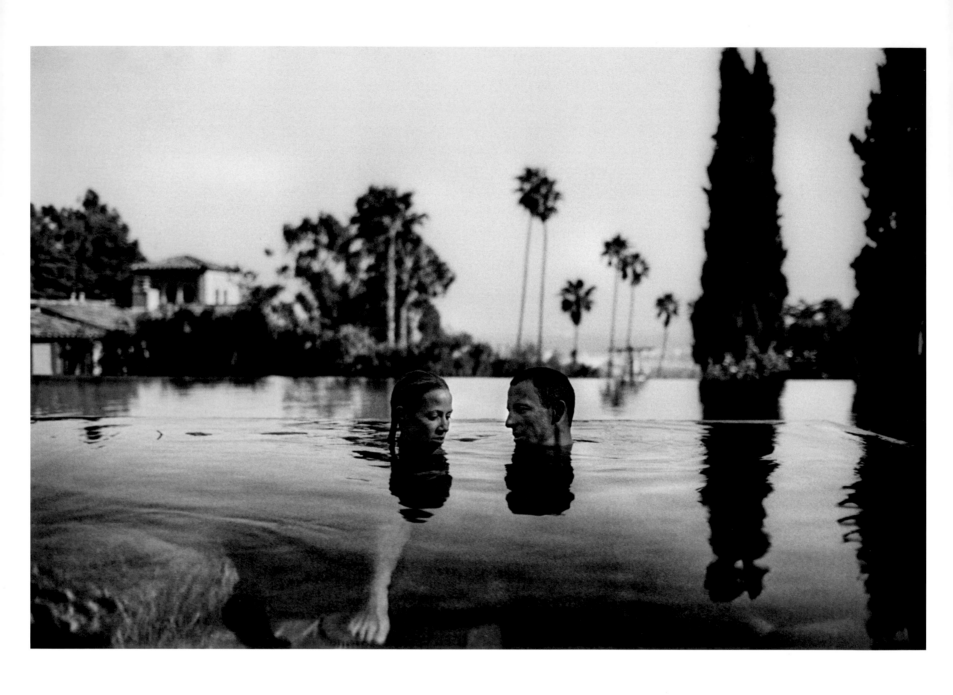

In a rare moment of calm before the 2004 Tour de France, Lance Armstrong relaxes in the pool with his then girlfriend, Sheryl Crow, at her home in the Hollywood Hills.

Armstrong heads to the wardrobe trailer during the filming of a commercial for the Subaru car company near Los Angeles, California. In 2004 Armstrong's advertising worth was at its peak. His only line in the Subaru ad was, 'We have ignition.'

During the build-up to the 2004 Tour de France, Armstrong would take daily training rides around the Calfornian countryside. Each ride would last for seven or eight hours, and would usually be conducted alone.

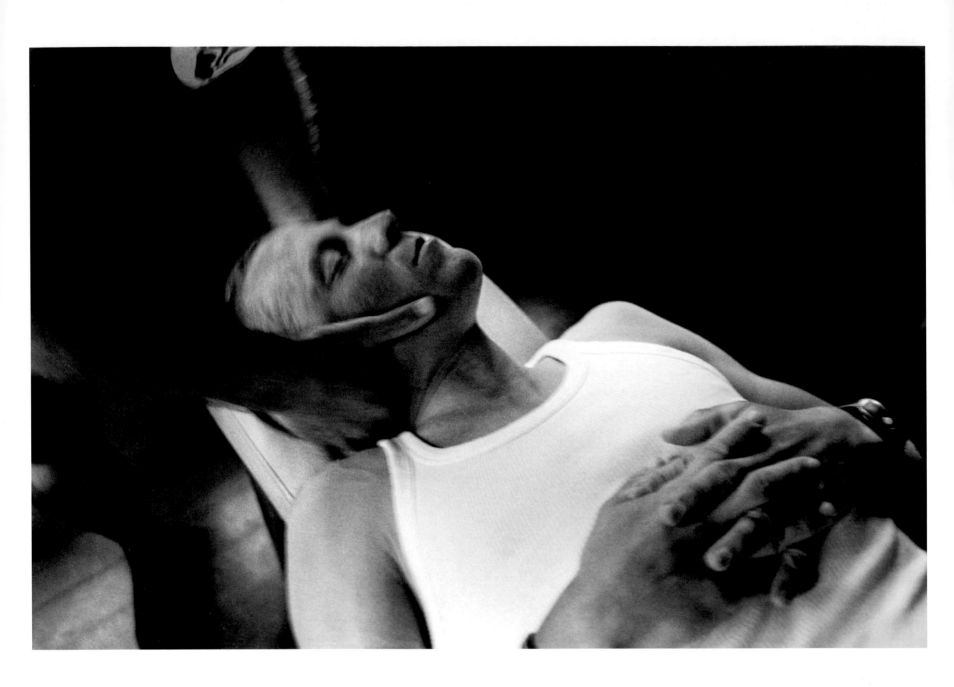

Along with spending
several hours a day on a
bike, Armstrong was a great
advocate of chiropractic
treatment and massage during
the recovery phase. Indeed,
he was known to spend up to
three hours at a time on the
massage table.

Over the course of his racing career, Armstrong's physique changed considerably. Following his recovery from cancer, he lost a lot of weight and became a much more powerful athlete.

# THE SPECTATORS

For his first editorial commission, Henri Cartier-Bresson famously photographed the coronation of George VI in London in 1937. However, rather than photograph the newly crowned monarch, Cartier-Bresson chose to take pictures of the waiting crowd. It was, perhaps, the first time an important historical event had been recorded without showing the event itself. It wasn't the first time that a crowd had been photographed – nor would it be the last – but at that time, for a piece of reportage, it was unique. Louis Aragon, the then editor of *Ce soir*, the left-leaning newspaper that had commissioned the photographs, was no doubt somewhat perplexed by Cartier-Bresson's approach, but the photographer clearly believed that people watching history being made was an event in itself. The excitement and adoration felt by the British public as they waited to catch a glimpse of the royal entourage, with many sleeping out on the streets the night before, is something that cycle-racing fans can empathize with.

Although Cartier-Bresson took only a few pictures of a Tour de France, his photographs are, characteristically, of the people surrounding the race. The waiting and the anticipation are as much a part of the spectacle as the race itself – emotionally involved spectators make for compelling subjects, and a photographer can work anonymously and spontaneously. New York-born Richard Kalvar, who has lived in Paris for more than forty years, took a Metro into Paris one day in 1978 to photograph the Tour. 'I was curious to know what it looked like,' he explained, 'with all those people lined up, watching.' Belgian photographer Martine Franck was also intrigued by the crowds at the Tour, taking pictures in both colour and black and white from the rooftop of her Parisian home. Other Magnum photographers to take an interest in the crowd include Guy Le Querrec, Robert Capa, Harry Gruyaert and John Vink.

Each major bicycle race around the world has its own type of crowd. Stand by the side of the road in a small Belgian town, with about fifteen minutes to go before the arrival of the Tour of Flanders, and you'll probably find yourself alone, wondering if anything is actually going to happen. Ten minutes before the riders are due to arrive and still there'll be no one around. Then, with five minutes to go, the roadside will fill up with hundreds of people. They'll appear as if from nowhere, often arriving on motorcycles from an earlier stage of the race, or emerging from the cosy cafés and living rooms where they can follow the action until the very last minute before rushing outside and seeing the race steam past. At the Giro d'Italia in Italy, and at the Vuelta a España in Spain, the race is almost a distraction – a chaotic, colourful interlude in the daily routines of Mediterranean life. Spectators mill about beforehand, chatting about the race, about the weather and about lunch.

But it's at the Tour de France that you'll find cycling's biggest crowds, with families mingling at the roadside and lunch going on for hours. In the mountains, the camper vans often arrive days before the race is due, the few moments when the riders pass by being the focus of the occupants' entire holiday. They follow the Tour on tiny televisions with terrible reception and listen to radios broadcasting scant information. But if you're a true cycling fan, then nothing can beat the spectacle of the race; even the merest glimpse of the leaders is worth all the effort. Although many of the photographs on the following pages are the result of chance encounters, they all reveal an interest in people and what they do when a bike race is nearby.

**Mark Power**   Tour de France, 1994, Brighton, England: The Tour has passed through the United Kingdom on four separate occasions, the most recent being in 2014, when it started in Yorkshire. The Grand Départ is regularly held in neighbouring European countries.

**Leonard Freed** Tour de France, 1975, final stage, Place de la Concorde, Paris: An Eddy Merckx fan tries to get a better view of the action. Merckx had a tough Tour that year (see page 251), eventually limping into Paris in second place overall.

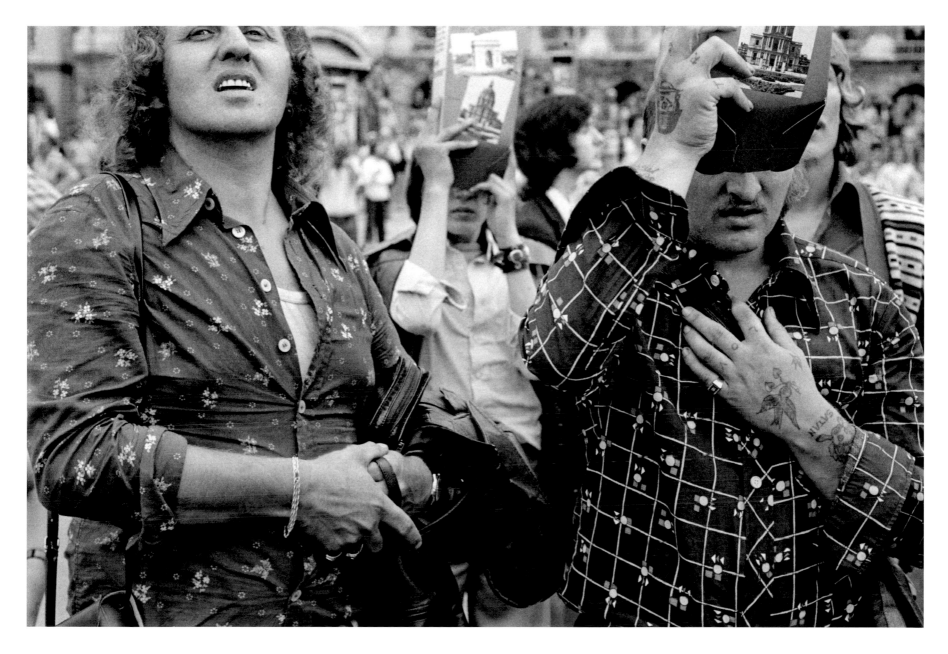

**Leonard Freed** Tour de France, 1975, final stage, Place de la Concorde, Paris: With so many spectators hoping to catch a glimpse of the speeding peloton, the cardboard periscope was an essential accessory. The winner of that year's final stage was Belgian sprinter Walter Godefroot.

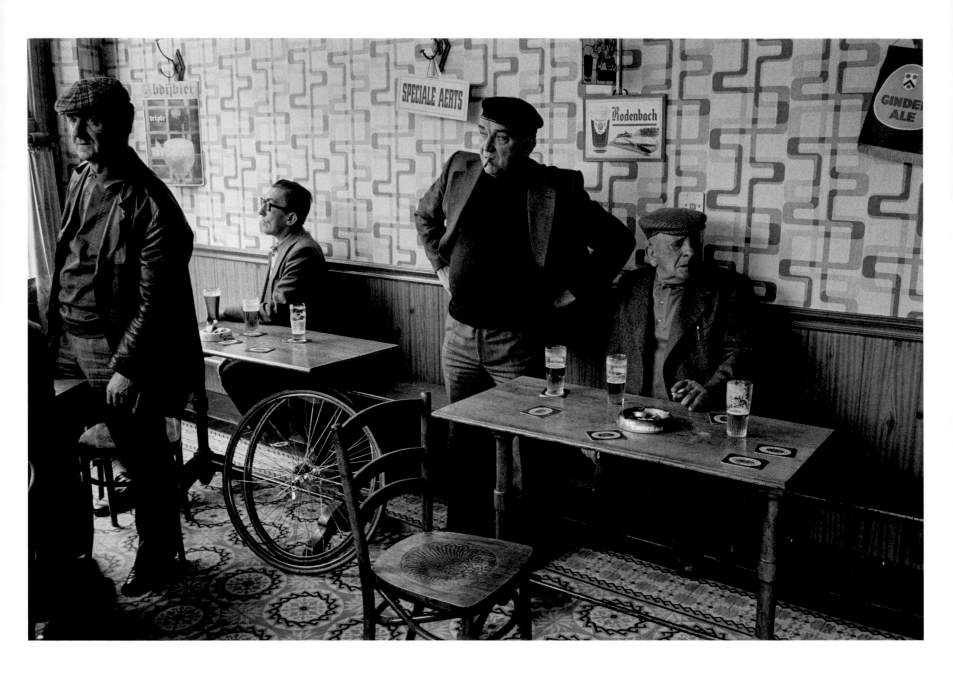

**John Vink** Sint-Genesius-
Rode, Flanders, Belgium,
1979: At weekends, Belgian
cafés are often used as race
headquarters. Here, a 'support
team' for an amateur race
await the arrival of the
Paris–Brussels race held
the same day.

THE SPECTATORS

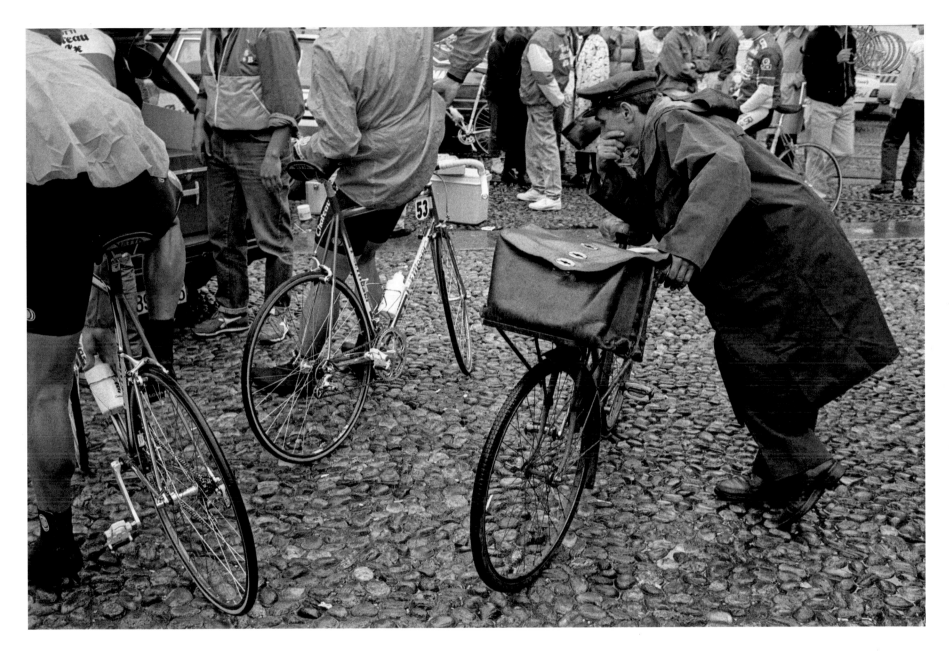

**John Vink**  Milan, 1988:
In Belgium, 'riding like a
postman' is a classic cycling
insult. But this is Italy, and the
postman is taking an interest
in the Château d'Ax team of
Gianni Bugno, Tony Rominger
and the controversial Dr
Michele Ferrari, one-time
coach of Lance Armstrong.

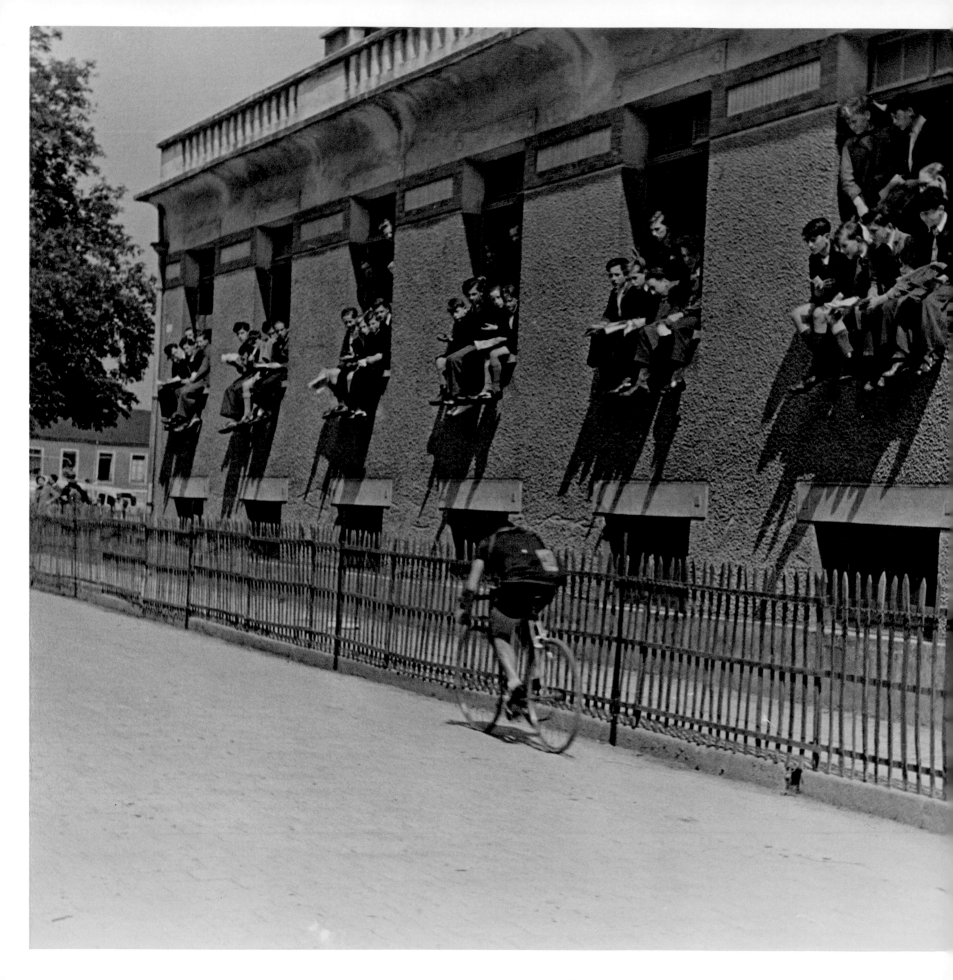

**Robert Capa** Tour de France, 1939: A lone Belgian rider passes a school during a time trial.

**Martine Franck** A crowd gathers outside the fourteenth-century Porte de la Saunerie in Manosque, south-east France, to watch the 1976 Tour de France. This was the Tour's first visit to Manosque; its second would take place in 1982.

THE SPECTATORS

**Martine Franck**   The stage of the 1976 Tour that ended in Manosque – Stage 11, from Montgenèvre – was won by José Viejo. The Spaniard's winning margin remains the largest of any Tour stage since the Second World War: the second-placed rider arrived 22 minutes and 50 seconds later.

**Henri Cartier-Bresson**
Tour de France, 1969, Stage 5, Nancy to Mulhouse: The winner of Stage 5 in 1969 was the Portuguese cyclist Joaquim Agostinho, one of only a handful of riders on the Tour feared and respected by the great Eddy Merckx. The wearer of the yellow jersey after this stage was the Frenchman Désiré Letort, who would hold the lead for only twenty-four hours, losing it to Merckx the following day and eventually finishing the race in ninth place. The rider pictured here, however, is none of these men. It is in fact the green-jersey holder at the time, the Italian sprinter Marino Basso.

Like Letort's brief reign at the top of the leaderboard, Basso's hold on the points-classification jersey was short-lived, and once the race had entered the mountains he would also lose out to Merckx. Basso was a great sprinter on the flat, but was not built for the mountains. He was crowned world champion in 1972, and became a *gregario* (support rider) to Merckx in his formidable Molteni team. After retiring from professional racing, Basso worked for his family's eponymous bicycle company, founded by Alcide Basso in 1974. As for Merckx, not only did he win the 1969 Tour overall, he also walked away with every jersey on offer – including Basso's green one.

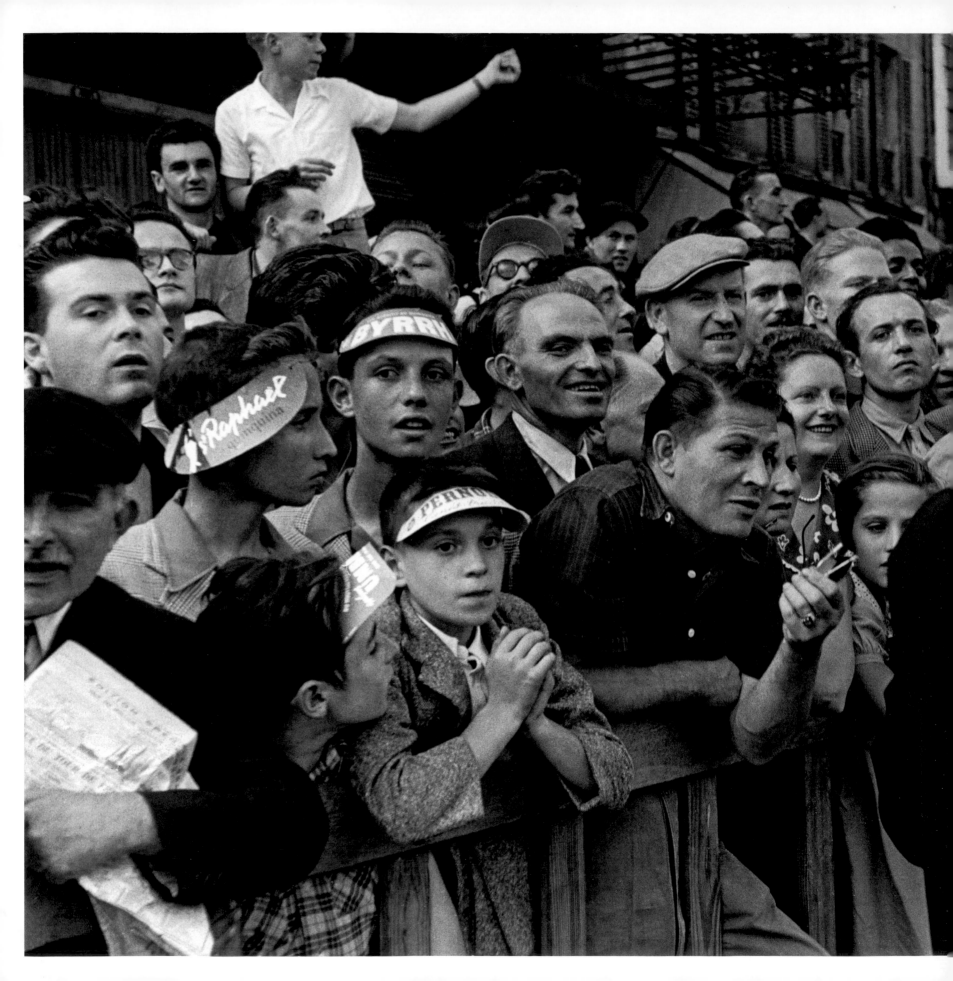

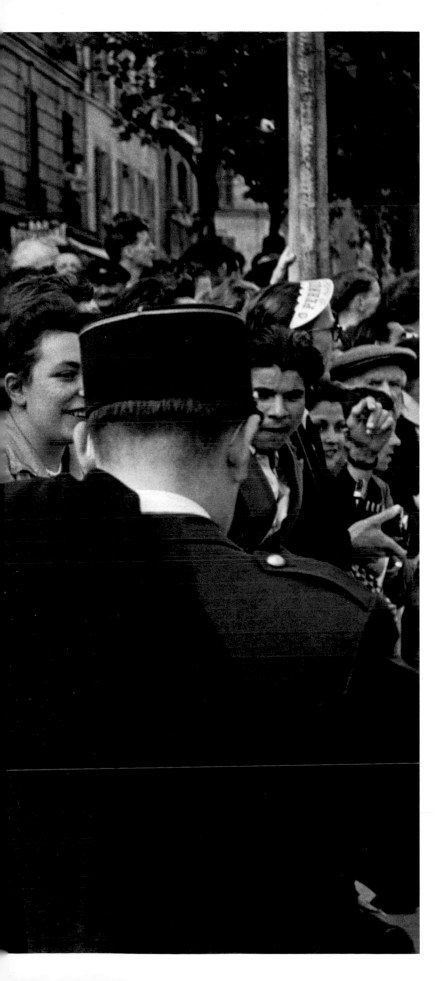

**Henri Cartier-Bresson**
Cartier-Bresson was famed for wandering the streets of Paris, taking photographs from dawn 'til dusk and often into the night. It shouldn't come as a great surprise, therefore, to learn that the focus of one of his adventures in the city was the Tour de France. This photograph is of the 1952 Tour, significant in the modern era for being Fausto Coppi's second and last Tour victory. The Italian was so dominant in the pre- and post-war years that Tour organizers had to increase the prize money for the placings to keep the other riders interested. In 1952 he was the winner of the newly included Alpe d'Huez stage, where he cemented his lead; by the time he reached the finish in Paris, he was almost half an hour ahead of his nearest rival, the Belgian Stan Ockers. Despite Coppi's dominance, the crowds turned out in their thousands to see the race arrive in the French capital.

237

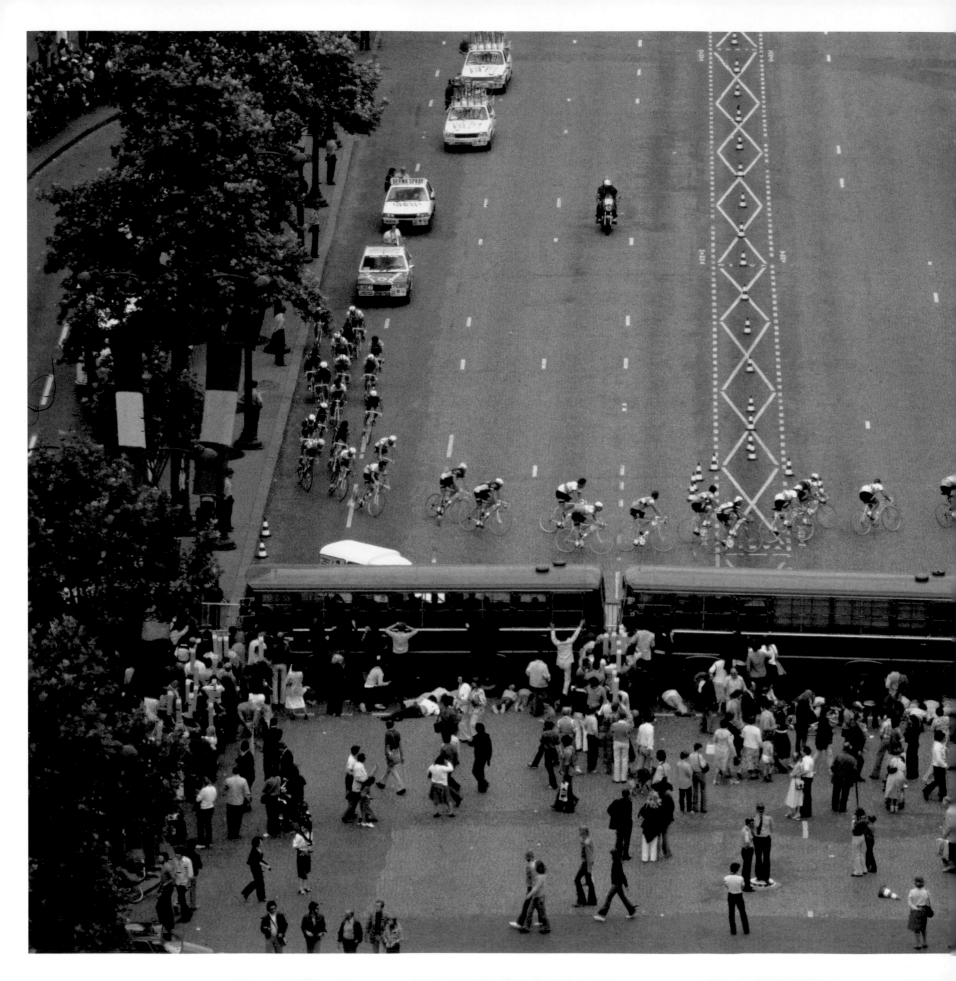

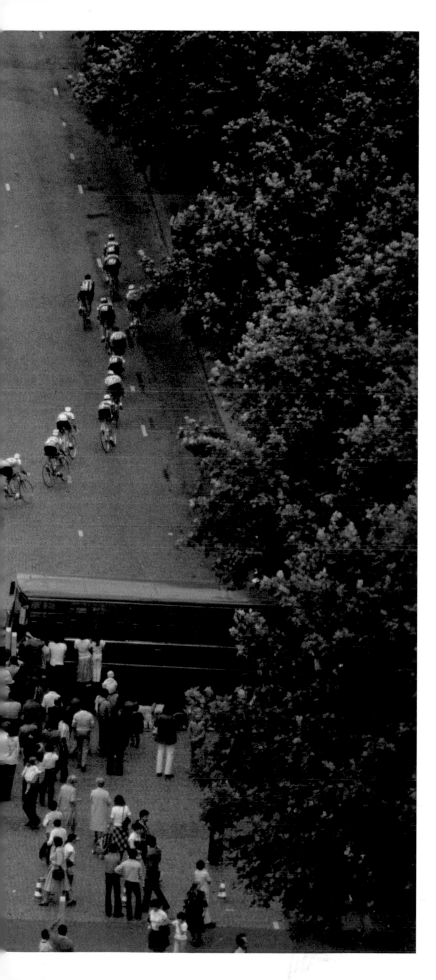

**Guy Le Querrec** Tour de France, 1979, final stage, Paris: This view of the peloton was taken from the top of the Arc de Triomphe. Today, the riders use the roundabout that encircles the monument to turn around and retrace their steps down the Champs-Élysées. The winner of the final stage in 1979 – and of the race overall – was Bernard Hinault.

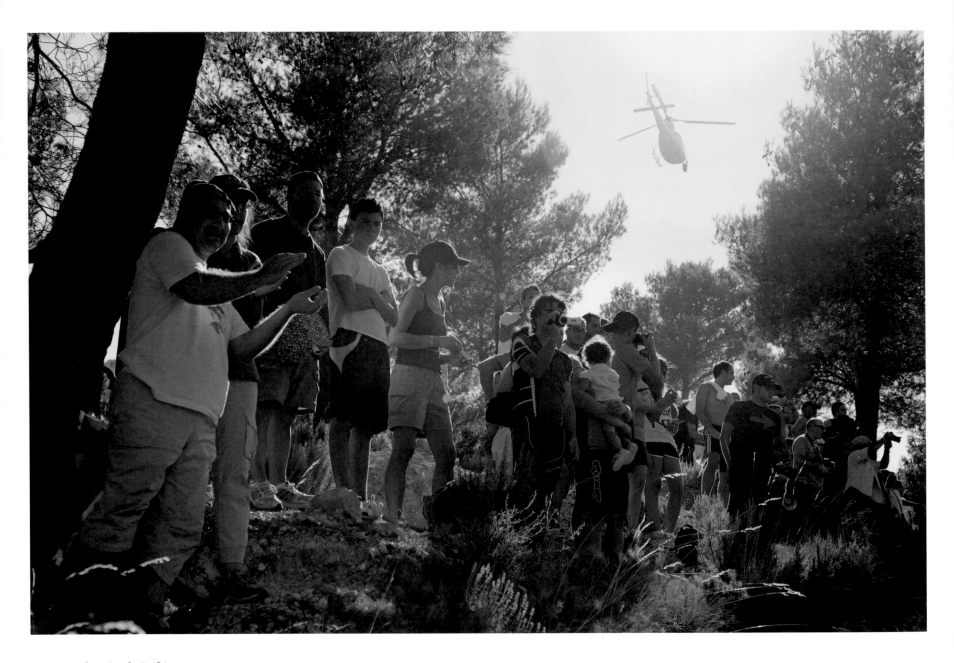

**Chris Steele-Perkins**
Vuelta a España, 2010,
Stage 8: A TV helicopter
passes over Xorret de Catí in
the Sierra del Maigmó. The
climb is feared by riders, as
the gradient in parts reaches
22 per cent. The stage was
won by French veteran racer
David Moncoutié.

**Chris Steele-Perkins**
Vuelta a España, 2010, Stage 7:
Stilt-walking jugglers perform
before the start of the stage,
which runs from Murcia to
Orihuela.

241

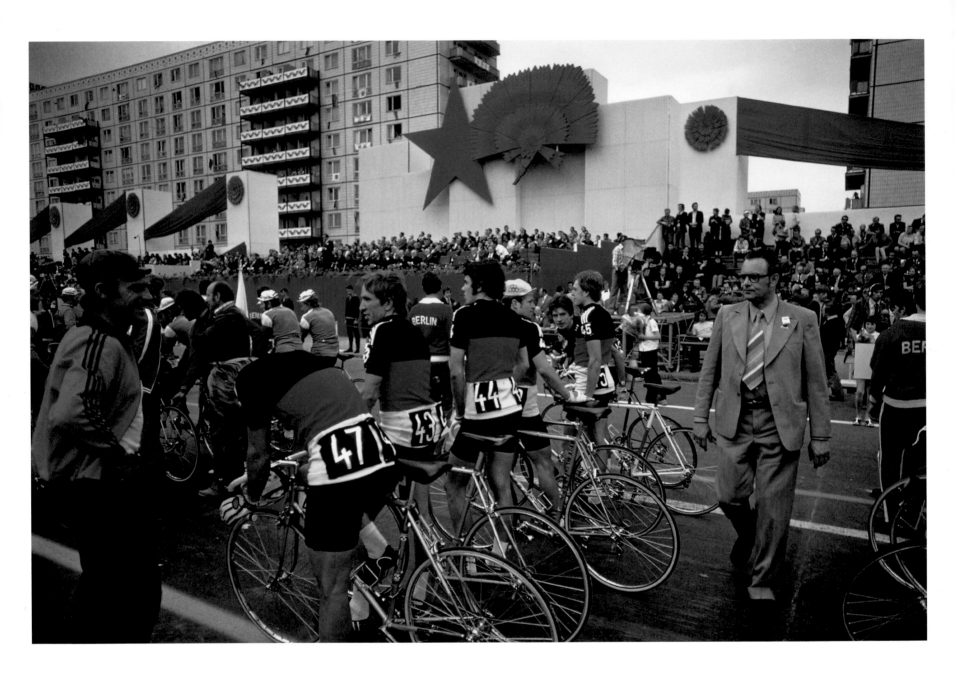

**Thomas Hoepker**
Friedensfahrt, or 'Peace Race', 1974, Karl-Marx-Allee, East Berlin: During the Cold War the Peace Race was known as the 'Tour de France of the East'.

From 1952 it took in the cities of Warsaw, Berlin and Prague, covering around 2,000 km (1,243 miles) over two weeks. National amateur teams from all over Europe would take part.

**Thomas Hoepker**
East Berlin, 1974: The visit of the Peace Race to East Berlin in 1974 coincided with the celebrations marking the 25th anniversary of the creation of the German Democratic Republic. Here, a contingent of Russian officials carry a historic 1945 victory flag during a parade along Karl-Marx-Allee. The jeep in which they are travelling bears the flag of the socialist youth organization FDJ (Free German Youth).

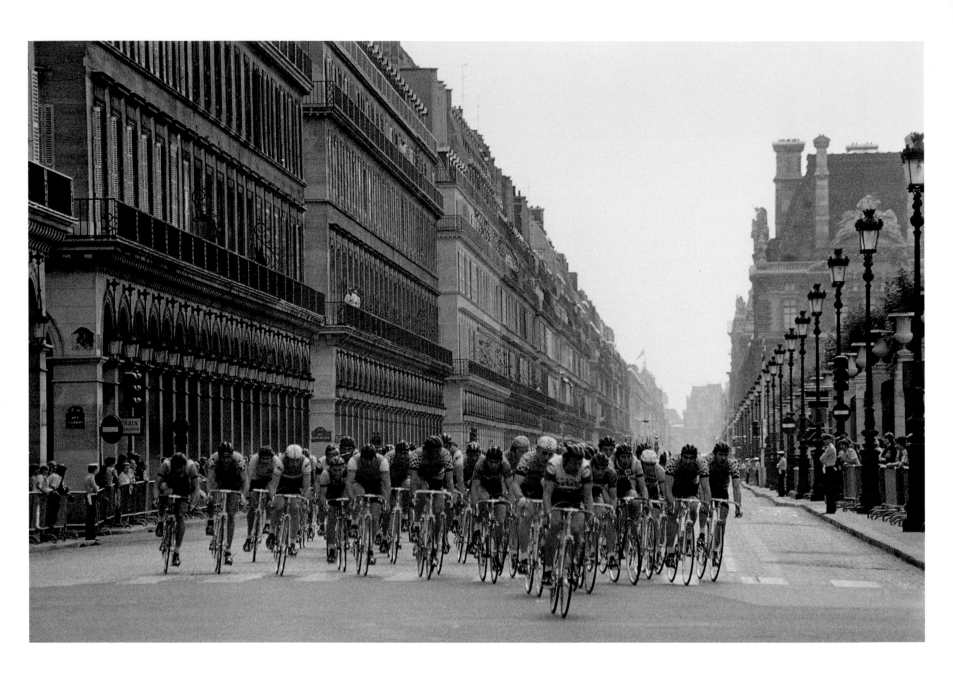

**Richard Kalvar**  Tour de France, 1978, final stage, Paris: As it reaches the end of the rue de Rivoli, the peloton races on to the Place de la Concorde.

THE SPECTATORS

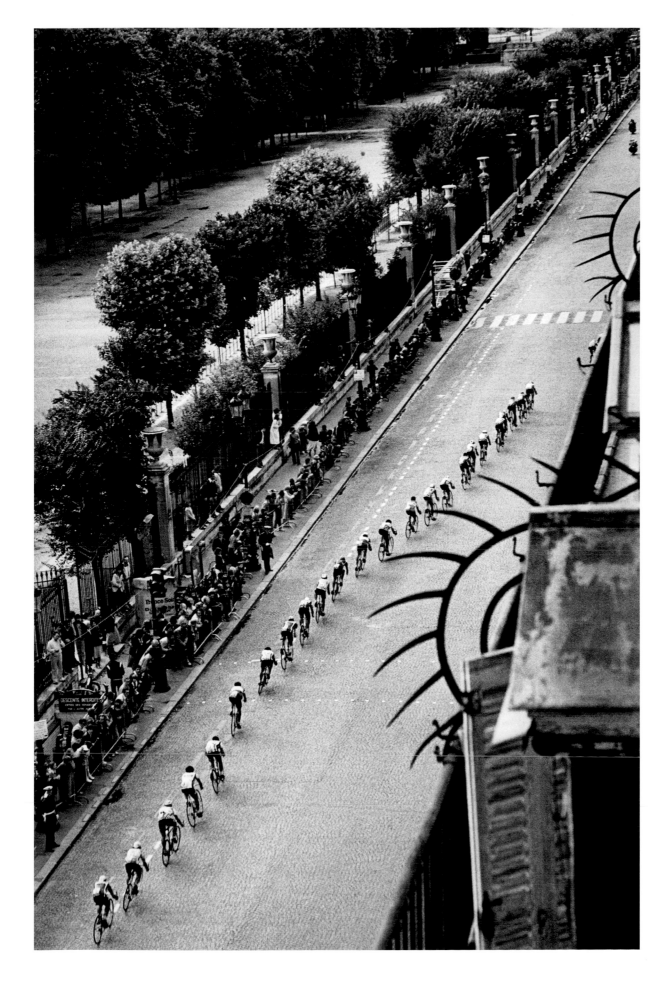

**Martine Franck**
Tour de France, 1980, final stage, Paris: With the Jardin de Tuileries on its left, the peloton rides flat-out down the rue de Rivoli as it heads towards the finishing line on the Champs-Élysées. The stage was won by Belgian sprinter Pol Verschuere, while overall victory went to the Dutchman Joop Zoetemelk. This was Zoetemelk's first and only Tour victory, having finished second on five previous occasions (he would finish second again in 1982). The photograph was taken from the roof of the apartment building in which Martine Franck lived with her husband, Henri Cartier-Bresson.

**Richard Kalvar** Spectators at the 1978 Tour de France – some with additional viewing apparatus – wait for the riders to reach the finish on the Champs-Élysées. While the final stage was won by Gerrie Knetemann, it was Bernard Hinault who emerged as the overall winner after just under 4,000 km (2,485 miles) of racing around France.

THE SPECTATORS

**Richard Kalvar**  Tour de
France, 1978, final stage,
Paris: The Tour attracts a wide
variety of spectators, from
families to film-makers.

THE SPECTATORS

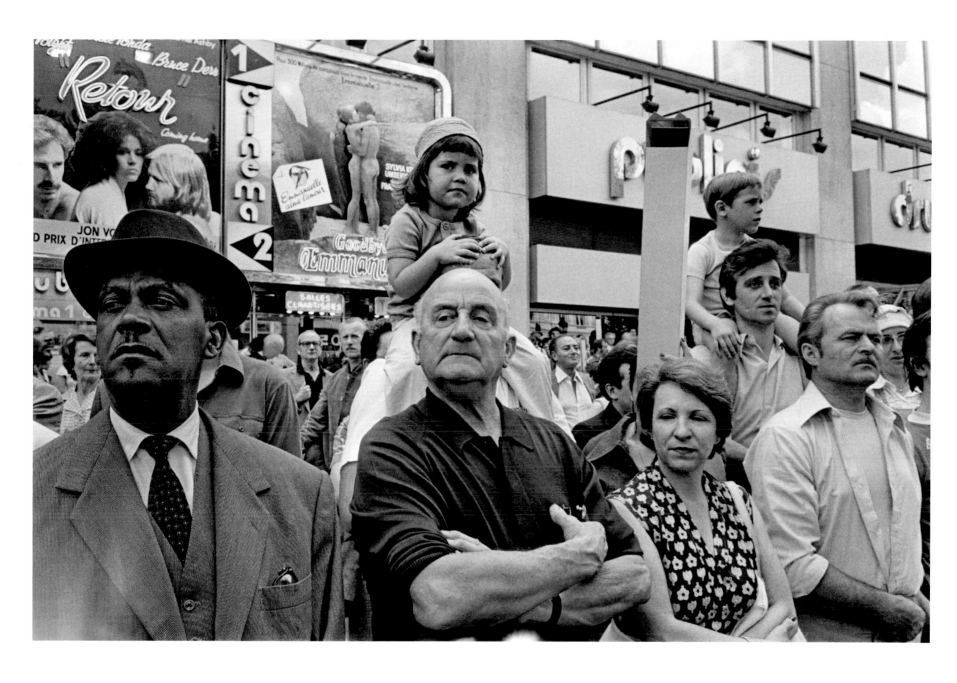

**Richard Kalvar** Tour de
France, 1978, final stage,
Paris: A crowd gathers outside
the Publicis Cinémas on the
Champs-Élysées.

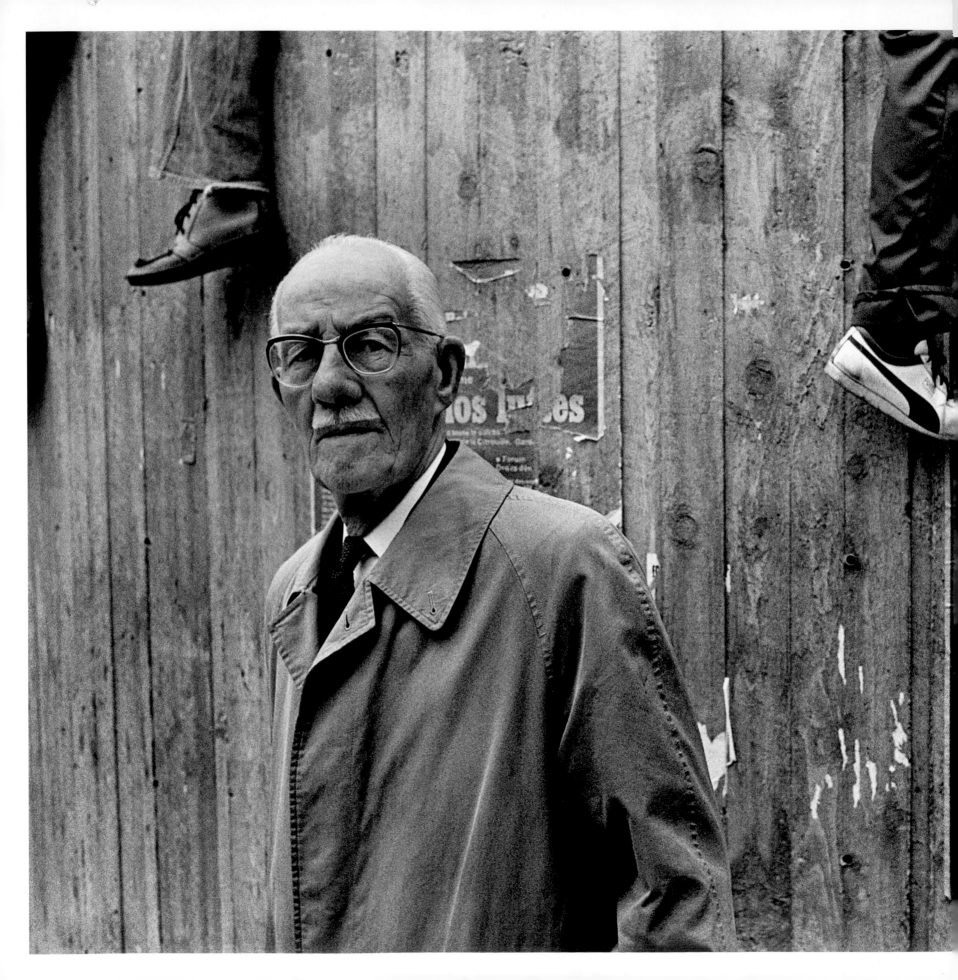

**Harry Gruyaert** Tour de France, 1975, end of Stage 1a, Molenbeek, Belgium: The racing in the opening stages of the 1975 Tour was fast and furious, with Eddy Merckx setting the pace and helping to split the peloton into several groups. The Tour would eventually be won by Bernard Thévenet, but not before yet more drama. Merckx was punched in the kidneys by a spectator on Stage 14, lost the yellow jersey to Thévenet on Stage 15, and collided with another rider on the way to the start of Stage 17, breaking a cheekbone and losing any hope of regaining the lead. It is said that the only reason Merckx finished the race was so that his teammates would not miss out on the prize money that, as is traditional in bike racing, his second place overall and other classification wins would earn them.

The pioneering Magnum photo agency was founded in 1947 by a small group of like-minded photographers: Robert Capa, Henri Cartier-Bresson, George Rodger, David 'Chim' Seymour and William Vandivert. Cartier-Bresson described the cooperative as 'a community of thought, a shared human quality, a curiosity about what is going on in the world, a respect for what is going on and a desire to transcribe it visually'. The photographs in this book are taken from a tiny part of Magnum's archive, but they showcase some of the finest reportage taken at bicycle races and, hopefully, place the bicycle race in a cultural context, as one of the world's favourite pastimes.

### Christopher Anderson (b. 1970)

Canadian-born Texan photographer Christopher Anderson gained international recognition in 1999 when he joined, and photographed, a group of refugees from Haiti who were trying to reach the United States in a small, hand-made wooden boat. The boat sank in the Caribbean, and the resulting photographs of his and the Haitians' ordeal won him the Robert Capa Gold Medal in 2000. Anderson photographed Lance Armstrong after travelling to France in 2003 to watch him win his fifth Tour. Taken in the early summer of 2004, the 'behind the scenes' photographs of the American rider preparing for what would be a record-breaking sixth Tour victory were unprecedented at the time, and, despite the subsequent doping revelations, remain a personal and intimate portrait of a complicated sports star. The photos were first published in *Esquire* magazine.

### René Burri (1933–2014)

Born in Switzerland, René Burri started taking pictures while working as a documentary film-maker during his military service. He became a Magnum associate in 1955, and a full member in 1959. Burri is known for his series of portraits of such figures as Picasso, Giacometti and Le Courbusier. Perhaps his most famous series, however, is of Ernesto 'Che' Guevara, taken in 1963 while he was working in Cuba. The pictures were used around the world, especially those in which the Cuban revolutionary is seen smoking a cigar.

Burri's book *Die Deutschen* (The Germans), a collection of photographs depicting everyday life in Germany, was first published in Switzerland in 1962. His photographs of the 1964 Berlin Six-Day Race are from a series depicting leisure activities and sporting events, and were published in a later edition of the book. Over the course of his career, Burri lived and worked in Paris and Zurich.

### Robert Capa (1913–1954)

Born André Friedmann to Jewish parents in Budapest, the man who would become Robert Capa studied political science at the Deutsche Hochschule für Politik in Berlin, where he also worked as a darkroom assistant. He left Germany in 1933, eventually settling in Paris. It was there that he met Gerta Pohorylle, who, after learning the rudiments of photography from Capa, would become not only his companion but also his professional partner; together, they forged new photographic identities, with Friedmann becoming Robert Capa and Pohorylle changing her name to Gerda Taró. In 1937, while the couple were in Spain covering the civil war, Taró was killed in a road accident. After travelling to China in 1938 and following the 1939 Tour de France, Capa emigrated to New York. He returned to Europe to document the Second World War, famously covering the landing of American troops at Omaha Beach on D-Day.

Capa took his surname from his childhood nickname, which in Hungarian means 'shark' – an apt description of his wide grin and wild spirit. His advice to young photographers was simple: 'Like people and let them know it.' He was regarded as something of a bon viveur – always well dressed and in good company – and enjoyed his life in post-war Paris to the full. Holidays were occupied with skiing, days at the races, or time at the Riviera casinos. He was friends with writers, artists and film-makers of note, including Ernest Hemingway, Pablo Picasso and John Huston. Despite his reputation for enjoying the good life, he was well regarded by his peers, often lending young photographers money and helping them out with assignments. On 25 May 1954 Capa was working for *Life* magazine in Thai Binh, Indochina (Vietnam), when he stepped on a landmine and was killed.

**Henri Cartier-Bresson (1908–2004)**
Writing about her memories of Henri Cartier-Bresson, the American photojournalist and Magnum photographer Eve Arnold said: 'He had that talent great teachers and editors have for making you excited … He carried you beyond analysis into a world that could make you think the unthinkable, that made you free. He acted as a catalyst that enabled you to go beyond your expectations.' The long-time figurehead of Magnum, Cartier-Bresson was one of the twentieth century's finest and most influential photographers. After training as a painter, he took up photography in the early 1930s. During the Second World War, having escaped from a prisoner-of-war camp on his third attempt, he joined an underground group set up to assist other escapees. Despite the fact that he documented some of the twentieth century's most significant events, including the Spanish Civil War and the liberation of Paris in 1945, some of his best-known photographs are of everyday life. In 1952, having spent three years travelling in the East, Cartier-Bresson returned to Europe and published his first book, *Images à la sauvette* (published in English as *The Decisive Moment*). He retired from photography in 1975, and took up painting and drawing again. However, it is for his photography that he will be remembered, and his compelling images of the 1957 Paris Six-Day Race at the Vél d'Hiv are testament to his extraordinary legacy.

**Martine Franck (1938–2012)**
Martine Franck, who became a full member of Magnum in 1983, is remembered for her documentary-style photographs of leading cultural figures and of people living in remote places, such as a group of monks in Tibet and a small Gaelic community on the island of Tory. In 1972, after working in Paris for the Vu photo agency for a couple of years, she co-founded the Viva agency. There is no evidence to suggest that Franck was particularly enthusiastic about cycle racing, but one can safely assume that, as a Belgian national, she would have had at least some knowledge of the sport. Franck had a keen eye for shape and composition, and her photographs of the Tour de France from her apartment on the rue de Rivoli exemplify her characteristic style. The second wife of Henri Cartier-Bresson, she worked as president of the Henri Cartier-Bresson Foundation – established in 2003 by Franck and her daughter – up until her death in 2012.

**Leonard Freed (1929–2006)**
Leonard Freed joined Magnum in 1972. He originally wanted to be an artist; however, after taking pictures in the Netherlands in 1953, he soon discovered that his passion lay in photography. He had an ability to see quirkiness in the most difficult of environments, addressing such complex social issues and international conflicts as the American civil rights movement and the 1973 Arab–Israeli War. Freed's early work is best represented by his book *Black in White America* (1968), which chronicles Martin Luther King Jr's celebrated 1963 march across the United States from Alabama to Washington DC, culminating in his 'I have a dream' speech. Freed is still highly regarded by the photographic community as a 'concerned photographer'. In the 1970s he spent seven years photographing the police department in his native New York, a project that resulted in one of the finest books of reportage photography of the twentieth century, *Police Work* (1980).

**Harry Gruyaert (b. 1941)**
Belgian photographer Harry Gruyaert began his career in the worlds of fashion and industry while contributing to magazines and newspapers; he also worked as a director of photography for Flemish television. His personal work includes stories from Belgium, India, Egypt and Morocco. For his series *TV Shots*, Gruyaert photographed such events as the 1972 Munich Olympics and the Apollo missions as they were shown on a television set, choosing to use a British TV in London because the colours were more vivid and easier to capture on film. The series was later published in book form. In order to achieve the rich colours and vivid contrasts that became synonymous with his work, Gruyaert used Kodachrome film and the Cibachrome printing process. When Kodachrome film finally went out of production in 2009, he simply moved on to digital printing. Colour remains central to his photography, and the Kodachrome work is exemplified by his pictures of the 1982 Tour de France, taken the year after he first joined Magnum.

**Thomas Hoepker (b. 1936)**
Magnum began distributing Thomas Hoepker's archive in 1964, the same year in which he started working for the German magazine *Stern* as a photojournalist. In 1972 he worked as a cameraman and producer of documentary films for German television, and from 1974 began collaborating with his wife, the journalist Eva Windmoeller. Hoepker's photographs of East Berlin in 1974 were taken at the same time as the arrival of the Friedensfahrt, or 'Peace Race', a multiple-stage bicycle race held in the Eastern bloc countries of East Germany, Poland and Czechoslovakia between 1948 and 2006. Contested over the course of two weeks, it was renowned for being as challenging as the Tour de France and similar Western European races. Hoepker returned to *Stern* in 1987, working as art director for two years, and in 1989 became a full member of Magnum. His colour work is particularly stylish, and in 1968 he was awarded the prestigious Kulturpreis of the Deutsche Gesellschaft für Photographie. President of Magnum from 2003 to 2006, Hoepker now lives in New York. A retrospective exhibition of his work toured Germany and Europe in 2007.

**Richard Kalvar (b. 1944)**
The American-born Richard Kalvar moved from New York to Paris in 1972, helping to found the Viva agency that same year. He has lived in Paris ever since. Kalvar became an associate member of Magnum in 1975, and a full member two years later. He has subsequently served as the agency's vice-president and president. A major retrospective of his work was shown at the Maison Européenne de la Photographie in 2007, accompanied by the publication of his book *Earthlings*. Kalvar has attended the Tour de France a couple of times, mainly, he has said, out of curiosity. His work often displays a unique sense of humour and a sense of the absurd, although he once said that 'The merely amusing is a temptation I struggle to avoid.'

**Guy Le Querrec (b. 1941)**
Born in Paris into a modest family from Brittany, Guy Le Querrec has been a prolific reportage photographer for more than sixty years. Today, he is perhaps best known for his intimate and sympathetic portrayal of the world of jazz, both on- and offstage. A co-founder of the Viva agency, he became a member of Magnum in 1976. He is a keen follower of cycle racing, and his photographs of the Renault-Elf team in 1985 represent one of the finest pieces of reportage on a professional cycling team to date. The photos from that project included here are just a small sample of what is a relatively large body of work. It was rare at that time for a photographer to be granted such access to a cycling team, and Le Querrec's images display a keen understanding of and empathy with the riders.

**Mark Power (b. 1959)**
British photographer Mark Power joined Magnum in 2002, becoming a full member in 2007. In his early days as a photographer, Power worked in the editorial and charity sectors; later, in 1992, he began teaching, and is currently a professor of photography at the University of Brighton. This appointment coincided with a shift in his work towards long-term, self-initiated projects, which now sit comfortably alongside a number of large-scale commissions in the industrial realm. Power's work has been exhibited in numerous galleries and museums, and is part of several important collections, both public and private; it has also been published in seven books. Power photographed the Tour de France when it visited Brighton in 1994. The Tour often starts in European nations other than France, and regularly holds stages in neighbouring countries. The race first came to the United Kingdom in 1974, and, since its trip to Brighton, has ventured across the Channel on two other occasions, in 2007 and 2014.

**David Seymour (1911–1956)**
David 'Chim' Seymour (né Dawid Szymin) was born in Warsaw to Jewish parents. His father was a respected publisher of works in Yiddish and Hebrew. At the outbreak of the First World War the family moved to Russia, returning to Poland in 1919. Seymour studied first in Leipzig and then in Paris at the Sorbonne, where he became interested in photography. From 1934 Seymour's picture stories began to appear regularly in the newspaper *Paris-soir* and the monthly illustrated magazine *Regards*, a forerunner to *Life* and *Paris Match*. The influence of *Regards* on photojournalism and the 'concerned photographers' of the period was significant, even if its circulation was smaller than that of such similar titles as *Picture Post* and *Vu*. Seymour's one photograph of cycle racing was of a motor-paced race at an outdoor velodrome in post-war Germany, where such racing had become particularly popular. In 1954, following the death of Robert Capa, Seymour was named president of Magnum. He would hold this post until 10 November 1956, when, while travelling close to the Suez Canal to cover a prisoner exchange, he was killed by Egyptian machine-gun fire.

**Chris Steele-Perkins (b. 1947)**
Born in the same year in which Magnum was founded, Chris Steele-Perkins started work as a freelance photographer, moving to London in 1971. He became interested in urban and social issues, including poverty, and in 1973 embarked on a trip to Bangladesh. He joined the Viva agency in 1976, and Magnum in 1979. Also that year he published his first photobook, *The Teds*, about the British Teddy-boy subculture. He has since published several books based on long-term projects in Afghanistan, Japan and the United Kingdom, including *Afghanistan* (2000), *Fuji: Images of Contemporary Japan* (2002) and *England, My England: A Photographer's Portrait* (2009); his most recent book is *A Place in the Country* (2014). Steele-Perkins' cycling-related work includes coverage of the 1996 Atlanta Paralympics and the 2010 Vuelta a España.

**John Vink (b. 1948)**
Belgian-born photojournalist John Vink has travelled the globe, documenting the plight of various communities in the developing world. Since 1973 his work has been published in a large number of newspapers and magazines, including *Libération*, *Le Monde*, *Time*, *Fortune*, the *New York Times Magazine*, *The Independent* and *L'Europeo*. In 1986 Vink joined the French agency Vu, the same year in which he was awarded the prestigious W. Eugene Smith Grant in Humanistic Photography for 'Waters in Sahel', a two-year documentary project on water management in rural and urban Africa. His cycling work is extensive, with much of it having been shot in his native Belgium. His images of the 1985 Tour de France, taken for *Libération*, formed the basis of his 1986 exhibition at the Maison de la Culture in Amiens, France. Vink now lives and works in Cambodia. He has been a member of Magnum since 1997.

Acknowledgments

The author would like to thank Ruth Hoffmann and Hamish Crooks at Magnum London, as well as Eva Bodinet and Enrico Mochi at Magnum Paris; Lucas Dietrich, Johanna Neurath, Bethany Wright and Mark Ralph at Thames & Hudson; Claudia Paladini and Stuart Smith at Smith Design; Teddy Cutler and Andy McGrath for translation and transcription help; Robert Millar, who has a keen eye for famous faces from the 1980s; Jack Thurston and Matt Seaton for their insight and help with the Vél d'Hiv; Fabrice Leboulanger at PresseSports/ *L'Équipe*, and the French cycling historian and sports journalist Serge Laget, for their help with French movie stars of 1939 (among others); and film-maker Jørgen Leth.

A huge debt of thanks is owed to all the Magnum photographers, especially those interviewed and consulted for this book: Harry Gruyaert, John Vink, Guy Le Querrec, Richard Kalvar, Christopher Anderson, Chris Steele-Perkins and Stuart Franklin.

And lastly, *muchas gracias*, Taz.

## About the Author

Guy Andrews has been a cycling journalist, author and editor for more than twenty years. Before that he worked as a bicycle mechanic, a teacher and an enthusiastic – if not altogether successful – bike racer. In 2006 he founded and co-published the cycle-racing magazine *Rouleur*, editing the publication for almost ten years. During that time he also produced and edited seven photographic cycling annuals, as well as promoting the related exhibitions in London, New York and Berlin.

Guy has written several books on the subjects of cycle racing and bicycle design and technology, notably *The Custom Road Bike* (2010) and, with Rohan Dubash, *Bike Mechanic: Tales from the Road and the Workshop* (2014). He has also edited and art-directed several critically acclaimed titles published under Bloomsbury's Rouleur imprint, including *Maglia Rosa: Triumph and Tragedy at the Giro d'Italia* (2011) and *Coppi: Inside the Legend of the Campionissimo* (2012).

Guy is an avid collector of vintage photojournalism magazines, especially those on cycling. He lives in London.

*Cover, front*
Martine Franck: Six-day race, Paris, 1984
(see page 139)

*Cover, back*
Harry Gruyaert: Tour de France, 1985

*Page 2*
Guy Le Querrec: Bicycle race, Normandy,
France, 1961

*Page 4*
Harry Gruyaert: Olympic Games, Munich, 1972,
from the series *TV Shots*

*Magnum Cycling* © 2016 Thames & Hudson Ltd, London
Text © 2016 Guy Andrews
Photographs © 2016 the photographers/Magnum Photos

First published in 2016 in hardcover in the United States of
America by Thames & Hudson Inc., 500 Fifth Avenue,
New York, New York 10110

thamesandhudsonusa.com

Library of Congress Catalog Card Number 2015953616

ISBN 978-0-500-54457-0

Printed and bound in China by C & C Offset Printing Co. Ltd